Drawing the Human Head

GIOVANNI COLOMBO was born in Como, Italy, in 1961. After attending a lyceum for the arts, he enrolled in the Accademia di Belle Arti di Brera in Milan to study painting. In the early 1980s, he attended the studio of A. Tenchio to deepen his knowledge of engraving, where he met and became friends with many other artists and started working in illustration in addition to painting. In 1982 he began showing his artwork, in both group and individual shows, and in 1988 he started to teach painting at the "Fausto Melotti" State Art School in Cantù, Italy - where he still works today. He wrote *Percezione & Disegno: dalla visione alla rappresentazione* (Perception & Drawing: From Vision to Representation; Ikon, Milan, 1998). He has published several limited edition booklets and engravings. Today he lives and works in Como.

GIUSEPPE VIGLIOTTI was born in Estavayer Le Lac, Switzerland, in 1965 and currently teaches painting. In 1983 he received his diploma from a fine arts secondary school, and in 1986 his work was shown in numerous exhibitions, both group and individual. Since 1987 he's worked as a freelance illustrator and graphic designer for numerous publishers. In 1988 received his degree in painting at the Accademia di Belle Arti di Brera in Milan. From 2007 to 2010 he worked in art publishing, with specific experience relating to artists' books and the use of graphic design software, editorial layout and website creation. His current artistic focus is on video-installations, multimedia techniques and computer graphics. Today he lives and works in Como.

Giovanni Colombo
Giuseppe Vigliotti

Drawing the Human Head

Anatomy, Expressions, Emotions and Feelings

promopress

Drawing the Human Head
Anatomy, Expressions, Emotions and Feelings

Original title:
Disegnare il Volto
Anatomia, Espressioni, Emozioni e Sentimenti

Translation: Katherine Kirby

ISBN: 978-84-16851-02-7

Copyright © 2017 Ikon Editrice srl
Copyright © 2017 Promopress for the English language
edition

Promopress is a brand of:
Promotora de prensa internacional S.A.
C/ Ausiàs March 124
08013 Barcelona, Spain
Tel.: 0034 93 245 14 64
Fax: 0034 93 265 48 83
Email: info@promopress.es
www.promopresseditions.com
Facebook: Promopress Editions
Twitter: Promopress Editions @PromopressEd

First published in English: 2017

Cover design:
spread: David Lorente

Printed in China

*High-intensity smiling - the giving
of a broad grin, a beaming smile -
is completely different in function
from high-intensity laughing.
It has become specialized
as a species greeting signal.
If we greet someone by smiling at them,
they know we are friendly,
but if we greet them by laughing at them,
they may have reason to doubt it.*
"Desmond Morris *(The Naked Ape: A Zoologist's
Study of the Human Animal, 1968)*"

Man's numerous facial expressions developed as we evolved, connected to improving visual communication between groups and individuals. The emotions of our ancestors helped ensure the survival of our species. Such a complex outer display of feelings has evolved only in a few groups of mammals, such as upper primates, horses, dogs and cats.

Bonobos (close relatives of chimpanzees) have developed mimicry and communication abilities equivalent to that of a two or three year old child. They're known to be capable of altruism, compassion, empathy, kindness and patience.

Our species possesses a more mimicry capacity which is more refined and complex than any other animal alive today. Scholars have recently shown that it takes just a few short seconds to evaluate someone we've never met before and to sense his or her mood, even if s/he tries to hide it.

Fear, for example, allowed primitive man to defend against danger, but it was equally important for our ancestors to be able to express this danger and thereby defend the group and children. The ability to feel and express disgust even allowed us to distinguish between edible and poisonous or rotten food.

Our emotions are accompanied by various physical reactions: palpitations, blushing, sweating…the body assumes different postures, hands create gestures, the face produces vocal expressions and mimics.

The face is often the "mirror" of our most intimate feelings. Without realising it, through facial

mimicry we communicate our emotions and thoughts, no matter how superficial or profound, to others. Expressions are always present, even when our facial muscles are resting, breathing is regular, the skin is relaxed, in the balanced state we called "calm". An inexpressive mask is a paradox, something forced, a game where children try to hold their faces completely still; the "Great Stone Face" of Buster Keaton as an unconventional quest for comedy through inexpressive shades.

This book hopes to be a sort of catalogue of expressions manifested in historical works of art and images from modern-day culture, some of them drawn by the authors to create greater unity between them.

We've taken a look at the face, the most meaningful "element" of bodily expression as a whole, and we've tried to analyse its main gestural variations.

In the past few years, we've witnessed an explosion in scientific studies on emotions, and today we increasingly speak of "teaching emotional intelligence". Finally, the close connection between thoughts, emotions and social relationships is being understood.

A well-known concept in visual arts education, in order to learn how to draw, you have learn how to see, how to take apart and re-assemble a language, its structure. But seeing isn't looking; it's searching, hypothesising; recognising and thinking.

This book was designed for those interested in images and expressions, for those who believe that emotions are fundamental attitudes to have in life and that we can learn to recognise them, express them and direct them.

Dedicated to young people in particular, the test was written, illustrated and arranged by two fine arts teachers who are well aware of the fact that the task of helping recognise personal feelings and emotions falls on the shoulder of adults, with the hope of contributing (through art) to a greater awareness of oneself and others.

Buster Keaton's "Great Stone Face"

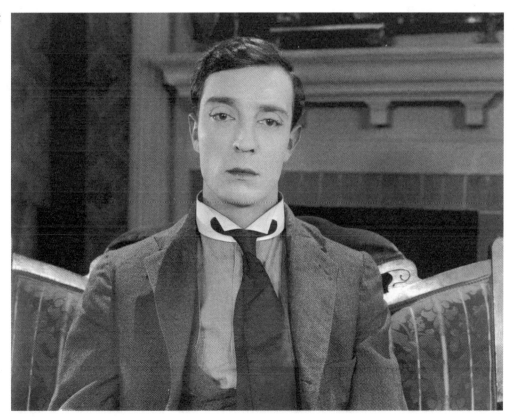

With Hellenism in the 4th century B.C., an interest in the identification of typologies, of passions, of ages, especially in sculpture, with particular attention to virtuosity in the rendering of expressions.

This era saw the gradual blossoming, along with expressive characterisation, the art of portraiture, genre scenes, and stylistic virtuosity (in contrast to classical idealisation), which broke with a pure and simple goal of mimesis. The ideal of kalokagatia (or kalos kagathos, greatness in spirit expressed through beauty and aplomb) was abandoned. Expressions were no longer hidden: wrinkles and accentuated facial features substituted the artificially impassable forms of perfection.

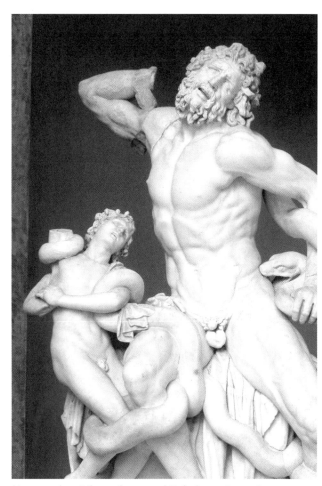

Hagesander, Athanodorus and Polydorus, Laocoön and his Sons, *second half of the 1st century BC*

Pergamon Altar *(c. 200 BC)*

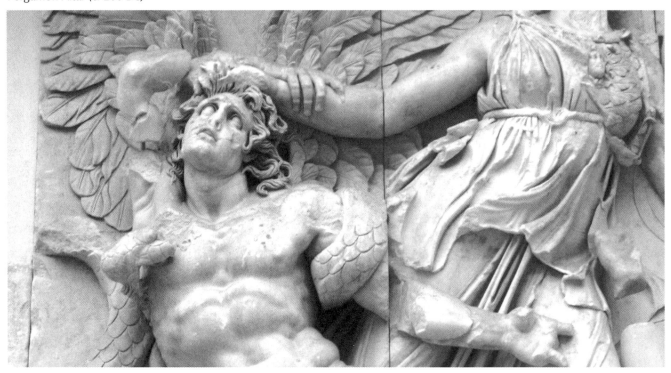

The apex of plastic rendering of facial expression is perhaps the celebrated Laocoön (mid-first century BC) depicting Hagesander, Athanodorus and Polydorus, were the literary myth is translated into sculpture. In Roman art which is Hellenistic in origin, portraiture soars to new heights, and the characters portrayed, even when they don't appear moved by intense emotions, tell us about their character and life through the wrinkles of expression which time and emotions carved into their skin.

In medieval culture, expressions were linked to vices and virtues, to symbolic, allegorical imagery, such as hair standing on end to represent anger, smiles, and stupidity, as often seen in the representations of vices (e.g. Giotto, Scrovegni Chapel, Padua, Italy).

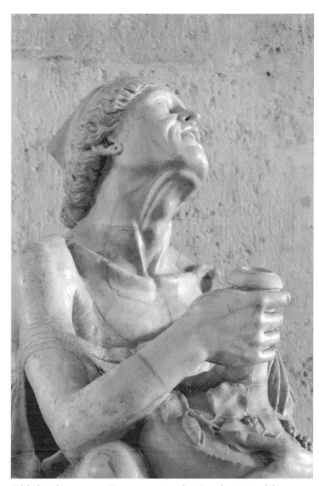

Old drunk woman, *Roman copy of a Greek original from the 2nd century BC*

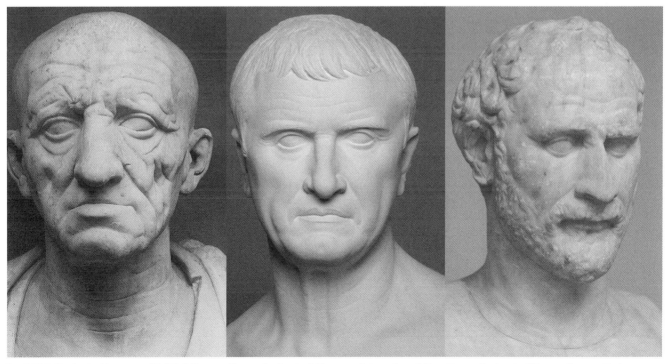

Bust 535, Torlonia Museum, 80-70 BC *Copy of a bust of Crassus, 1st century BC* *Copy of a bust of Demosthenes, 3rd century BC*

During the Renaissance, expressions were connected to four temperaments: sanguine, choleric, phlegmatic and melancholic; notably seen in Melencolia I by Albert Durer.

But it is with Da Vinci that the studio of expressions became modern.

"You'll make the figures in that act, which will be sufficient to demonstrate that which the figure has in his soul; otherwise your art will not be laudable."Thus he wrote in his *Treatise on Painting* and opened art" to science and to future psychology. Da Vinci's enigmatic expressions and Michelangelo's furious ones were examined again in Mannerism and then in the 1600s, the century that had a great interest in the study and representation of human passions.

A few sculptures by Bernini are also quite celebrated, in addition to the

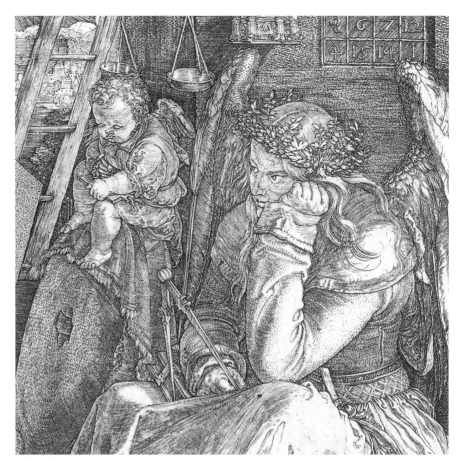

Albrecht Dürer, Melanconia I, *1514*

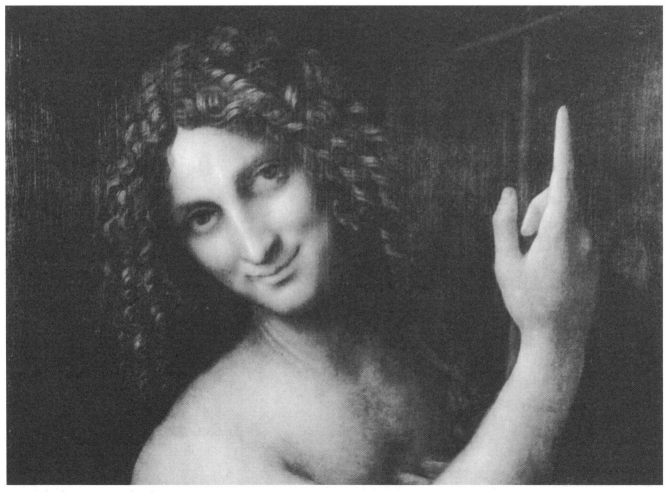

Leonardo da Vinci, St. John the Baptist, *1508-1513*

work of Rembrandt and Velázquez, who set up the work of Charles Le Brun, the first court painter to Louis XIV, who illustrated Descartes ideas in his *Conference sur l'expression générale e particulière* of 1698. It was the first systematic study of "figures and passions", an illustrated manual to be used by artists with a repertoire of expressive faces.

Hence the growing interest, even educational, in emotions and their facial expressions for all of the 1700s. This was developed in particular by William Hogarth, a painter and theorist, an expert on the theatre. More expressions and theatricality are found in paintings by Johann Heinrich Füssli.

In the 19th century, the most in-depth study on facial expressions and "impulses of the soul" was, without a doubt, by Géricault,

Charles Le Brun, Woman Bearing a Child, *1649*

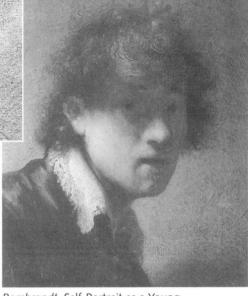

Rembrandt, Self-Portrait as a Young Man, *1629*

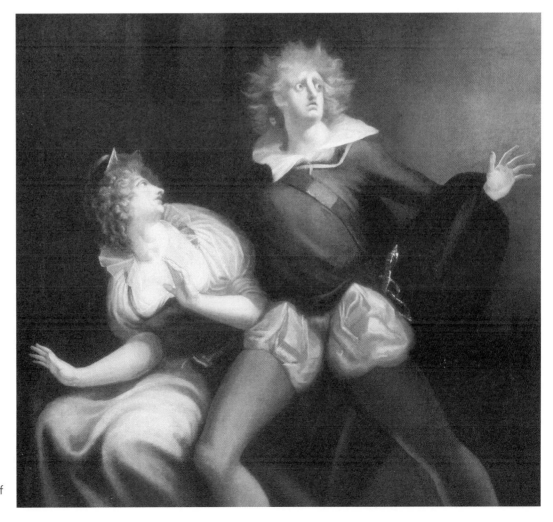

Johann Heinrich Füssli, Hamlet and the Ghost of Hamlet's Father, *1793*

Théodore Géricault, A Woman Addicted to Gambling, *1822-1823*

with his series on the mentally ill. Positivism and Darwinism were interested in the expression of emotions, and it would no longer be art to study them, rather science through a more objective means: photography.

The 20th century was even more concerned with facial expressions, not just in photography and in film, but also in graphics, illustration and comics.

Contemporary art brought gestural expressions to a sort of abstraction, deformation, a more internal than external expressivity, feelings and pain of the psyche more than what's seen on the face.

Ferdinand Holder, Woman, *1907*

Umberto Boccioni, Self-Portrait, *1908*

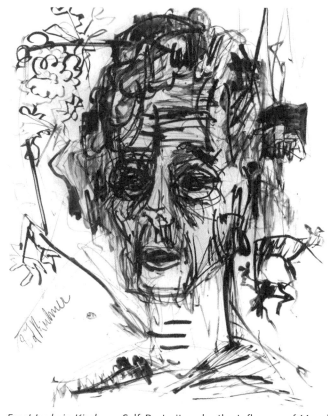

Ernst Ludwig Kirchner, Self-Portrait under the Influence of Morphine, *1917*

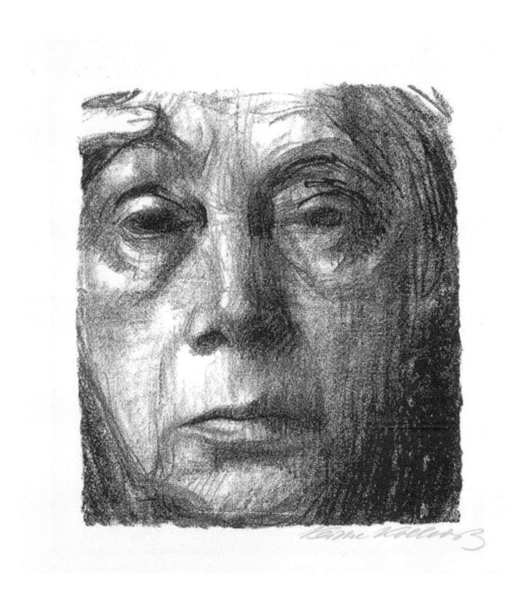

Käthe Kollwitz, Self-Portrait,
1934

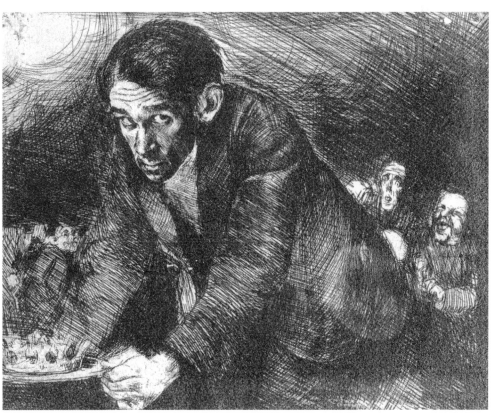

Bruno Schulz, Self-Portrait,
c. 1920

Charles Le Brun

The 17th century saw a particular interest in human passions, following a long tradition of philosophical and symptomatic reflection which began with Hippocrates and Galen on down to Descartes. Shortly after, philosophical and medical publications appear, followed by a theory on figurative representation. In 1646 *Les Passions de l'âme* by Descartes was published, and between 1640 and 1662 *Les Caractères des Passions* by Marin Cureau de la Chambre, the personal physician to Louis XIV, followed by *Conférence sur L'expression Générale et Particulière des Passions* by Charles Le Brun.

Le Brun, the king's painter, was the first to systematically study human expressions, based on Cartesian mechanics. He illustrated his publication, *Conférence sur l'Expression*, which was held in 1668 at the Académie Royale de Peinture et de Sculpture in Paris, with 12 engraved plates, creating a sort of alphabet of emotions.
In the text, he states his desire to "demonstrate the expression which reveals the impulses of the soul, making the effects of passion visible". Each of the 23 figures in the plates presents different "passion" imprinted on the face, represented twice, once from the front and once in profile; the face

Studies on the expressions of the face and preparatory sketches by Charles Le Brun

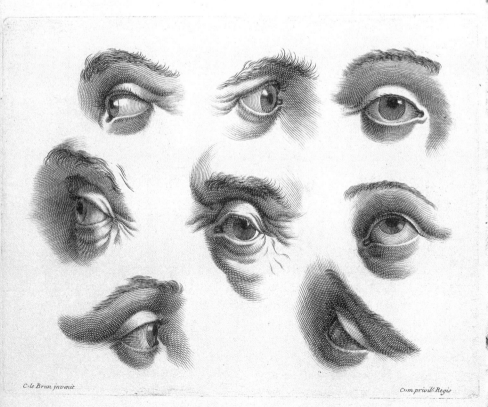

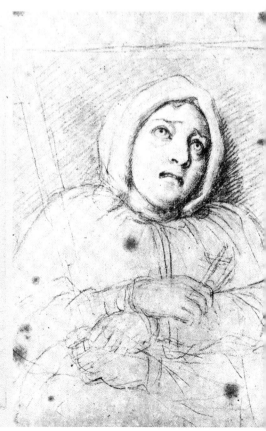

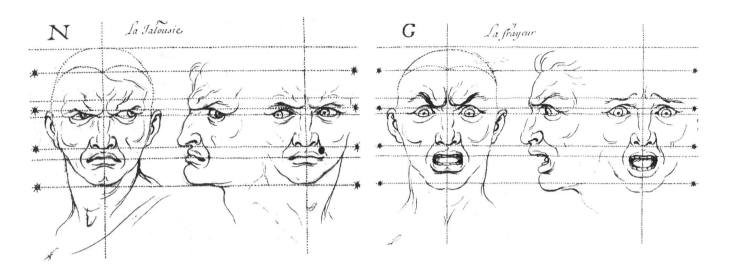

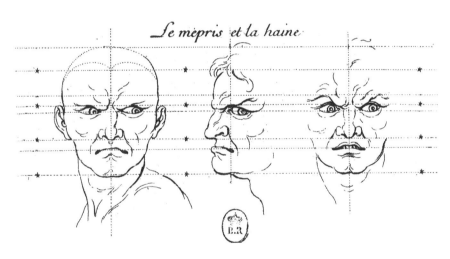

A few plates by Le Brun on the study of facial expressions

on the right shows a greater/different level of expressive intensity.

The face is framed by a type of grid, with the eyebrows and the mouth acting as indicators which rise and fall with respect to the guidelines. The movements of the eyebrow, mouth, nose, eyes and forehead are all distinct elements, the interplay of which produces different emotional expressions.

Another painter who had an interested in expressions was Roger de Piles (1635-1709) who theorised in his *Cours de Peinture par Principes*, Paris 1708:

"It's not so much the exactness of the design in portraits which provides a soul and sense of truth, as much as the harmony of the parts in the moment in which the disposition and the temperament of the model must be imitated [...] Few painters have been accurate enough to properly combine all the parts at once: at times the mouth smiles and the eyes are sad; other times the eyes are happy but the cheeks are sagging; for this reason, their work has a false air and appears unnatural. For this reason, we must make sure that, when the model has a smiling air, his eyes close, the angles of his mouth rise up towards the nostrils, his cheeks puff up and his eyebrows elongate out."

The influence of Charles Le Brun's study of emotional, passionate expressions lasted for the entire first half of the 18th century, both in academia and everyday culture. We see them, in fact, in the collection of illustrated plates of the *Encyclopédie*, the first edition of which was published in Paris in 1762. *Recueil de Planches sur les Sciences, les Arts Libéraux et Arts Mécaniques Avec Leur Explication* collects prints which illustrate and complete the discussion found in the encyclopaedia's articles.

Of particular interest, for our study, are the images which refer to the visual arts, especially the *Drawing* chapter of thirty-one plates. Charles-Nicolas Cochin le Jeune (1715-1790) directed its execution (the reproduction of drawings and engravings) and even devised a few of them himself.

We'll present a few etchings taken from plates *167, 168, 169,* inspired by Le Brun's original drawings and the reprinting of his book, updated after his death.

An artist's training includes not just theories on perspective and anatomy, but also one other topic: the observation of feelings and emotions. The text notes that the artist should dedicate quite a lot of time and attention to this study. The attentive eye of the draftsman will have to make use of memory and the imagination to capture the succession of expressions. To succeed in art, the artist must have studied the way emotions are portrayed in the work of the masters who have represented them best.

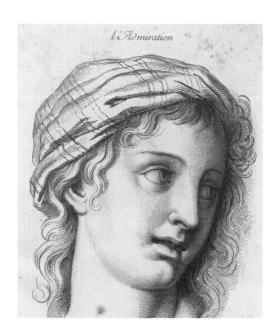

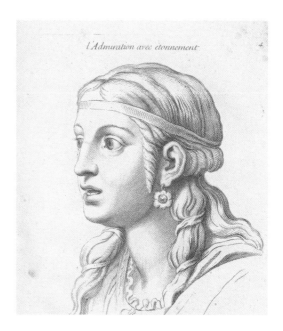

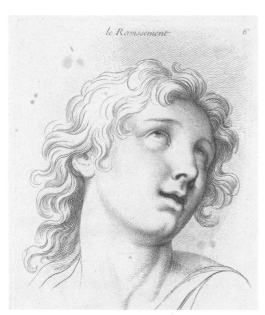

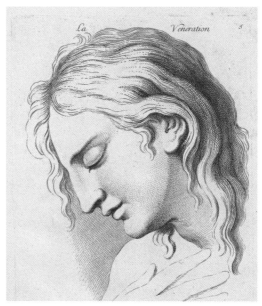

Expressions reproduced in tab. 167: simple admiration, admiration mixed with wonder, ecstasy, and veneration with a lowered gaze

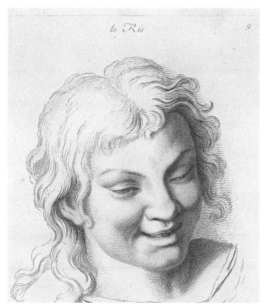
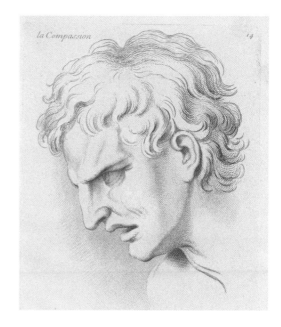

Expressions in tab. 168: compassion and laughter

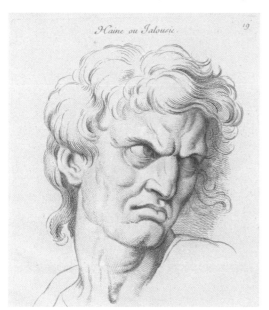
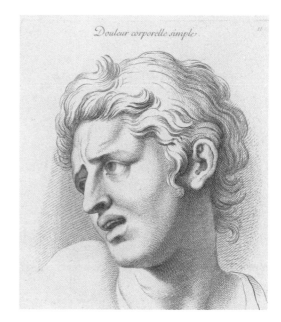

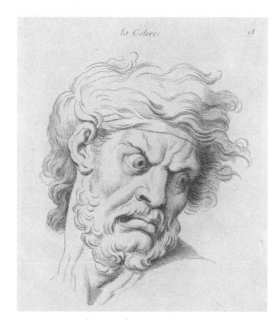
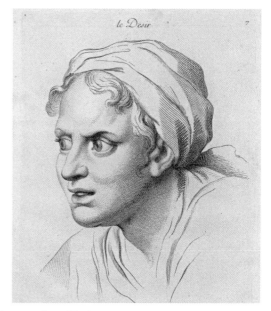

Expressions from tab. 169: hate or jealousy, anger, desire, acute suffering

Currently there is no completed, shared theory on the expression of emotions, though various lines of thinking have dealt with the matter. One of the first was that of James Lange, according to which emotion coincides with the experience of somatic changes: when the stimulus is sensed, it comes with a physiological modification, which in turn is perceived as emotion.

It's only thanks to the work of Darwin, in particular *The Expression of Emotion in Man and Animals* (1872) that facial expressions were recognised as having an evolutionary role, thus linked to the survival of the individual and the species.

His approach was a turning point with respect to previous studies, which saw a simple reflection of "divine features" in the human face, and thus not subject to further investigation. For Darwin, however, facial expressions have a well-defined characteristic among animals; they are signals for action and they communicate information from one animal to another. As such, they also influence behaviour.

With respect to other parts of the body, in the area of the face we find a greater quantity of elements which give it an exceptional expressive incisiveness.

Since the publication of Darwin's book, research on facial has not been interrupted. The common assumption was that human faces were, in some way, universally understood in their expressions. Darwin upheld the universality of

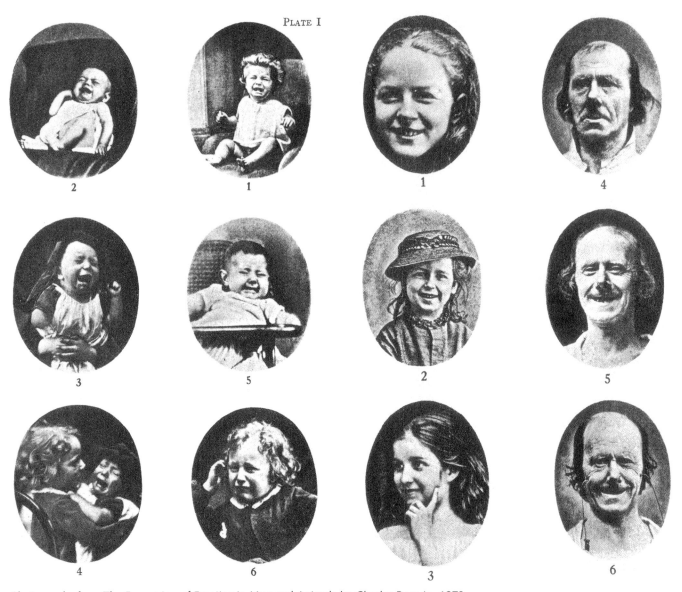

PLATE I

Photographs from The Expression of Emotion in Man and Animals *by Charles Darwin, 1872*

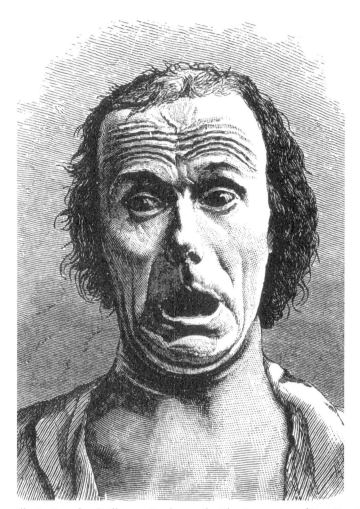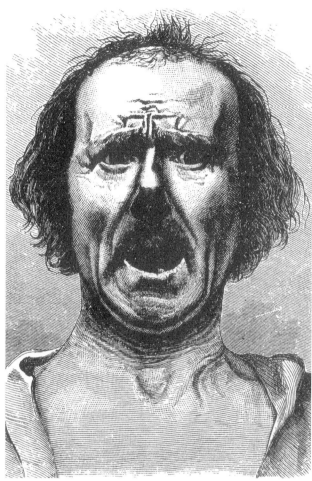

Illustrations by Guillaume Duchenne for The Expression of Emotion in Man and Animals *by Charles Darwin, 1872*

the facial expression of emotions and asserted that in the upper primates, you could find a type of facial gesturality similar to that of humans, in response to stimuli with an emotive origin.

Counter to Darwinian tradition, a large number of studies have tried to demonstrate how facial expressions are culturally determined.

On the opposite side, Tomkins, Izard, Ekman and Friesen have embraced the Darwinian tradition, giving it a new push and greater experimental support.

In particular, in the 1960s Ekman travelled to an isolated popula-tion in New Guinea, the Fore. He told a few of them various sto-ries relating to specific emotions, demonstrating some photos with a large number of facial expres-sions of Americans. He then asked his subjects to indicate the image which they associated with the story. Once he returned to America, he conducted the same experiment with a few American subjects, this time with images of the faces of the Fore. The same stories were associated with the faces which expressed the same emotion.

This confirmed Darwin's theories of "universality"; but the debate on the origin of facial expressions of emotion remained open. Ex-pressive behaviour is thus social-ised or is it innate?

One response came from the neurocultural theory of Paul Ek-man (1972). According to him, if it's true that the universality of facial expression has a counter-point in the universality of possi-ble causes (e.g. a bad smell pro-vokes an expression of disgust in everyone), it's also true that the cause for the expression may have its origin in the interperson-al relationship, or in the cultural rules which govern interaction between individuals. Ekman has

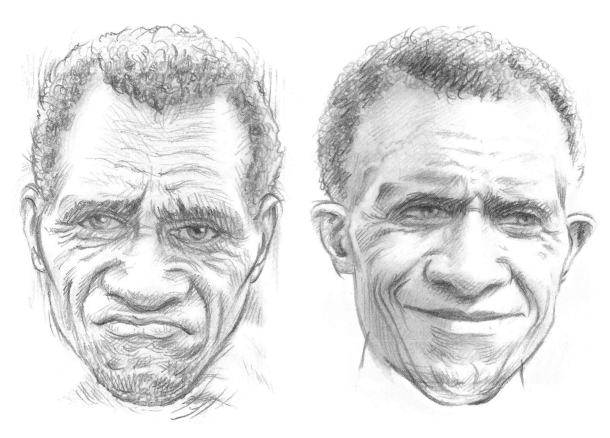

A few expressions of indigenous Fore people documented by Ekman

attempted to reconcile the two positions: that typical expressive configurations of emotions are innate and universal, while cultural differences are to be found in situations which elicit particular emotions and rules which govern emotional expression.

The word "neural" refers to the neuro-motor expressive programme. The word "cultural" refers in particular to the "activating circumstances" and to the "rules of display" (intensification, attenuation, neutralisation, simulation, dissimulation) which clearly represent the product of interaction between the individual and his social-cultural environment.

Some societies, more than others, require that the expression of emotions (especially negative ones) stays in the private sphere of the individual and doesn't make an appearance in his/her public life.

Ekman has also shown that the Japanese, more than Americans, try to control their facial expressions in front of stimuli which cause negative emotions, if those stimuli are presented when the person being examined was with his/her fellow countryman. Otherwise, it's quite common for certain ceremonies to require appropriate expressive behaviour. We don't laugh at funerals; we try to be happy at weddings and so on. In addition to the origin of expressive behaviour, there is also the evolutionary dimension to how we express emotions. The same facial expressions which are universally recognised (primary expressions) are present in a complete form starting from the very first weeks of life. Studies by Pannabecker and Emde (1980) have shown that the majority of mothers are able to distinctly

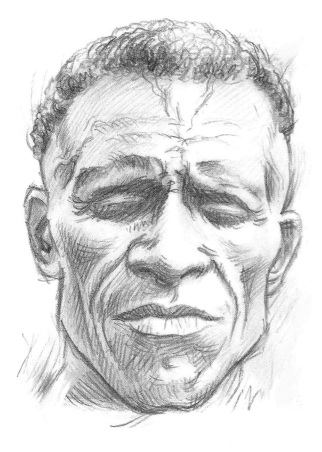
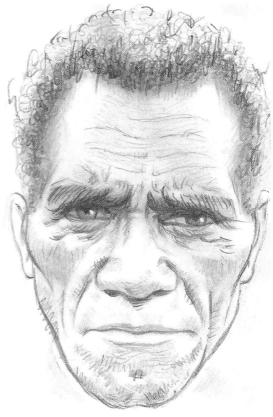

recognise, in the facial expressions of their children aged 0-3 months, a few emotions such as happiness, anger, fear, etc. In particular, studies by Eibl-Eibesfeldt (1970) have demonstrated that blind and blind-deaf children show some emotions on their faces from birth, such as joy and anger, demonstrating that, as acquiring these expressions by imitation is unlikely, such behaviour must be innate. From the cited authors, then, it emerges that a group of "fundamental" or "primary" emotions exist which can be differentiated by their adaptive characteristics. "Secondary" emotions, which arise from self-awareness, on the other hand, develop around 15-18 months old and come from introspection or from an evaluation which the individual makes of his/her behaviour in relation to internalised social norms.

Another aspect is that relating to the ability to control and stimulate facial gestures. The possibility of falsifying is relative to symbolic communication and to the language and activation of the dominating side of the brain: the ability to simulate requires, then, complex communicative abilities which allows one to think of a distant emotional experience.

Recent studies have shown that simulated facial expressions, unlike genuine ones, are often asymmetrical, that is, visible on the side of the face controlled by the dominant side of the brain.

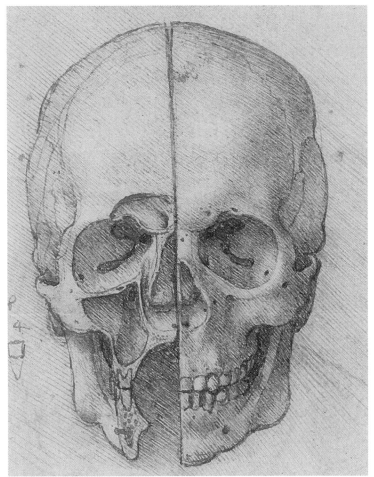

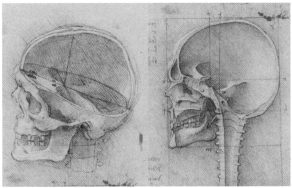

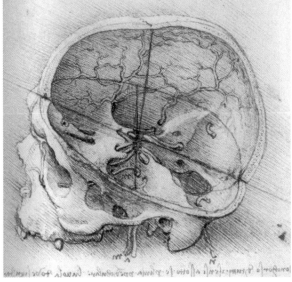

Gestural expressions of emotion is determined by facial muscles. The human face is able to produce a few dozen facial expressions, which are associated, alone or in combination with each other, to a set number of emotions. Facial expression muscles are small and flat; they are attached directly or indirectly to the skull and connect to the skin on the face. They don't simply move independently of one another: when one con-

tracts, it stimulates the movement of a series of other muscles, which have assisting or opposing functions. Another general rule is that wrinkles on facial skin always are in the opposite direction of the muscle which produces them, but this rule is often changed depending on bone structure or other anatomical particularities. You can clearly see this by observing the contraction of the frontalis (in "fear" expressions, we note the

maximum contraction of the muscles - see the *Fear/Pain* section). In any case, the expressions of one's emotional state are not executed through the contraction of a single muscle. Even if facial gestures appear localised, the dominant muscle of the expression must always be coordinated other muscles near and far.

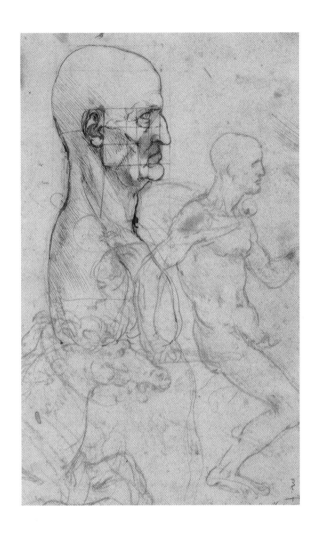

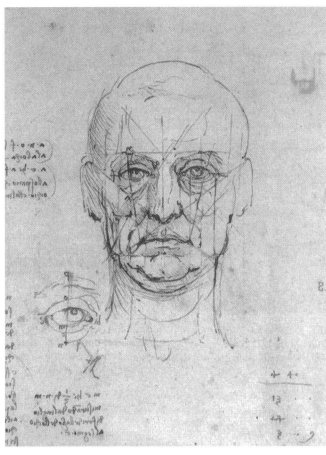

This and previous page: anatomical and proportional studies of the head by Leonardo da Vinci, c. 1488-89

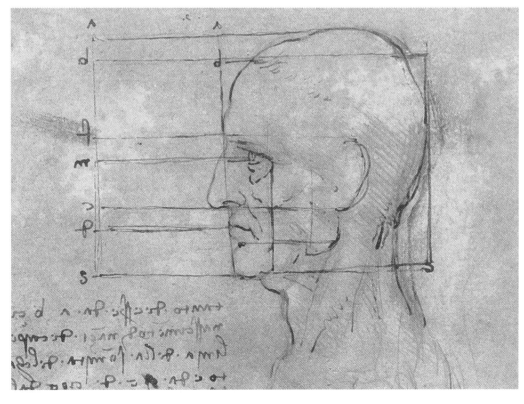

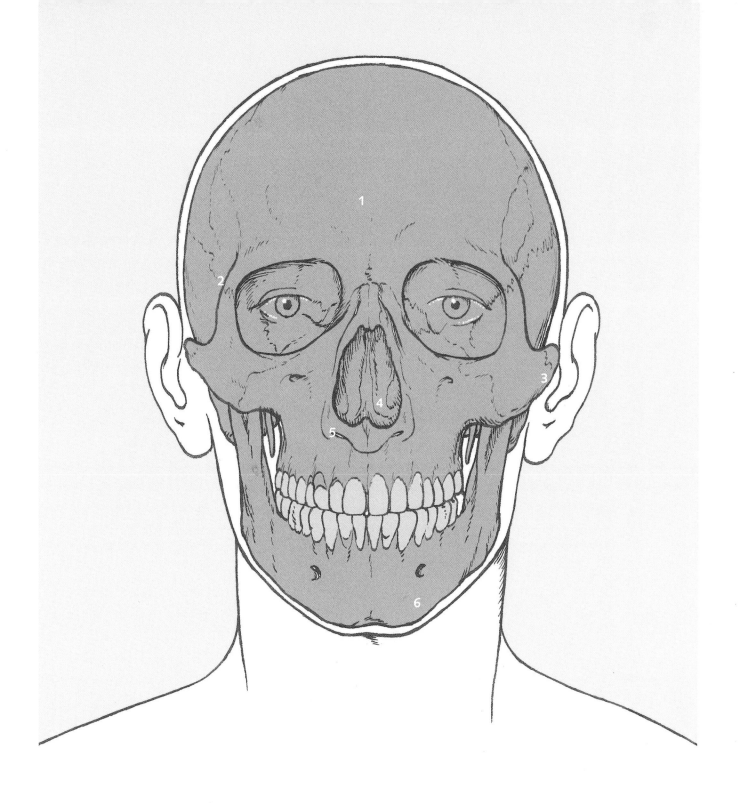

The skull (front view)

1) frontal bone **2)** temporal bone **3)** zygomatic bone **4)** nasal cavity **5)** maxilla **6)** mandible

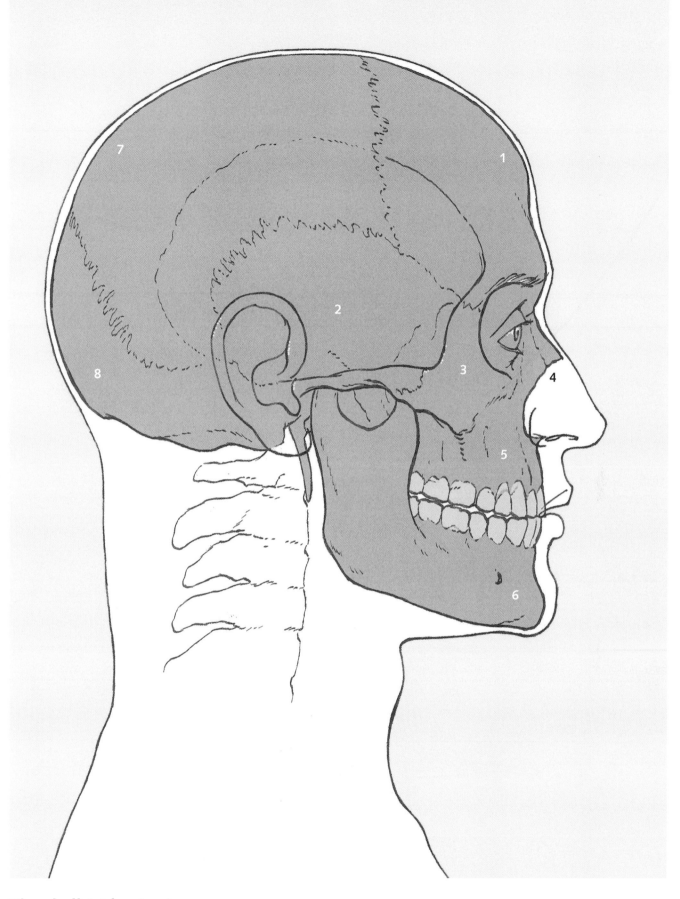

The skull (side view)

1) frontal bone **2)** temporal bone **3)** zygomatic bone **4)** nasal cavity **5)** maxilla **6)** mandible **7)** parietal bone **8)** occipital bone

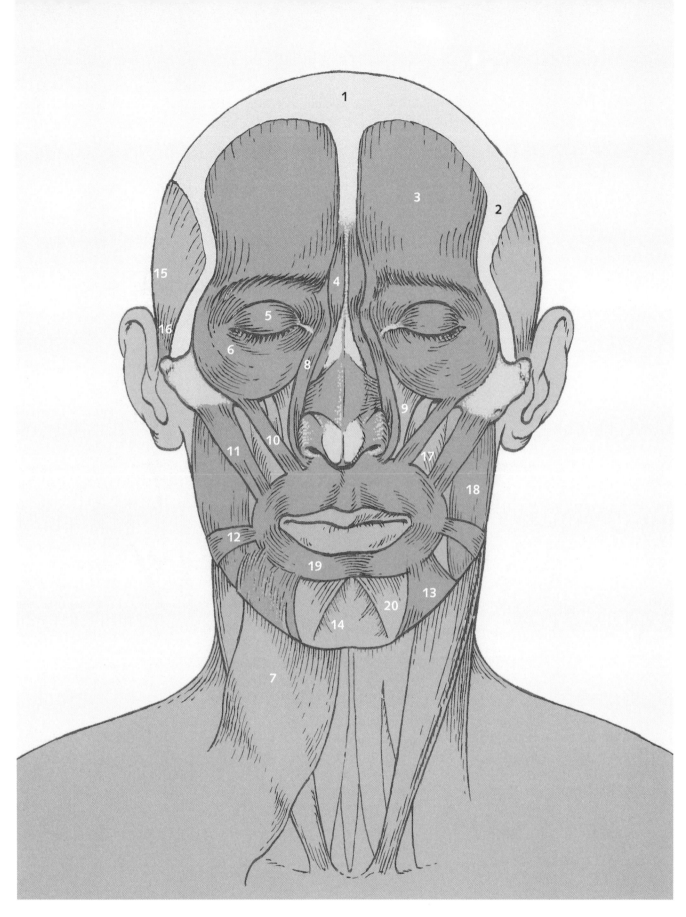

Superficial facial muscles (front view)

1) galea aponeurotica **2)** temporal fascia **3)** frontalis **4)** procerus **5)** orbicularis oculi (palpebral portion) **6)** or-bicularis oculi (orbital portion) **7)** platysma **8)** levator labii superioris (alaeque nasi) **9)** levator labii superioris **10)** zigomaticus minor **11)** zigomaticus major **12)** risorius **13)** depressor anguli oris **14)** mentalis **15)** auricularis superior **16)** auricolaris anterior **17)** buccinator **18)** masseter **19)** orbicolaris oris **20)** depressor labii inferioris

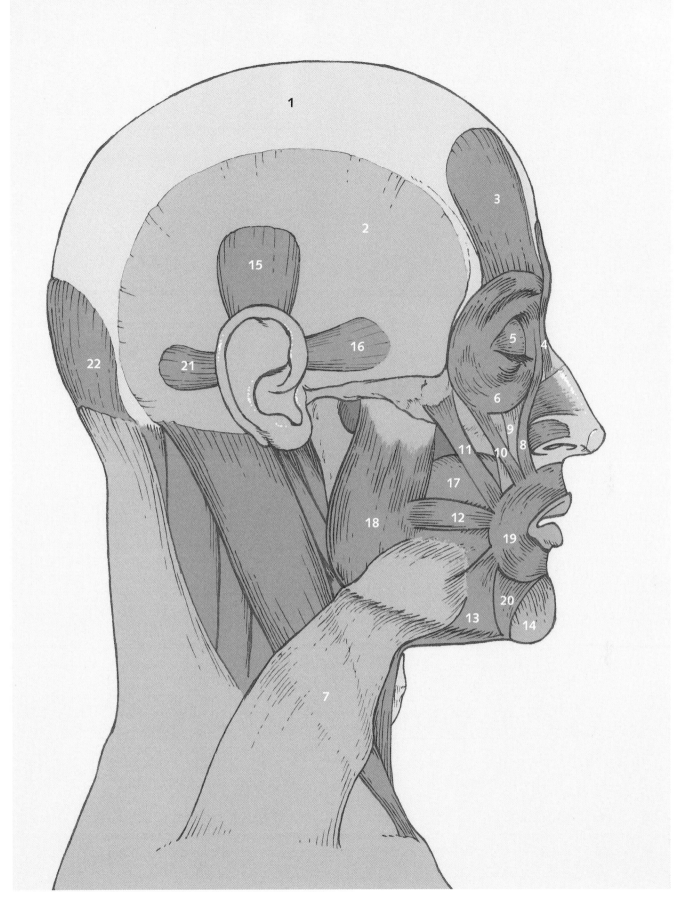

Superficial facial muscles (side view)

1) galea aponeurotica **2)** temporal fascia **3)** frontalis **4)** procerus **5)** m orbicularis oculi (palpebral portion) **6)** orbicularis oculi (orbital portion) **7)** platysma **8)** levator labii superioris (alaeque nasi) **9)** levator labii superioris **10)** zigomaticus minor **11)** zigomaticus major **12)** risorius **13)** depressor anguli oris **14)** mentalis **15)** auricularis superior **16)** auricolaris anterior **17)** buccinator **18)** masseter **19)** orbicolaris oris **20)** depressor labii inferioris **21)** auricolaris posterior **22)** occipital

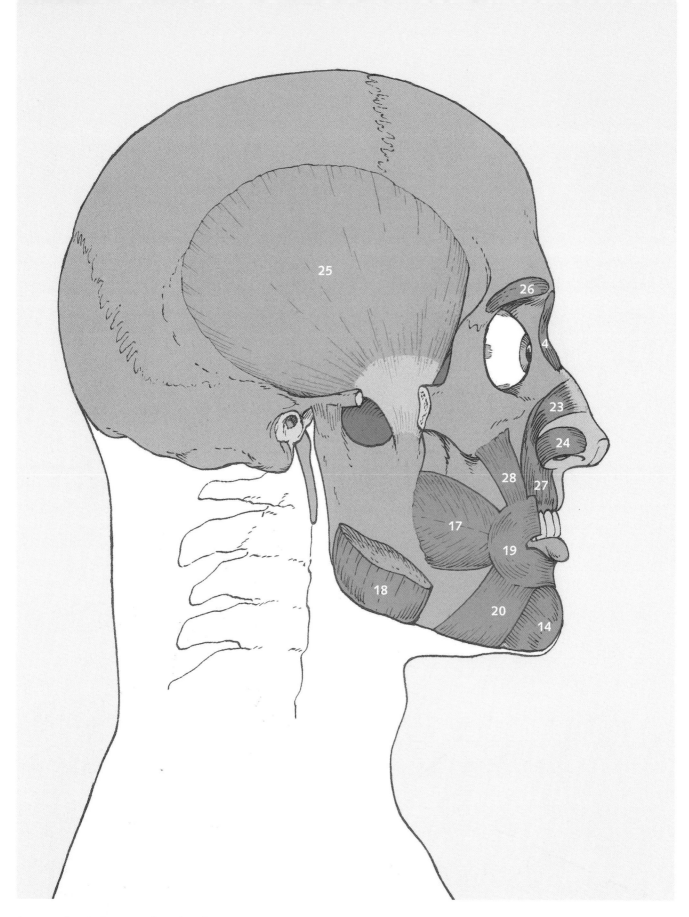

Deep facial muscles (side view)

4) procerus **14)** mentalis **17)** buccinator **18)** masseter (resected) **19)** orbicolaris oris **20)** depressor labii inferioris **23)** transverse part of nasalis muscle **24)** alar nasalis **25)** temporalis **26)** corrugator supercilii **27)** depressor sempti nasi **28)** levator anguli oris

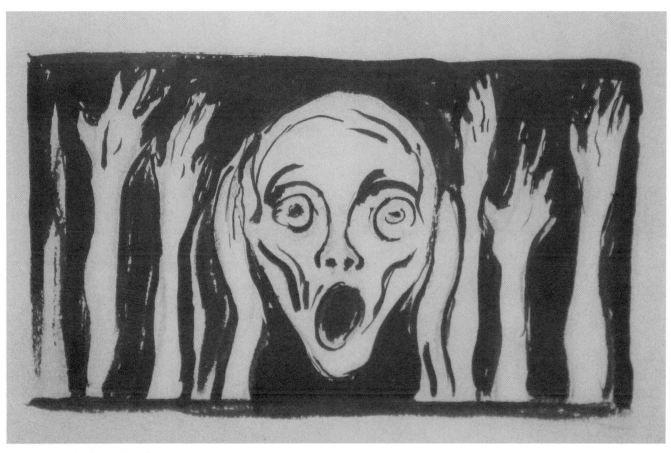

Edvard Munch, sketch for The Scream

José Guadalupe Posada, Calavera "El Morrongo" (Calavera of the Alley Cat)

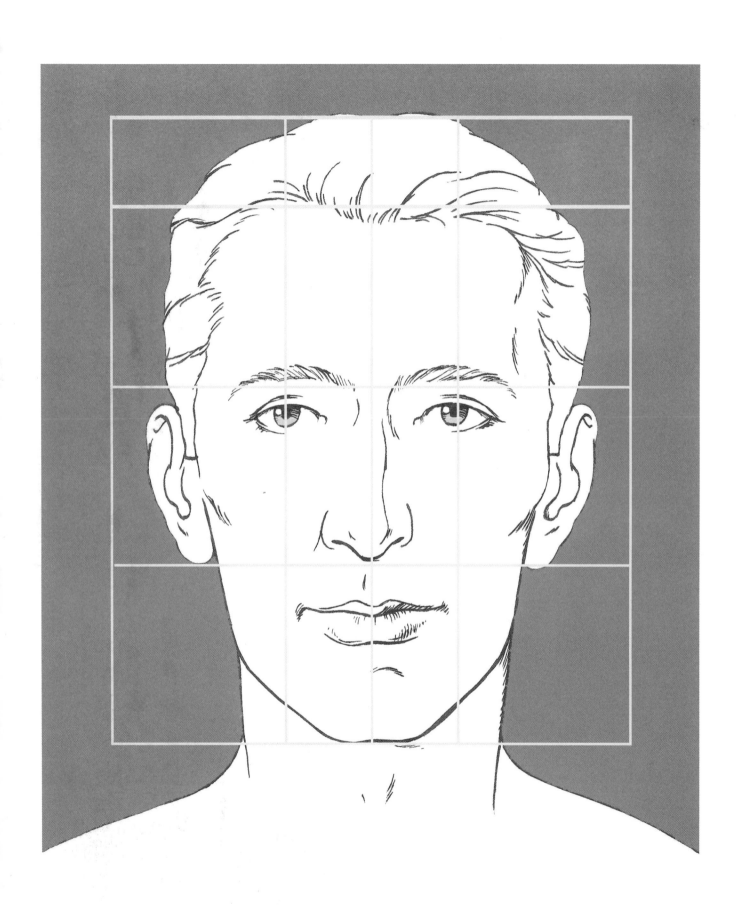

The male face, front view

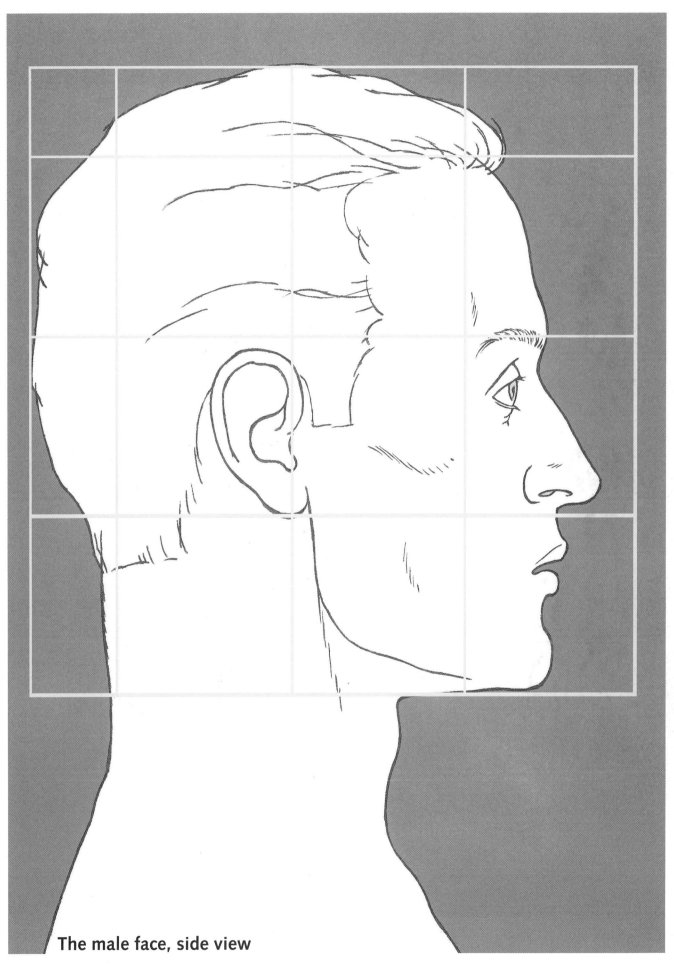

The male face, side view

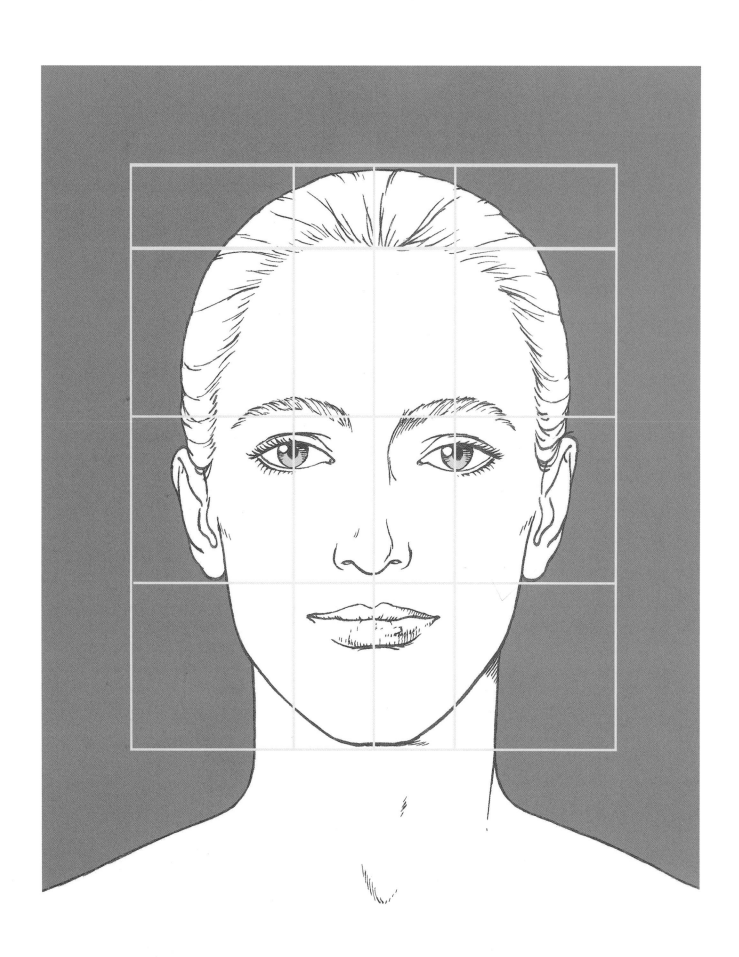

The female face, front view

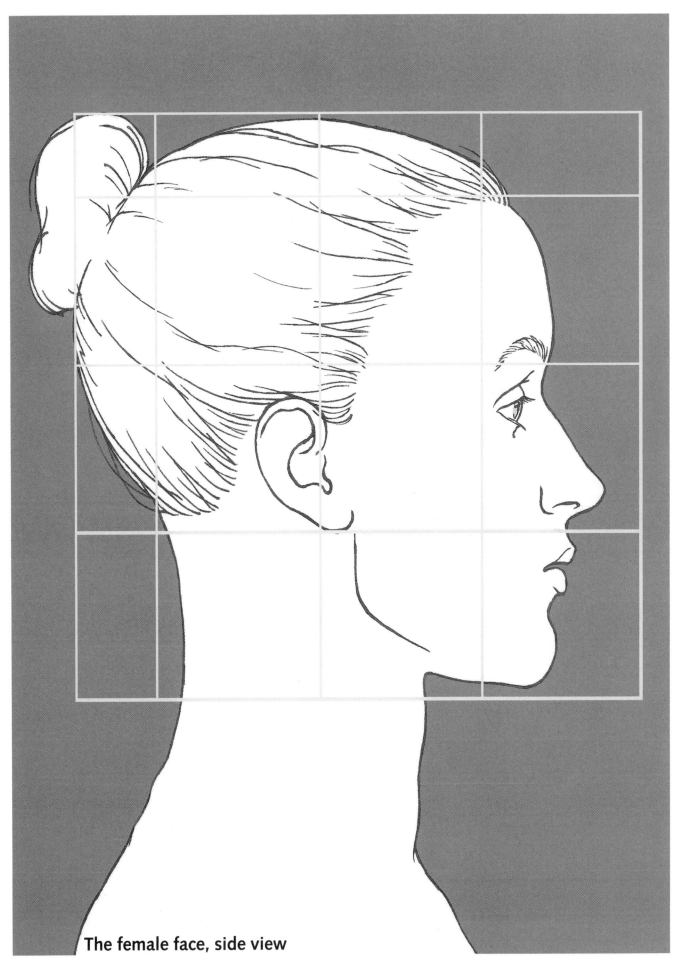

The female face, side view

After having studied and closely observed the expressions represented in works of art by the masters, after having analysed the basics of drawing the body and the proportions of the head, the student can start drawing. Initial simple exercises help the student arrive, through the study of the head, to more complex representations of emotions, feelings, thoughts and attitudes.

The initial phase is preparatory and starts from a study of the details of the face through copying simple structural diagrams.

These outlines also help students commit the main "gestural faces" to memory. Subsequently, these structures can be applied when creating a variety of expressions.

In this book, we wanted to propose various types of sketching diagrams, as we are convinced that a good artist must have a few of them in order to deal with diverse subjects.

Of course, the artist will eventually abandon these diagrams to create, with experience over time, a personal graphic language.

The beginner, however, mustn't underestimate the value of this phase, which may seem formal and boring, will prove to be quite useful further down the line. For teachers it is perhaps a bit more difficult to convey that idea, as compared to other technical factors. However, we won't tire of repeating the fundamental concepts of design which, if they're valid for artistic practices in general, are even more so for the re-

presentation of emotions which, along with portraiture, are an artistic and psychological challenge. In summary, it's necessary to:
• define the subject to be studied isolating him/her, framing him/her (be it an expression, a face, a figure, an environment with figures, etc.)
• create the proportions (height/width) or reduce it to simple geometric figures (flat or solid)
• when drawing the figure, proceed from general to specific (in the representation of a face, first trace the oval shape instead of a detail; the main masses precede secondary volumes)
• in chiaroscuro (tonal or graphic) first identify the darker shadows and the points of light, then halftones and blended shades.

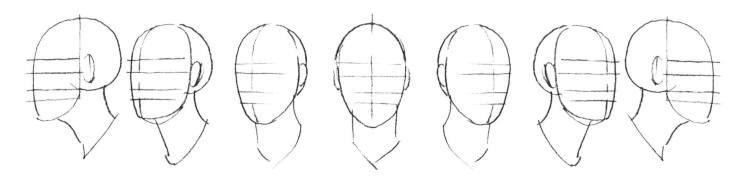

Most art students are convinced that knowing how to draw well means learning how to use graphic techniques and tools. They often think observation is a spontaneous, innate ability – a belief, however, which is incorrect. Visual perception isn't just a physiological factor but also a psychological one. The ability to observe depends on past experiences, from memory to imagination.

Those who are good at drawing are those who go beyond sensory data, beyond mere appearance, and that which s/he observes and portrays is in relation to a mental image which reveals the image's invisible aspects. In short, four factors are required to fully draw properly:

1. technique, 2. knowledge, 3. sensitivity, 4. creativity.

Below we propose a few guided exercises to help with technique. As for knowledge, in the following chapters we present a grouping of emotions and attitudes, where didactic drawing is always connected to examples by the hands of great masters.

For the third and fourth points, we believe that a book can only inspire the cited qualities. We still recommend drawing from live models, "real" dialogue with who you want to represent, direct observation of works of art and curiosity for internal and external worlds, constant sources of inspiration.

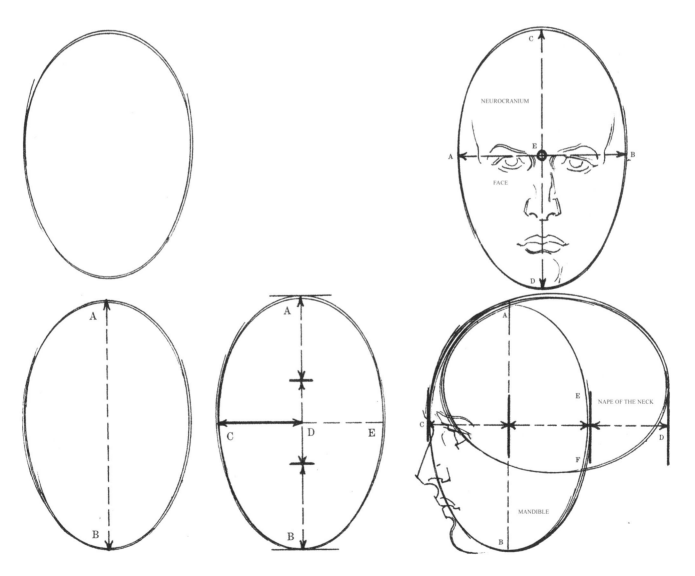

Establishing the proportions of the head, front view (note that the width of the head C-E should be exactly 2/3 of the height A-B)

Establishing the proportions of the head: front and side view (note that the vertical line A-B is equal to the horizontal line C-D in the side view)

Drawing facial details

Eyes

In the sketching diagrams, pay close attention to the particular arrangement of the eyelids which, like visors, wrap around the eyeball. You'll note, in particular, that when a living person's eye is totally shut, it's essentially the top eyelid to fall down to the lower lid (see: Expressions which mimic attitudes - *sleep and death*).

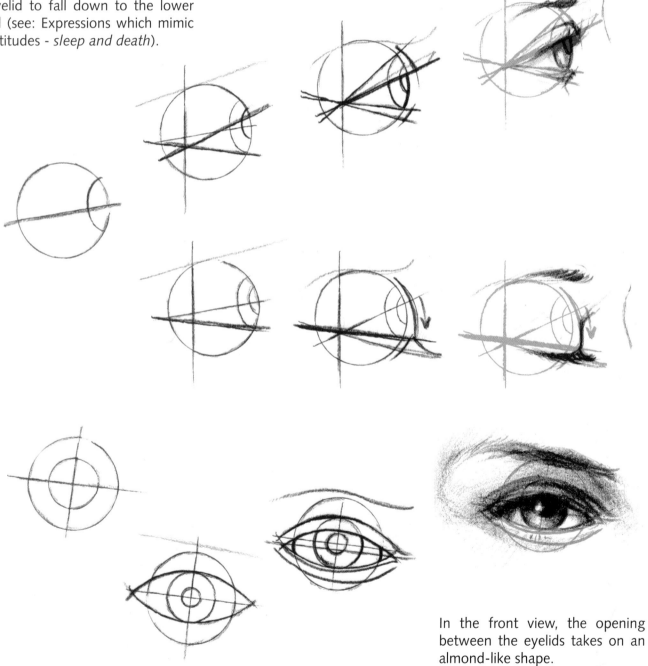

In the front view, the opening between the eyelids takes on an almond-like shape.
In general, the iris never appears in full, apart from certain emotions (surprise, fear, etc.), as the upper eyelid covers nearly a third of it.

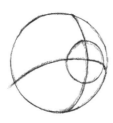
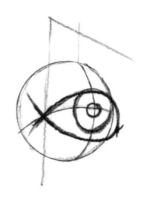
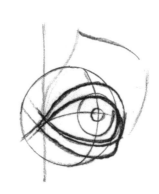
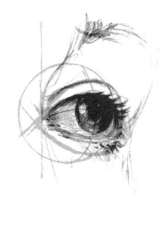
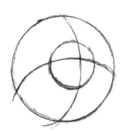
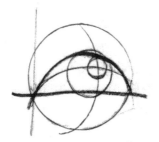
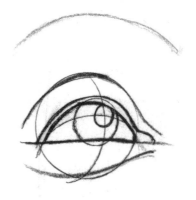
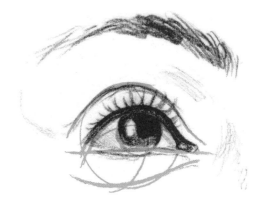

In the ¾ view, the eyelid opening forms a teardrop shape: the arches articulated by the rim of the eyelids are accentuated.

In foreshortened views from below, the lower eyelid rim tends to straighten, while the curvature of the upper eyelid is accentuated.

Nose

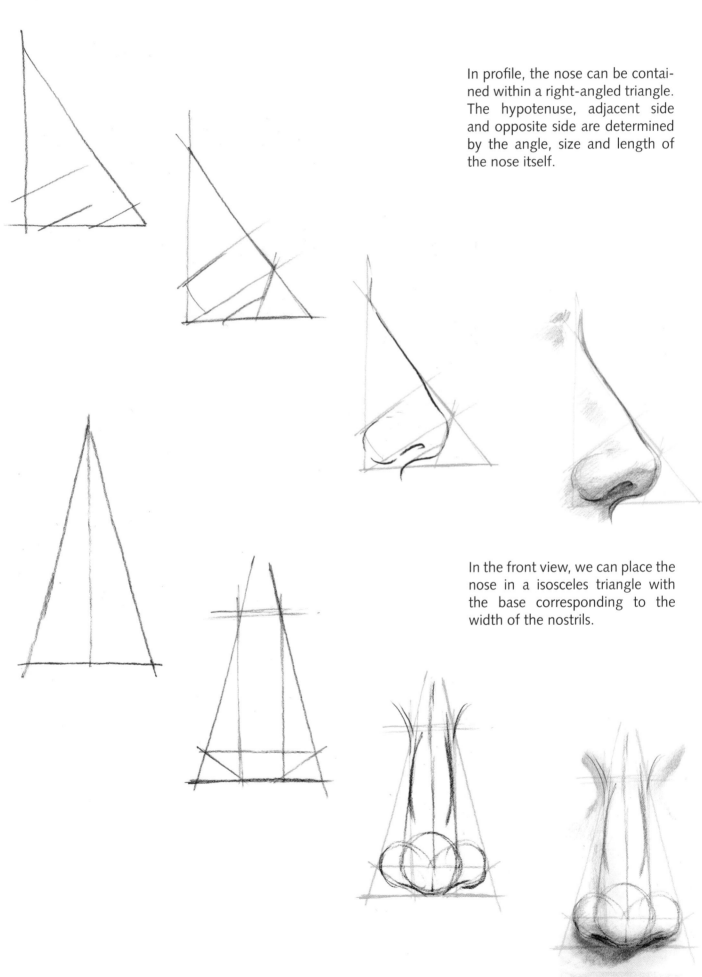

In profile, the nose can be contained within a right-angled triangle. The hypotenuse, adjacent side and opposite side are determined by the angle, size and length of the nose itself.

In the front view, we can place the nose in a isosceles triangle with the base corresponding to the width of the nostrils.

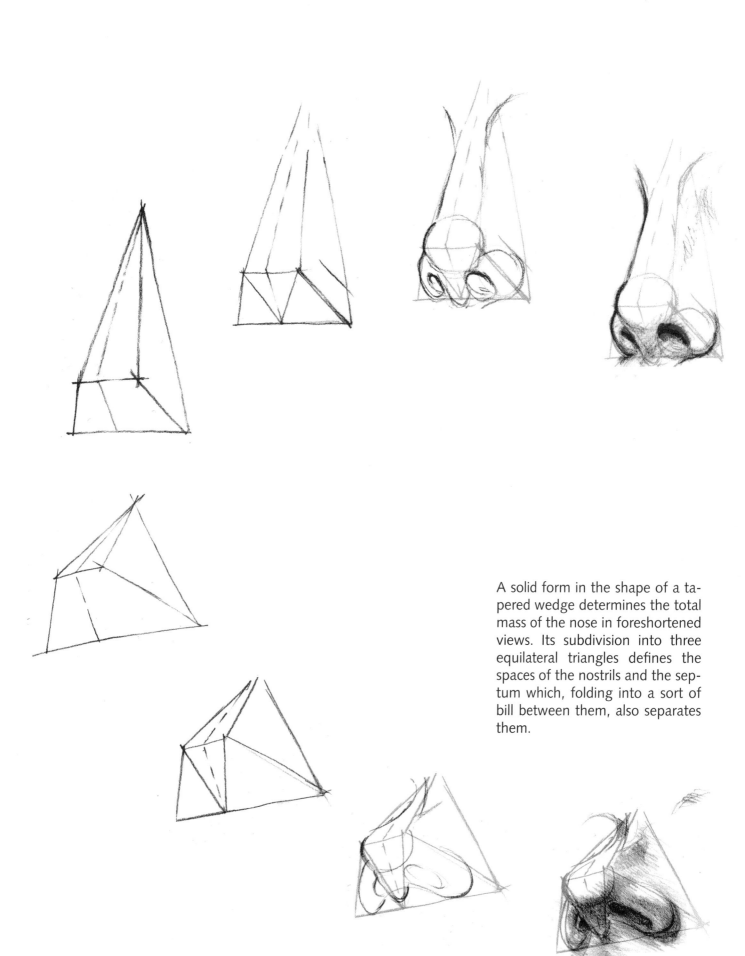

A solid form in the shape of a tapered wedge determines the total mass of the nose in foreshortened views. Its subdivision into three equilateral triangles defines the spaces of the nostrils and the septum which, folding into a sort of bill between them, also separates them.

Mouth

Placing the profile of the mouth within a triangle, we can see how the upper lip protrudes more than the lower lip. The line of closure when the mouth is closed doesn't divide the triangle into two equal parts, as the lower lip is usually thicker than the upper lip. This characteristic is easy to see in the construction sketch in the front view. Starting from two isosceles triangles of different heights joined at the bases, through a series of inner subdivisions, we can define the main form and mass of the mouth.

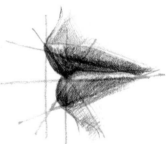

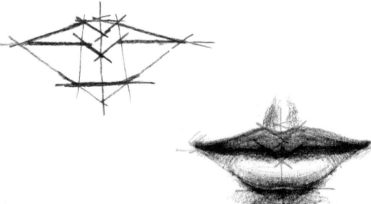

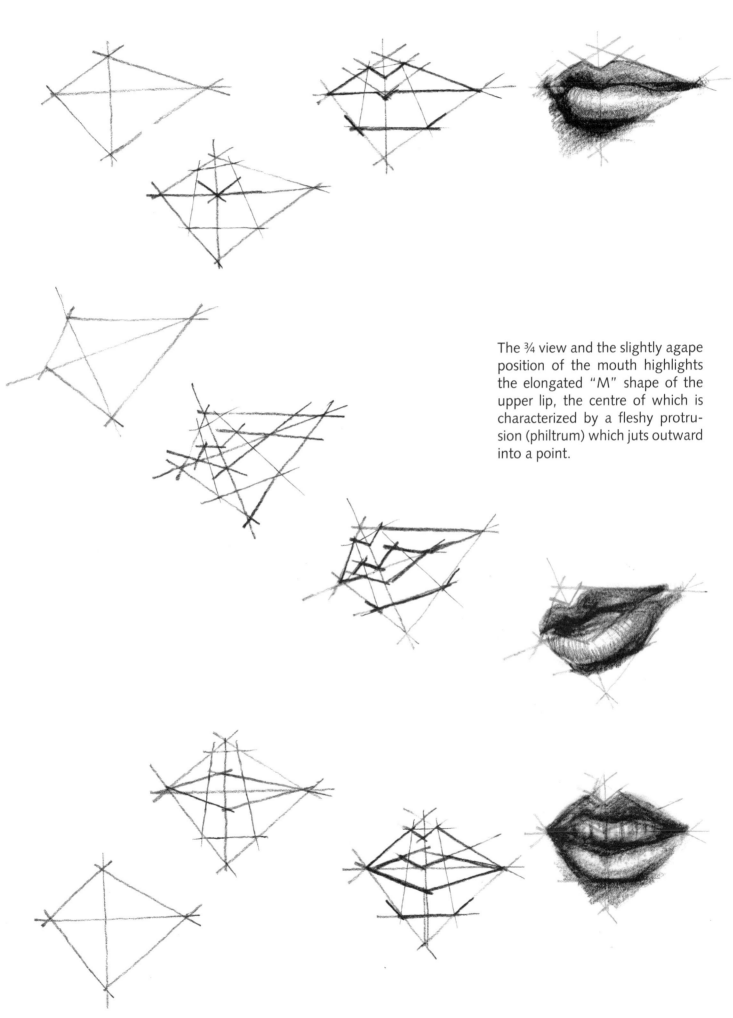

The ¾ view and the slightly agape position of the mouth highlights the elongated "M" shape of the upper lip, the centre of which is characterized by a fleshy protrusion (philtrum) which juts outward into a point.

Ears

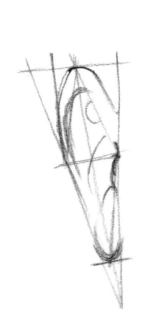
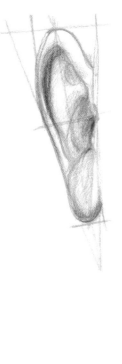

The shape of the ear is similar to that of a shell. It's made up of an auricle or pinna (the helix and anti-helix), an auricular opening protected by a protrusion (the tragus) and a lobe. Forked, the anti-helix takes on the shape of a curved "Y".

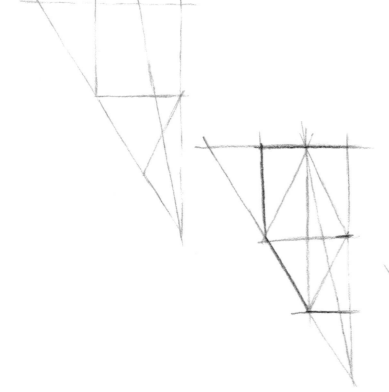

For both the side and front views, the ear can be placed within an upside-down right-angled triangle. The upper part of the ear corresponds to the surface of a square, which is created by identifying the base, corresponding to the tragus. Then draw the vertical median, originating from the highest point of the helix, and extend it until you reach the hypotenuse of the triangle to establish the total length of the ear.

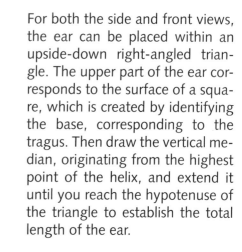
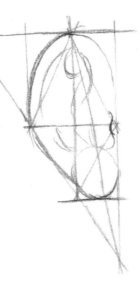
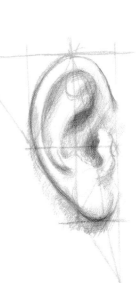

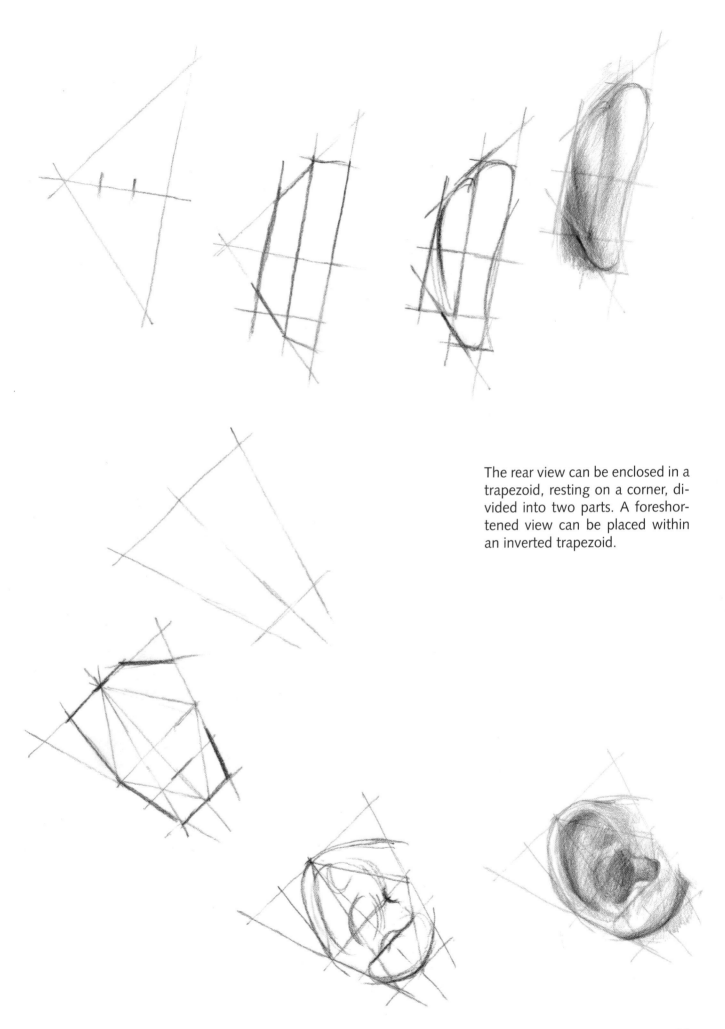

The rear view can be enclosed in a trapezoid, resting on a corner, divided into two parts. A foreshortened view can be placed within an inverted trapezoid.

43

Expressive sketches

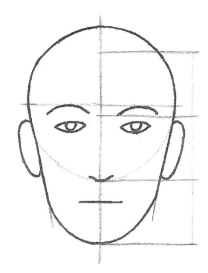

Base sketch

We know that a person's face is often thought of as happy, melancholy or serious, rather than triangular, with close-set eyes, a long nose, big mouth, etc. If the permanent features of a face are essentially limited, the number of expressive combinations which can occur are therefore also limited. However, even a very small child can immediately recognise various countenances and most common expressions. The reason why is simple: we perceive a face as a single unit. When observing someone as s/he smiles, we actually see a "happy" face, not a collection of muscle contractions. The eyes, the nose, the mouth, even the colouring, pupil dilation and other signs are not recognisable on their own. Rather we see their organization, which gives rise to unique, individual characteristics.

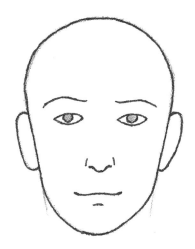

Relaxed

Boredom

Happiness

Contempt

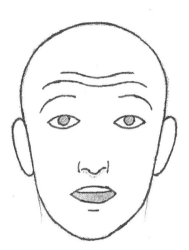

Surprise

Thus it isn't surprising that the rendering of facial expressions in art is a complex problem. In *On Painting* by Leon Battista Alberti (the oldest treatise on the subject), the author writes that it's difficult for the painter to distinguish (in representation) a laughing face from a crying one. Even today, students at fine art schools face notable difficulty in rendering the exact nuances of expression, just like the difficulty in creating precise features in a portrait.

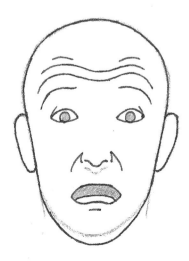

Fear

Before being able to create likeness in a portrait, we have to know how to draw a plausible head and face. The same is true for expressions as well: before attempting more minute differences, we should master fundamental emotions.

If for all real-life drawing it may be useful to have proportional canons (see "Anatomy and Physiognomy of the Head") and structure-diagrams, as they help save time, the same can be said for drawing expressions.

Here we present sketches for the main facial expressions. These sketches are to be used as generic bases, which can be varied according the artist's specific needs.

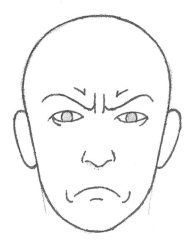

Anger

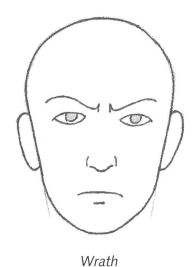

Wrath

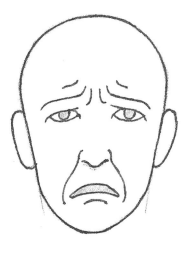

Sadness

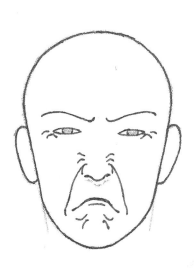

Disgust

Drawing the head

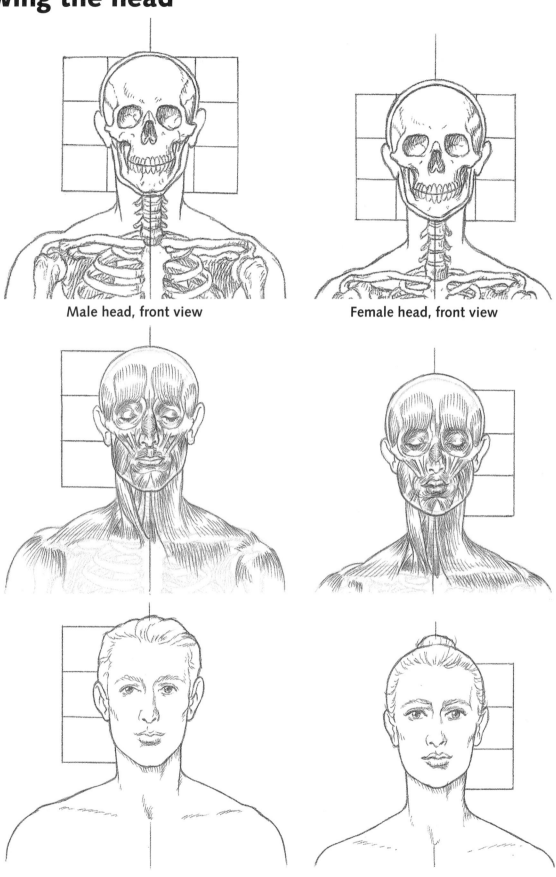

Male head, front view

Female head, front view

To learn how to draw from memory, it's helpful to first practice with a copy, then repeating the exercise on your own with a certain amount of freedom. Draw the skull on top of a proportional grid. Add the face's expressive muscles, then re-draw (or trace) it, completing the physiognomy, adding the hair and other details.

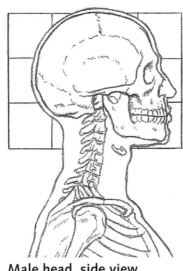

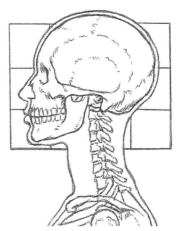

Male head, side view

Female head, side view

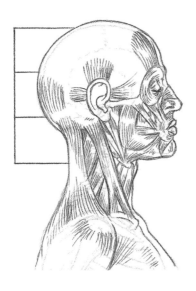

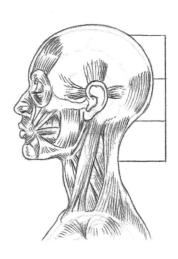

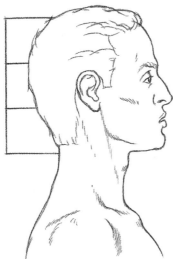

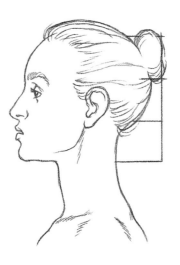

With repetition and practice, the proportional grids, the skull, the muscles and the physiognomy will become expertise, kept in the brain of the artist. At this point, you can draw faces and heads from memory, in different positions and with a wide variety of expressions.

Drawing expressions

Surprise

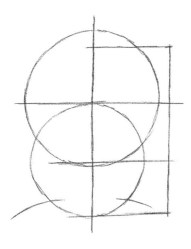 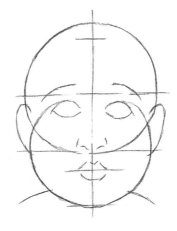 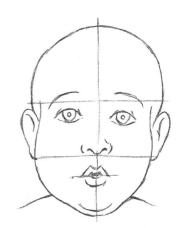

After having drawn the sketches for the main facial expressions and after having mastered the proportions and human anatomy, the student can move on to studying simple expressions, such as astonishment and surprise. Draw a circle where the perpendicular lines meet. Extend the vertical line and divide it into three modules, draw another circle and you now have the framework for the head. Add the eyes, nose and mouth on their respective axes. Continue on to add details and shading.

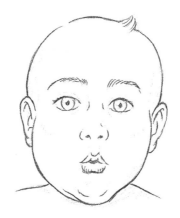

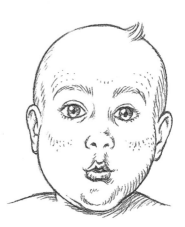

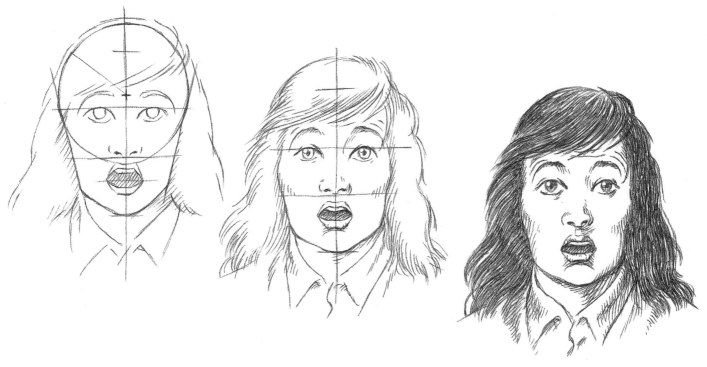

Smiling

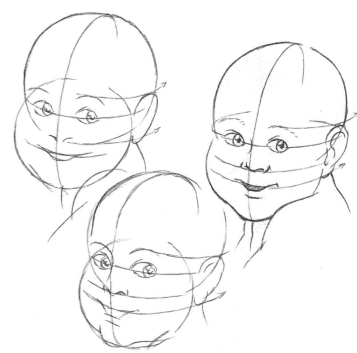

The drawings show the construction of the head, from the framework/structure to the expression. Note how each vertical axis defines the angle of the face. Here we've illustrated: the curious smile of a child, the full smile of an adolescent and the ironic smile of an adult.

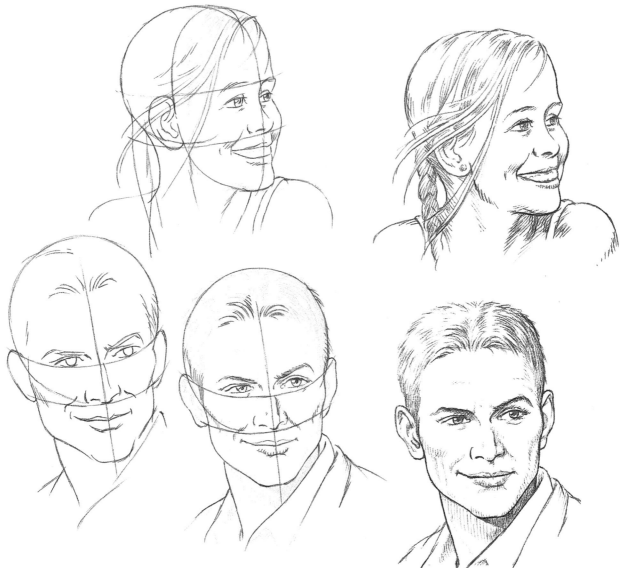

Laughing

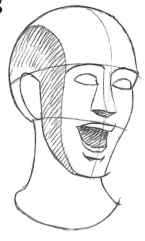

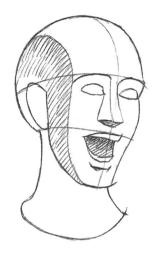

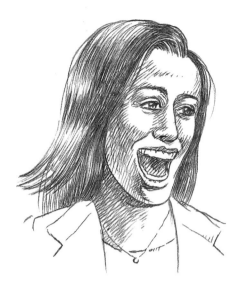

The illustrations show (from left to right) the schematic volume of the head, the axes used to construct the face and the final expression with shading. From top to bottom: laughter with an open mouth, laughter with the head tilted backwards and very intense laughter (the sort which also includes crying).

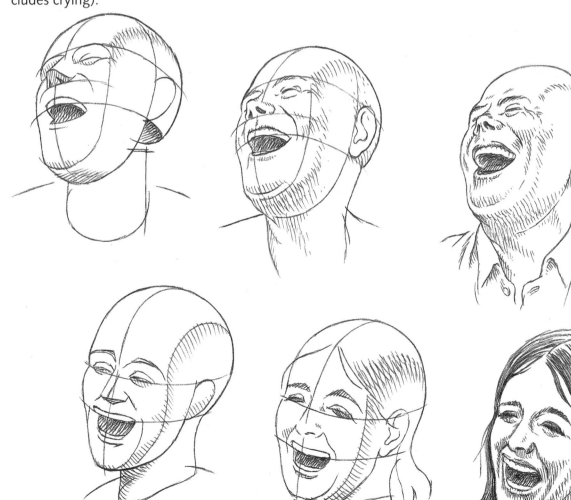

Sadness

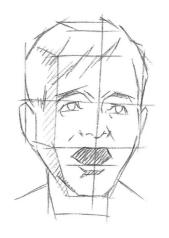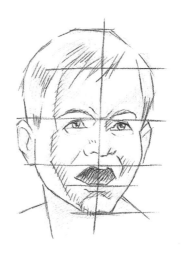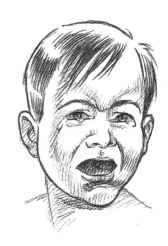

The construction of the head and the facial expression can be done through the composition of a framework made of geometric, block-like forms. From top to bottom: the angry crying of a child, painful sadness - a lump in the throat - of the young man, the inconsolable young woman.

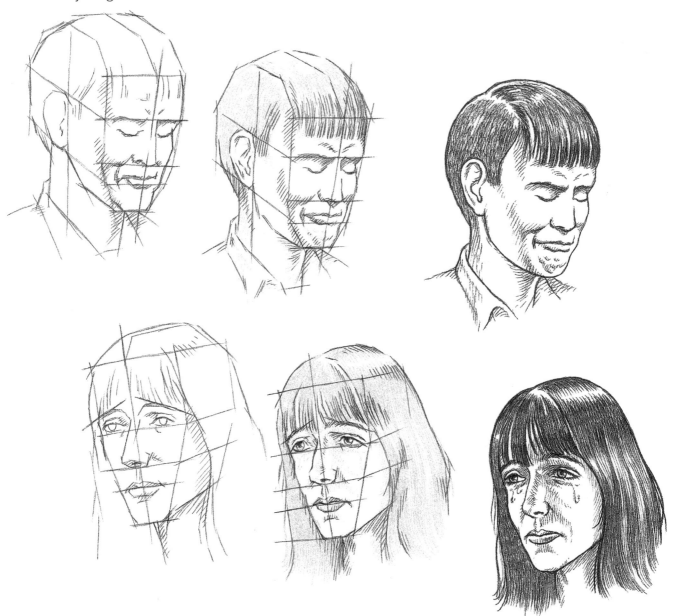

Disgust

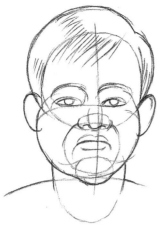
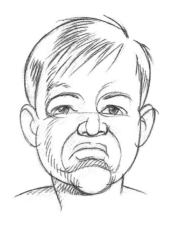
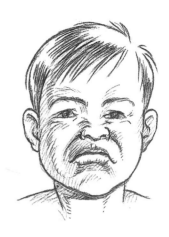

The illustrations show curvilinear compositional outlines, a rather quick method to create the shape of the face and the subsequent expression. From top to bottom: the aversion of a child, the repulsion of a woman, the disdain of an adult.

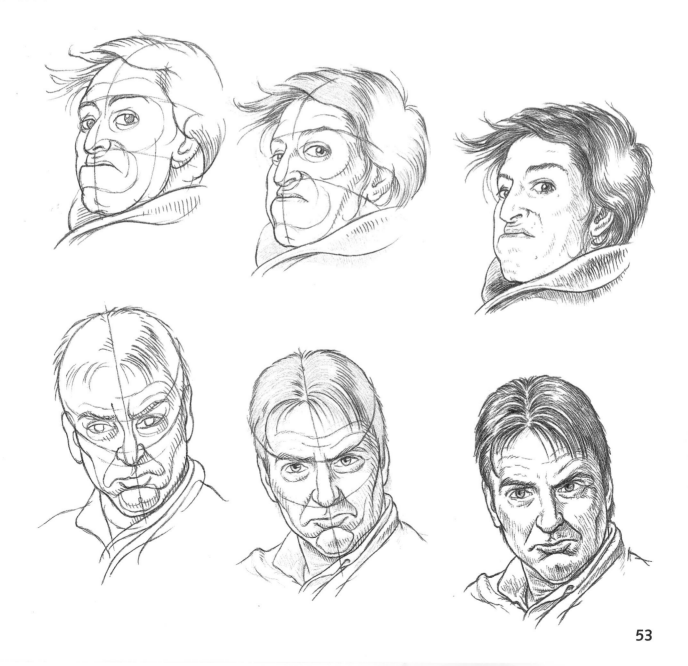

Fear

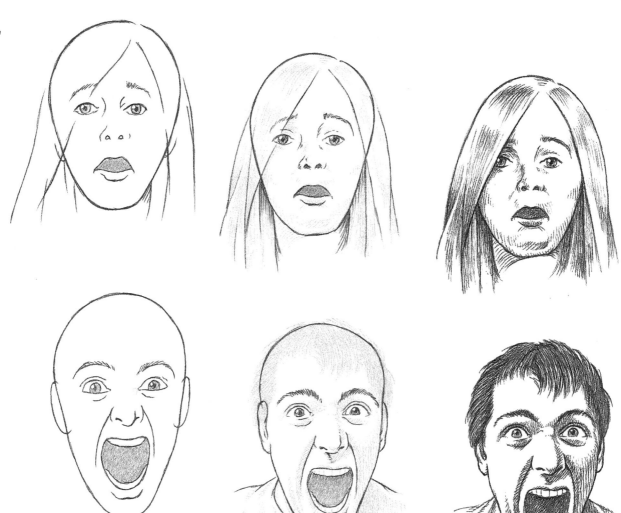

We can now draw an expression starting directly from the face (see: Drawing expressions) to arrive at the complete physiognomy. From top to bottom: the dismay of a little girl, the terrified scream of a young man, the fright of an old man.

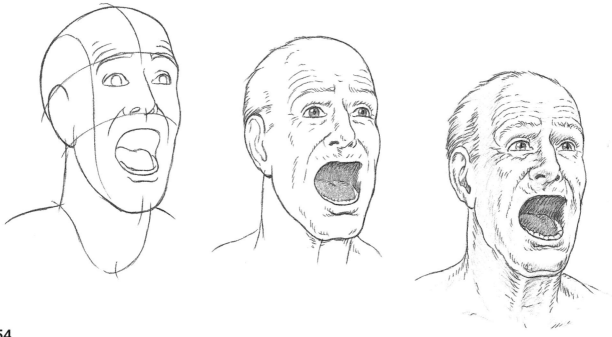

Anger

After completing various exercises, or for an experienced artist, it's possible to go directly to drawing the expression without the help of compositional outlines. The illustrations here show (from left to right): draft, the sketch and the completed drawing with hatching. The first two phases, though more generic, may be more effective. From top to bottom: the repressed anger of an adolescent, the wrath of a woman and the ire of an old man.

Drawing gazes

Eyes are more than just a simple organ for sight. Often called mirrors and windows to the soul, they always "look out" for something that goes beyond the purely visual. "We do not see the human eye as a receiver, it appears not to let anything in, but to send something out. The ear receives; the eye looks. (It casts glances, it flashes, radiates, gleams.) One can terrify with one's eyes, not with one's ear or nose. When you see the eye you see something going out from it. You see the look in the eye." (L. Wittgenstein, *Zettel*, 222).

The act of looking often expresses a state of mind or an attitude, at times more eloquent than a gestural configuration of the face.

A look can convey a message of love or hate "If looks could kill, how many dead men there would be! And if looks could fecundate, how many children! The streets would be full of corpses and pregnant woman!", in the words of Paul Valéry.

This is mainly due to the dilation or contraction of the pupil, followed by the movements of the eye and eye socket muscles. They also has the ability to communicate and violate, by its presence, the privacy of others.

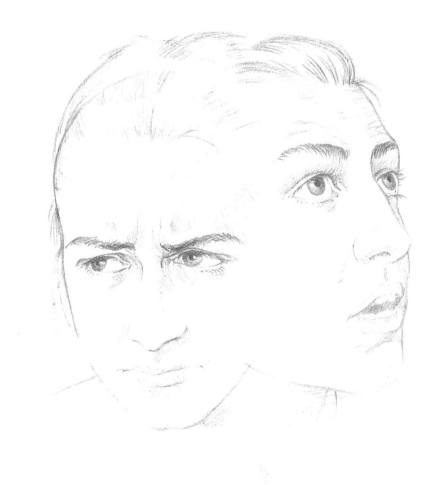

There are essentially two types of gazes: instinctive/unintentional or cultural/intentional. The former category includes gazes which express emotions, while the latter includes those which express feelings, interpersonal attitudes, and perceptions. Emotions come to us externally and we can, at most, try to hide them, always with a good amount of difficulty. They're temporary; we know that one can go from sadness to euphoria in just a few seconds. Attitudes, perceptions and feelings are, on the other hand, more deeply rooted and last longer. Put simply, we can say that they exist when emotions and moods result in ideas.

In short, the first type of gaze is a reaction to external stimulation, while the second is a product of our thoughts.

For an artist, concentrating on the face is crucial to capturing even the smallest expressive nuances.

Beginners should start by creating the eyes (eyelids, irises, pupils, bridge of the nose and eyebrows), paying close attention to the proportions and the direction of the gaze (see the illustrations at right).

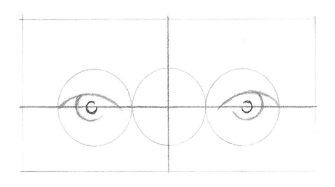

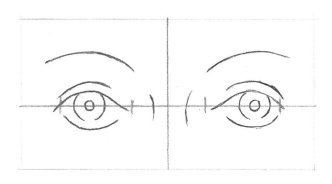

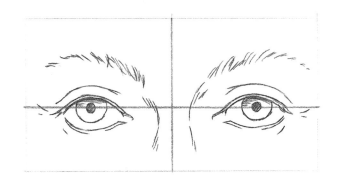

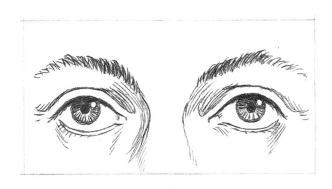

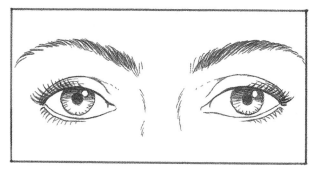

Direct/resolute gaze

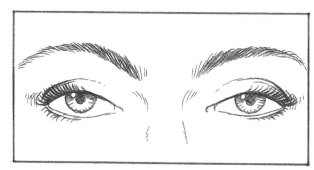

Languid gaze

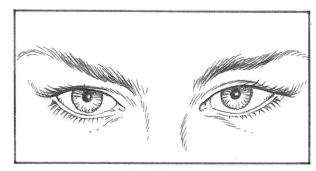

Hard/cold gaze

The first phase will consist of reproducing the various types of emotional gazes: sad, joyful, surprised, fearful, etc.

The second will require the construction of the various expressions of perceptions or feelings; starting from the easiest ones (concentration, contempt) to come to the more complex ones

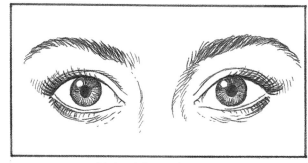

Naive/dreaming gaze

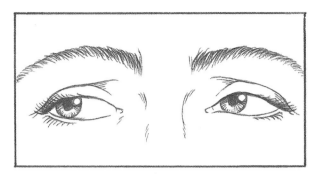

Concealing gaze

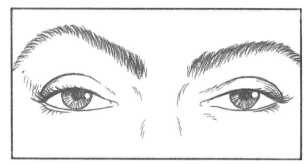

Ironic/scornful gaze

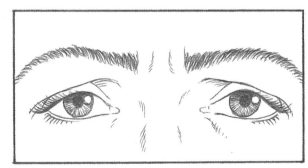

Depressed/introverted gaze

(embarrassment, adoration). Representing feelings such as love, for example, is already quite difficult when drawing the entire face, much more so when we are depicting just the gaze.

So, here we've represented looks which are meaningful for an artist who depicts a number of typical feelings and attitudes.

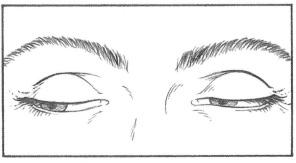

Elusive/inhibited gaze

There have been multiple attempts throughout history to classify emotions. However, so far we haven't been able to decide upon a universally-accepted classification system. The differences are due not just to the intrinsic subjectivity of the operation, but also to the notable number of parameters which can be taken as a base for their categorisation. We can thus divide them into two groups:

• Primary, basic or fundamental emotions.

• Secondary emotions: combinations or mixtures of primary emotions.

In a review of recent literature, Kemper (1987) lists the primary emotions as they've been proposed. For Kemper, there are at least four primary emotions with a physiological base: fear, anger, sadness and satisfaction. According to Kemper, secondary emotions derive from the primary emotions, as does social interaction. Thus, primary emotions are independent of culture; they're innate and old enough to have been handed down from our common ancestors. There's no doubt that facial expressions are an evident indicator of the emotions felt by an individual. Considering other bodily signals as well, Robert Plutchik identified eight fundamental emotions.

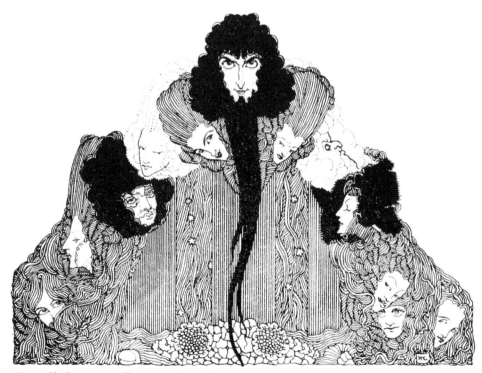

Harry Clarke, a 1922 illustration from The Fairy Tales of Perrault, *Harrap Ltd, London*

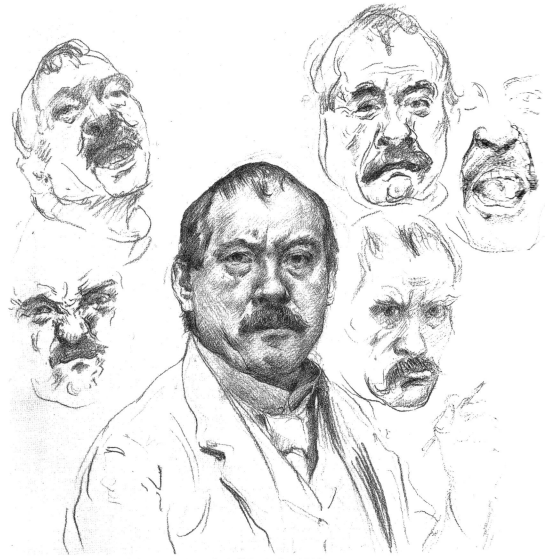

Feature details by Lovis Corinth, Self-Portraits, 1910

The 8 basic emotions are:
- Joy
- Agreement/Acceptance/Approval
- Anger/Ire
- Expectation/Anticipation/Waiting
- Disgust
- Sadness/Grief
- Fear
- Surprise

A few emotions with psychosocial origins are:
Primary dyads
(a mixture of similar emotions)
- joy + acceptance = friendship
- fear + surprise = alarm
Secondary dyads
(a mix of emotions separated by one degree)
- joy + fear = sense of guilt
- sadness + fear = resentment
Tertiary dyads
(a mix of emotions separated by two degrees)
- joy + surprise = delight
- anticipation + fear = anxiety

Ecstasy

At their most intense, joy and smiles become expressions of pleasure and ecstasy. The expression of amorous ecstasy is, however, different from mystic ecstasy. We often hear about the ambiguous nuances of this emotional state, especially in reference to the sculpture of Gian Lorenzo Bernini. Of his works, the *Ecstasy of Saint Teresa* best portrays this, where the memory of an intensely painful yet quite pleasing emotion seem to cohabit her almost abandoned body. In her provocative expression, her head is tilted back, eyes half-closed and rolled back, mouth slightly agape in a delirium of the senses, her muscles completely relaxed.

In amorous ecstasy, or rather, orgasm, the eyes are lowered or

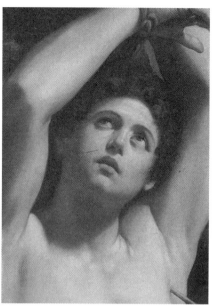

Guido Reni, Saint Sebastian, *1615-16*

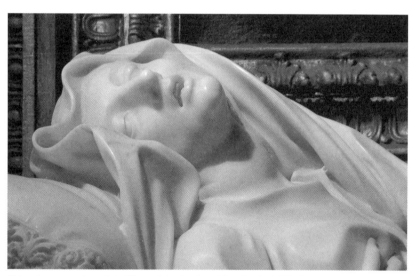

Gian Lorenzo Bernini, Blessed Ludovica Albertoni, *1672-73*

Francisco de Zurbarán, Saint Francis *(detail), 1658*

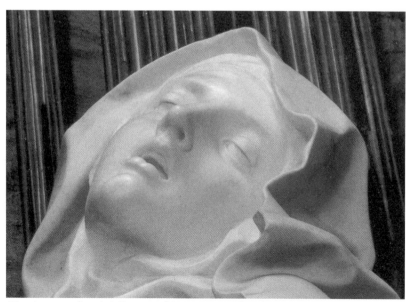

Gian Lorenzo Bernini, Ecstasy of Saint Teresa *(detail), 1647-52*

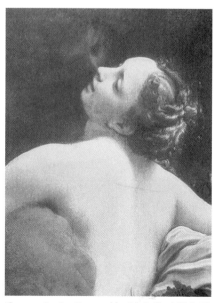

Correggio, Jupiter and Io *(detail), 1531-32*

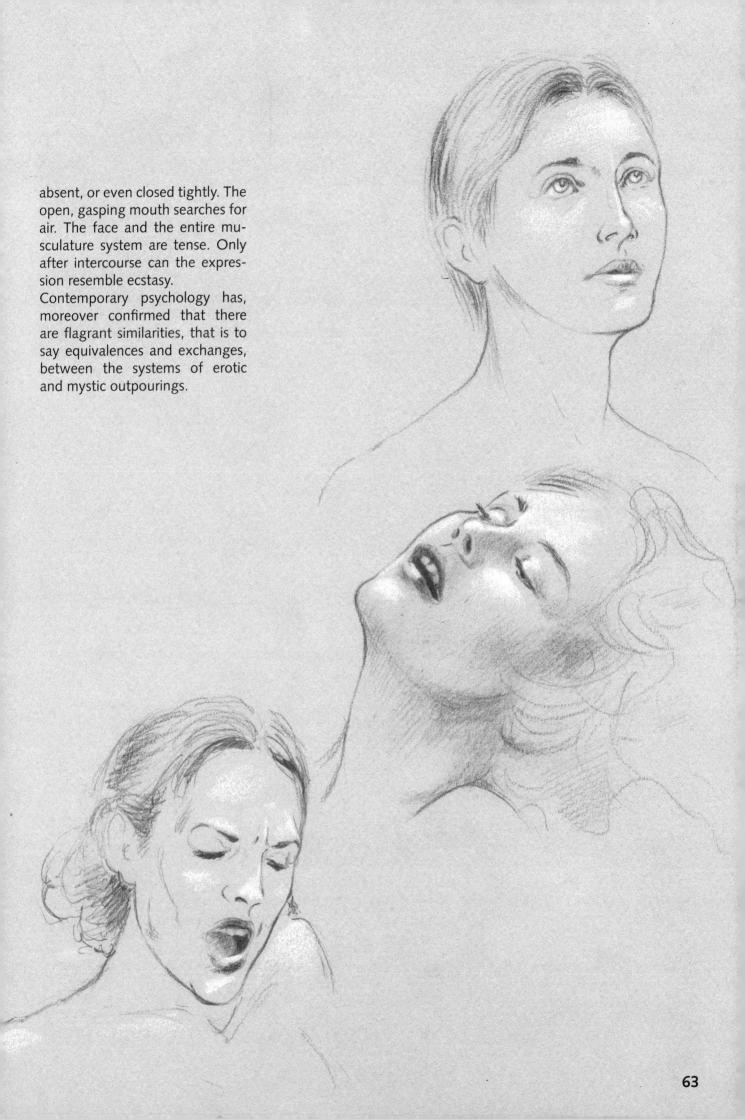

absent, or even closed tightly. The open, gasping mouth searches for air. The face and the entire musculature system are tense. Only after intercourse can the expression resemble ecstasy.

Contemporary psychology has, moreover confirmed that there are flagrant similarities, that is to say equivalences and exchanges, between the systems of erotic and mystic outpourings.

Joy/Laughter

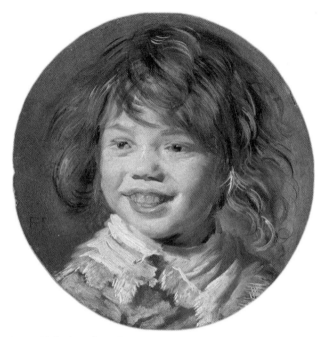

Franz Hals, Laughing Boy, *1620-25*

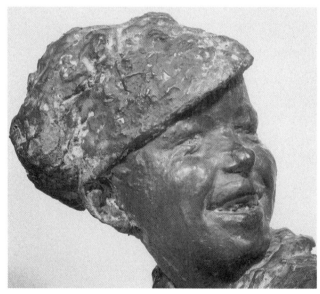

Medardo Rosso, Strillone (Paperboy), *1882-83*

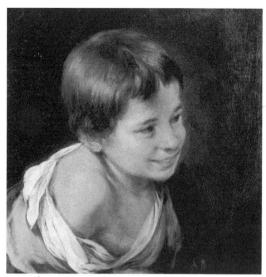

Bartolomé Esteban Murillo, Peasant Boy Leaning on a Sill, *1670-80*

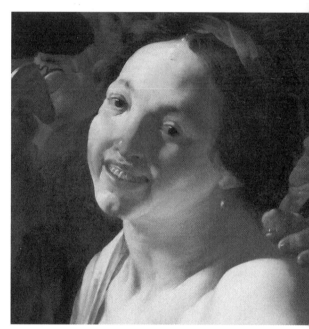

Hendrick ter Brugghen, Unequal Couple (detail), *1623*

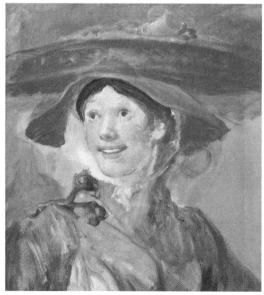

William Hogarth, The Shrimp Girl, *1750*

Well-being and pleasure find expression in smiling and laughter. When laughing, the face becomes round, the eyes become narrow, but have a certain sparkle, the mouth opens to show the upper teeth, the nose widens and, at the outer sides of the eye, numerous wrinkles form (crow's feet). The eyebrows are lifted and curved; the ears rise up and back. The main muscles involved are the zygomaticus major (contraction), the lower part of the orbicularis oculi of the eye (contraction), and the orbicularis oris of the mouth.

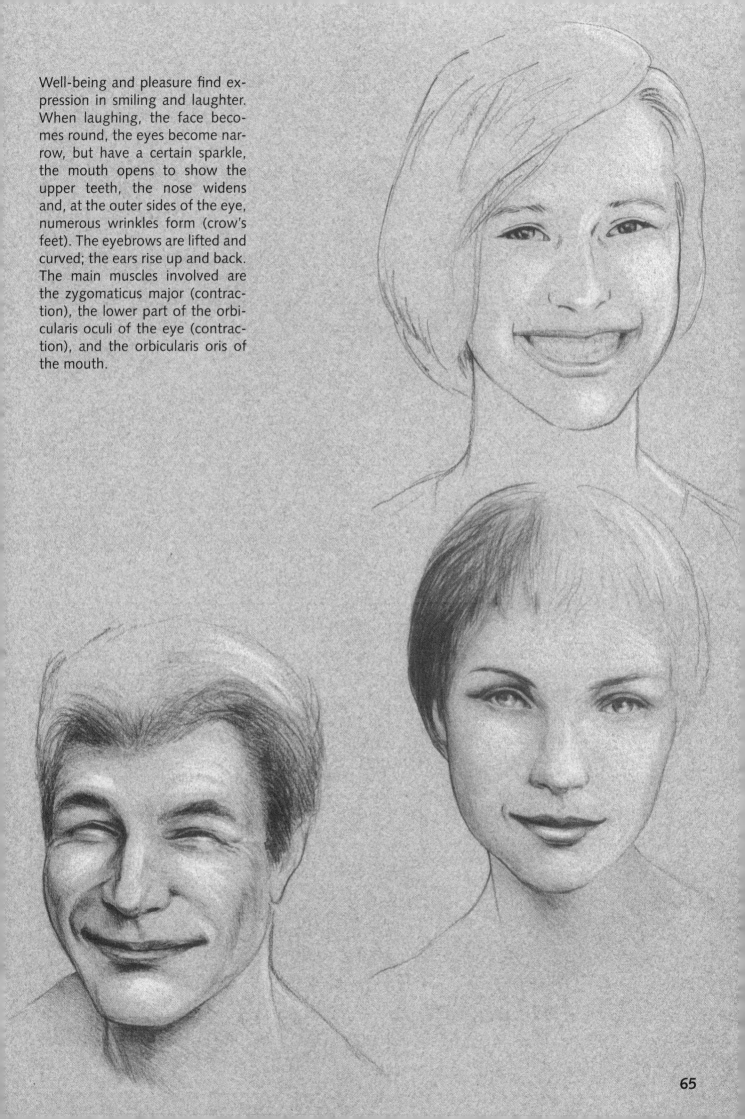

Laughter/Smiling

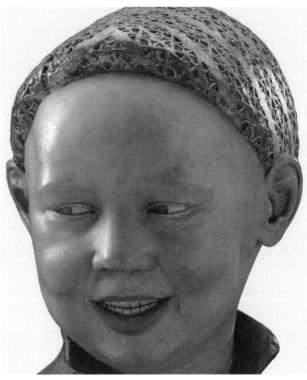

Guido Mazzoni, Laughing Boy, 1498

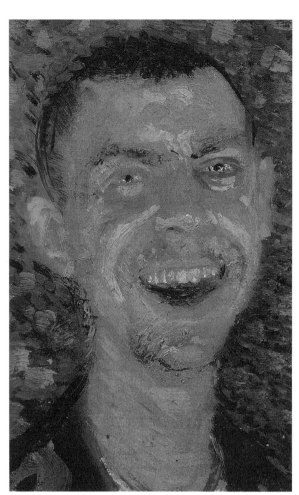

Richard Gerstl, Self-Portrait Laughing, 1908

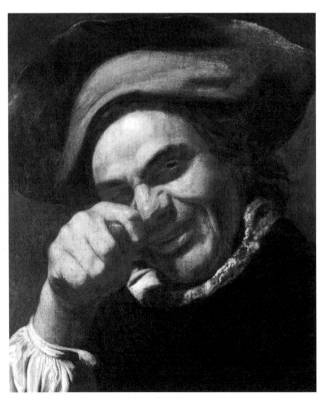

Anonymous, Bravo making the "Fica" Gesture, c. 1625

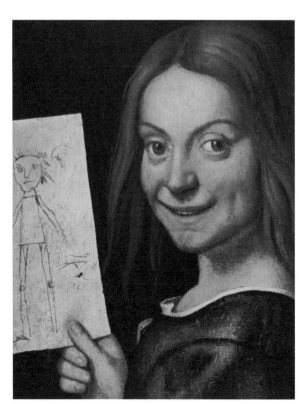

Giovan Francesco Caroto, Portrait of a Boy Holding a Drawing, c. 1520

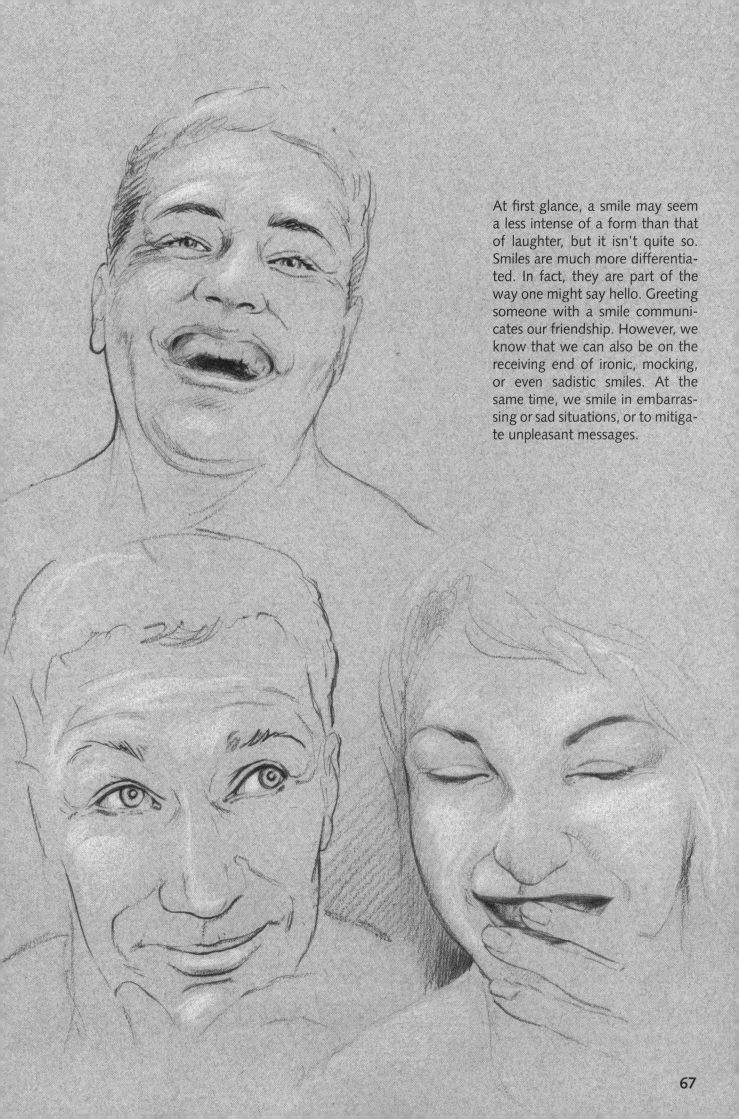

At first glance, a smile may seem a less intense of a form than that of laughter, but it isn't quite so. Smiles are much more differentiated. In fact, they are part of the way one might say hello. Greeting someone with a smile communicates our friendship. However, we know that we can also be on the receiving end of ironic, mocking, or even sadistic smiles. At the same time, we smile in embarrassing or sad situations, or to mitigate unpleasant messages.

Admiration/Adoration

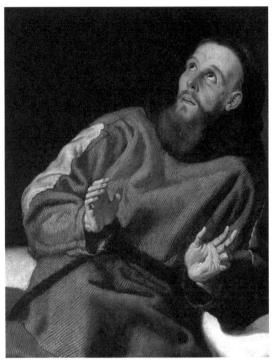

Francisco Ribalta, Saint Francis Comforted by an Angel, 1620

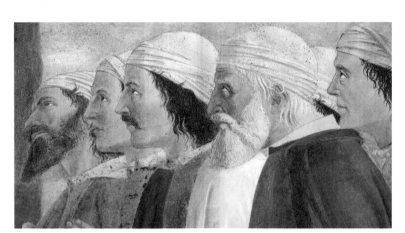

Piero della Francesca, Exaltation of the Cross (detail), 1452-66

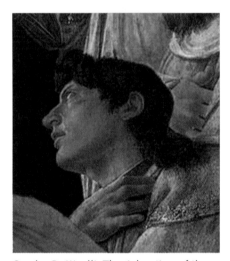

Sandro Botticelli, The Adoration of the Magi (detail), c. 1475

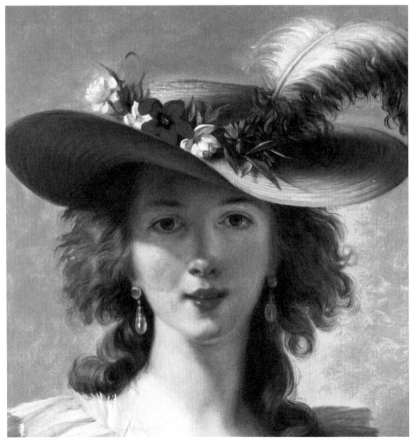

Élisabeth Vigée-Lebrun, Self-Portrait in a Straw Hat, after 1782

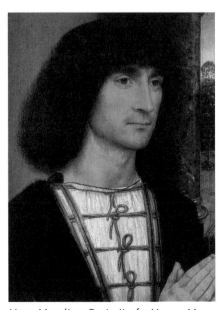

Hans Memling, Portrait of a Young Man, 1485-90

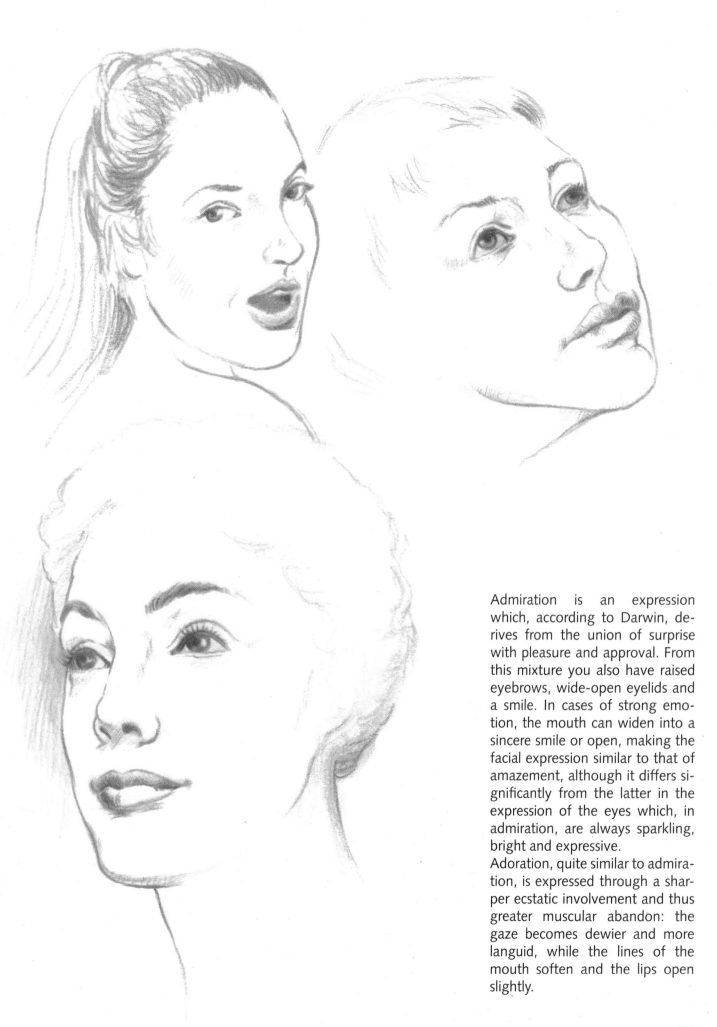

Admiration is an expression which, according to Darwin, derives from the union of surprise with pleasure and approval. From this mixture you also have raised eyebrows, wide-open eyelids and a smile. In cases of strong emotion, the mouth can widen into a sincere smile or open, making the facial expression similar to that of amazement, although it differs significantly from the latter in the expression of the eyes which, in admiration, are always sparkling, bright and expressive.

Adoration, quite similar to admiration, is expressed through a sharper ecstatic involvement and thus greater muscular abandon: the gaze becomes dewier and more languid, while the lines of the mouth soften and the lips open slightly.

Affection

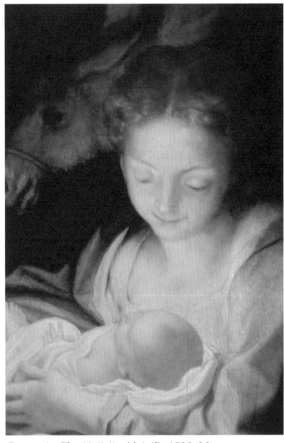

Correggio, The Nativity *(detail), 1529-30*

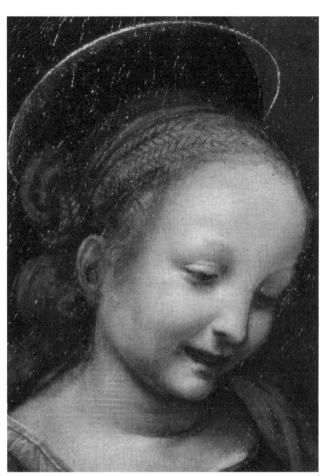

Leonardo da Vinci, Madonna and Child with Flowers (Madonna Benois) *(detail), 1478*

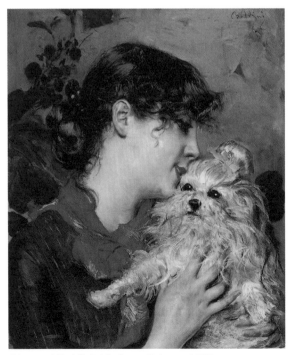

Giovanni Boldini, Madame Rejane, *1885*

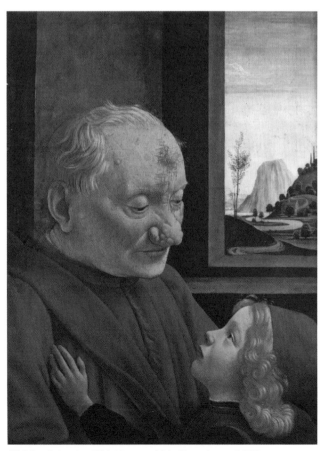

Ghirlandaio, An Old Man and his Grandson, *1480*

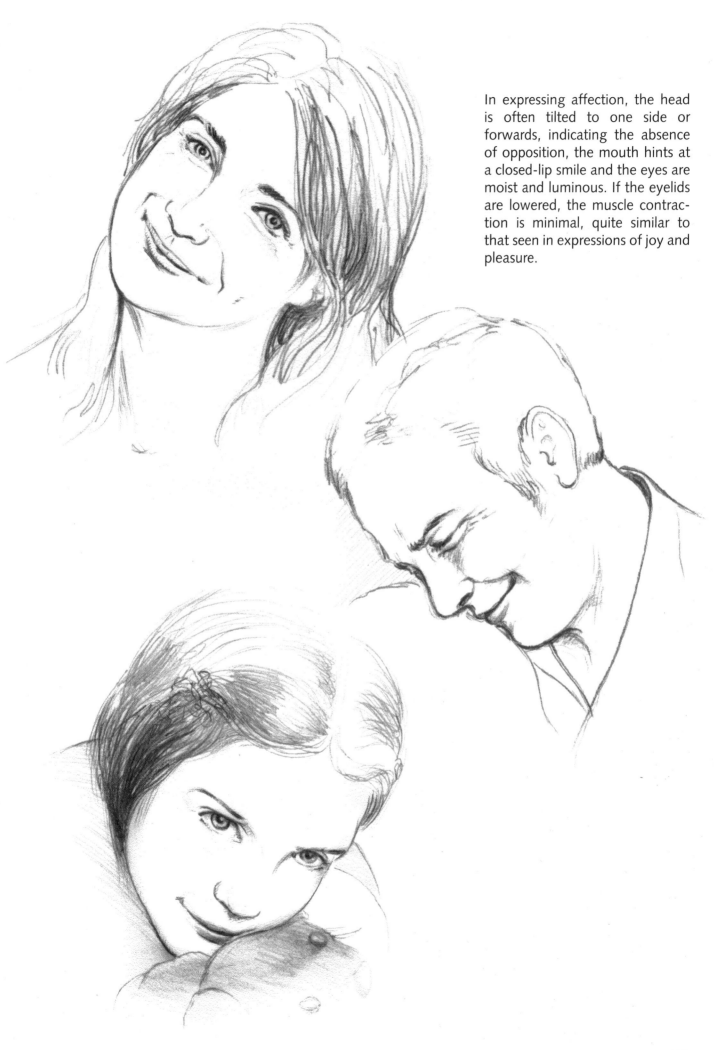

In expressing affection, the head is often tilted to one side or forwards, indicating the absence of opposition, the mouth hints at a closed-lip smile and the eyes are moist and luminous. If the eyelids are lowered, the muscle contraction is minimal, quite similar to that seen in expressions of joy and pleasure.

Rage/Anger

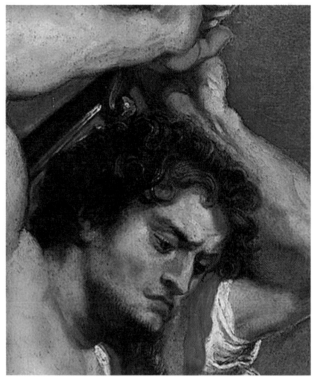

Peter Paul Rubens, David Slaying Goliath *(detail), 1630*

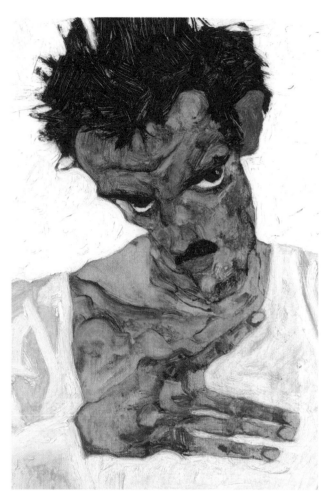

Egon Schiele, Self-Portrait with Lowered Head, *1912*

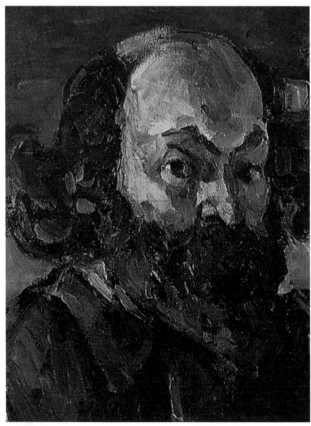

Paul Cézanne, Self-Portrait *(detail), 1873-76*

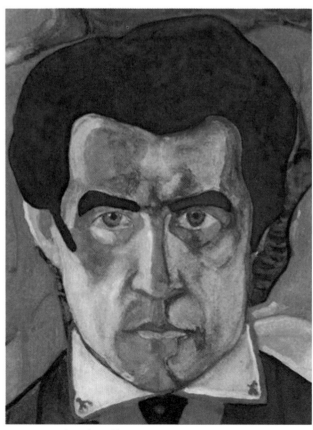

Kazimir Malevich, Self-Portrait, *1908-11*

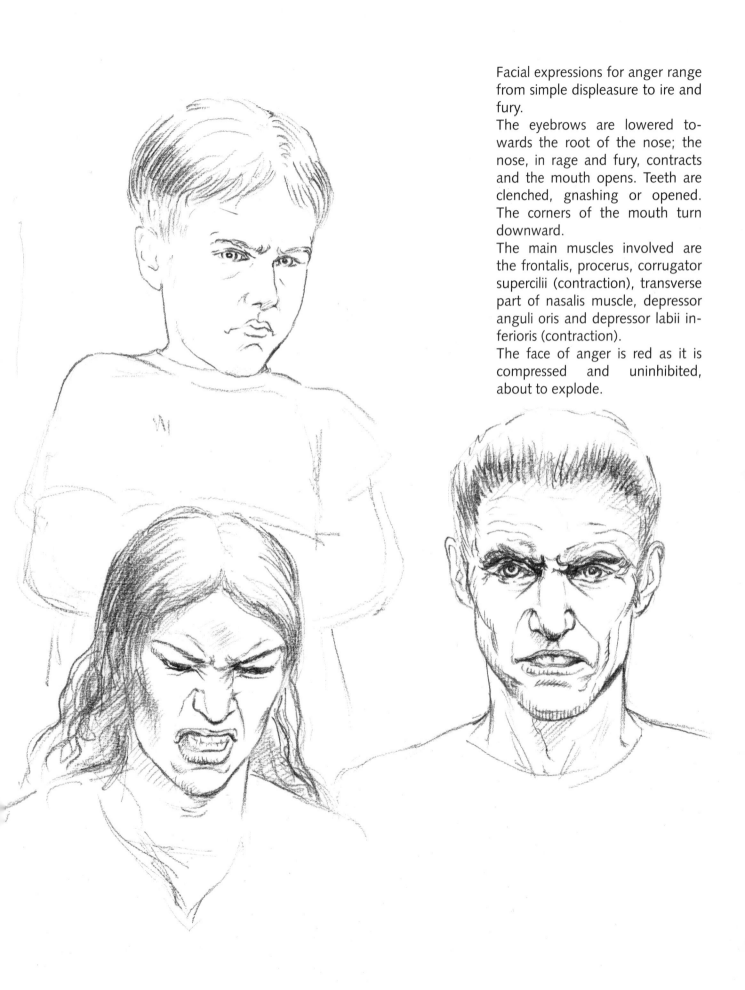

Facial expressions for anger range from simple displeasure to ire and fury.

The eyebrows are lowered towards the root of the nose; the nose, in rage and fury, contracts and the mouth opens. Teeth are clenched, gnashing or opened. The corners of the mouth turn downward.

The main muscles involved are the frontalis, procerus, corrugator supercilii (contraction), transverse part of nasalis muscle, depressor anguli oris and depressor labii inferioris (contraction).

The face of anger is red as it is compressed and uninhibited, about to explode.

Rage/Anger

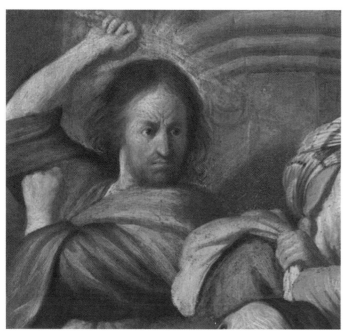

Rembrandt, Christ Driving the Moneychangers from the Temple (detail), 1626

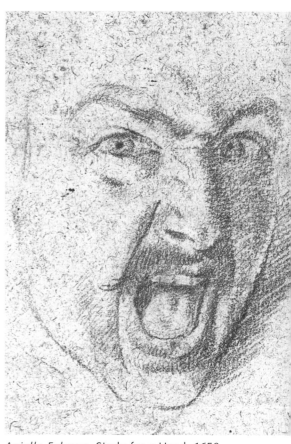

Aniello Falcone, Study for a Head, 1650

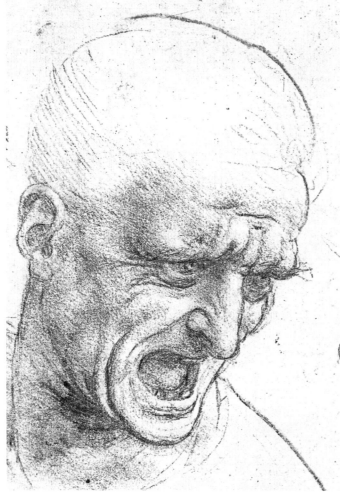

Leonardo da Vinci, Study for a Warrior's Head, 1504

Enrico Prampolini, Portrait of Marinetti, 1924-25

In fury, on the other hand, the face is pale, the lips drawn; the animal within us is ready to attack (the blood in our capillaries moves towards the muscles and inner organs in preparation for a fight). Threatening facial expressions, at times, can be ambiguous. Desmond Morris says that "the more the urge to attack dominates the urge to flee, the more the face pulls itself forwards." (*The Naked Ape*, Random House, 2010, p. 109). Wrinkling the forehead and showing one's teeth are considered signs of anger. In reality, they are an intimidating expression which hides more fear; the subject's next steps will tell us if s/he will attack or back off in retreat.

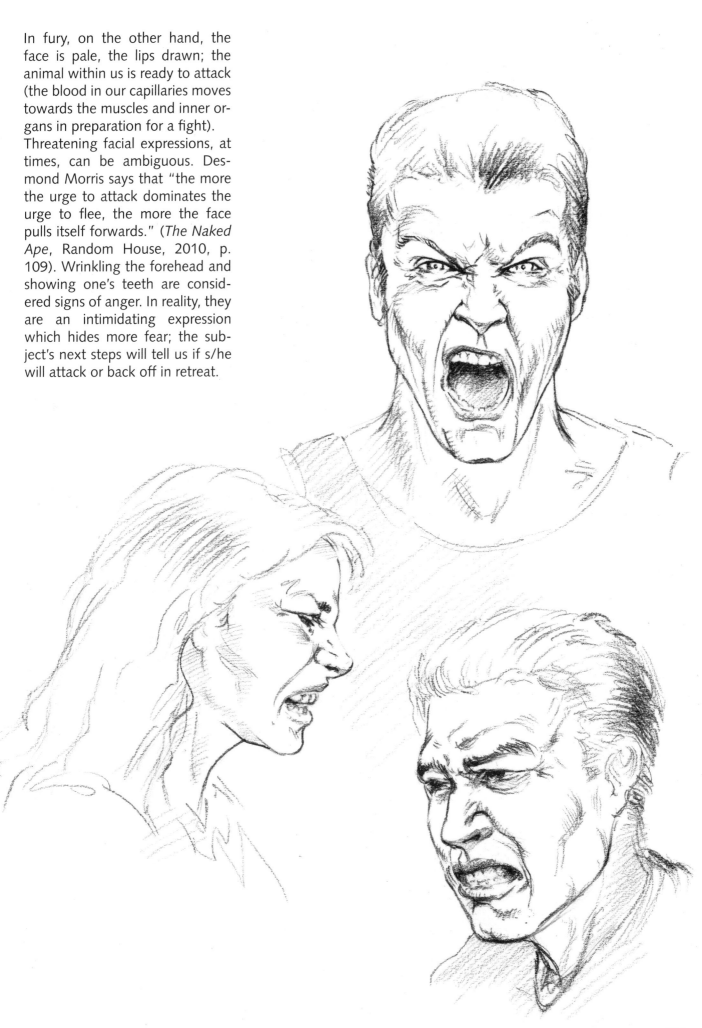

Attention/Awaiting

From the expression of rest and calm we move, with just a few changes, to that of waiting and attention: a slight contraction of the frontalis muscle, the bending of the eyebrow, and increase in the opening of the eyes (and of the pupil), and at times an imperceptible opening of the mouth.

In some cases, if the subject is slightly excited, the teeth gently bite the lower lip or perhaps even an object (the intensity of the grip increases if it is associated to a negative emotion, such as anxiety or apprehension). Some individuals, in situations of intense concentration, let the tip of their tongue stick out from their mouth.

Jean-Auguste-Dominique Ingres, Grande Odalisque *(detail), 1814*

Frans Hals, The Gypsy Girl, *1628-30*

Rembrandt, Sara Waiting for Tobias, *1647*

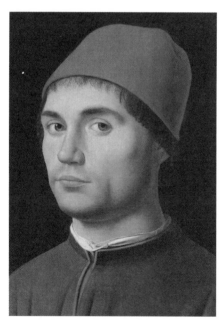

Antonello da Messina, Portrait of a Man, *1475-76*

Attention/Alert

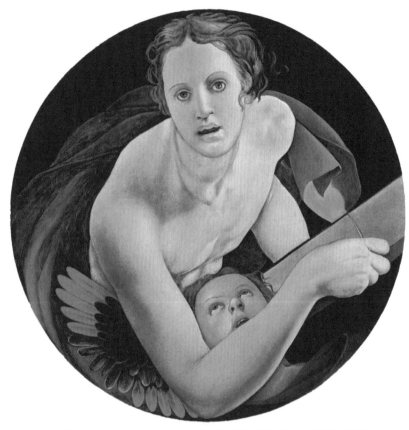

Jacopo da Pontormo (or Angelo Bronzino?), Saint Matthew, 1525-1528

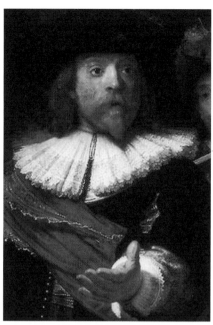

Rembrandt, The Night Watch (detail), 1642

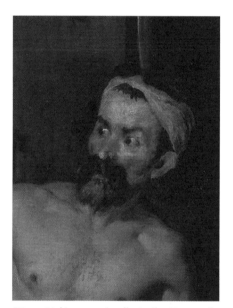

Diego Velázquez, Apollo in the Forge of Vulcan (detail), 1630

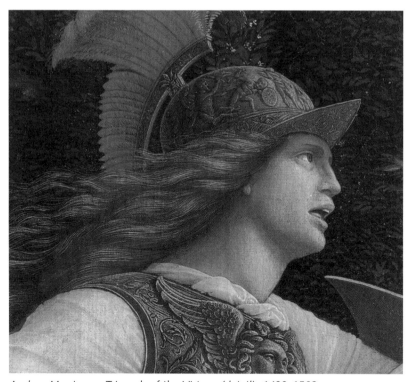

Andrea Mantegna, Triumph of the Virtues (detail), 1499-1502

Francesco Hayez, The Lampugnani Conspiracy (detail), 1826

In an alert expression, we highlight the will to expand the perceptive capacities of our senses: the contraction of the frontalis muscle and the arching of the eyebrows is pronounced, the eye becomes wide open, the mouth is slightly open and the nostrils flared. The muscles are tense and ready for action.

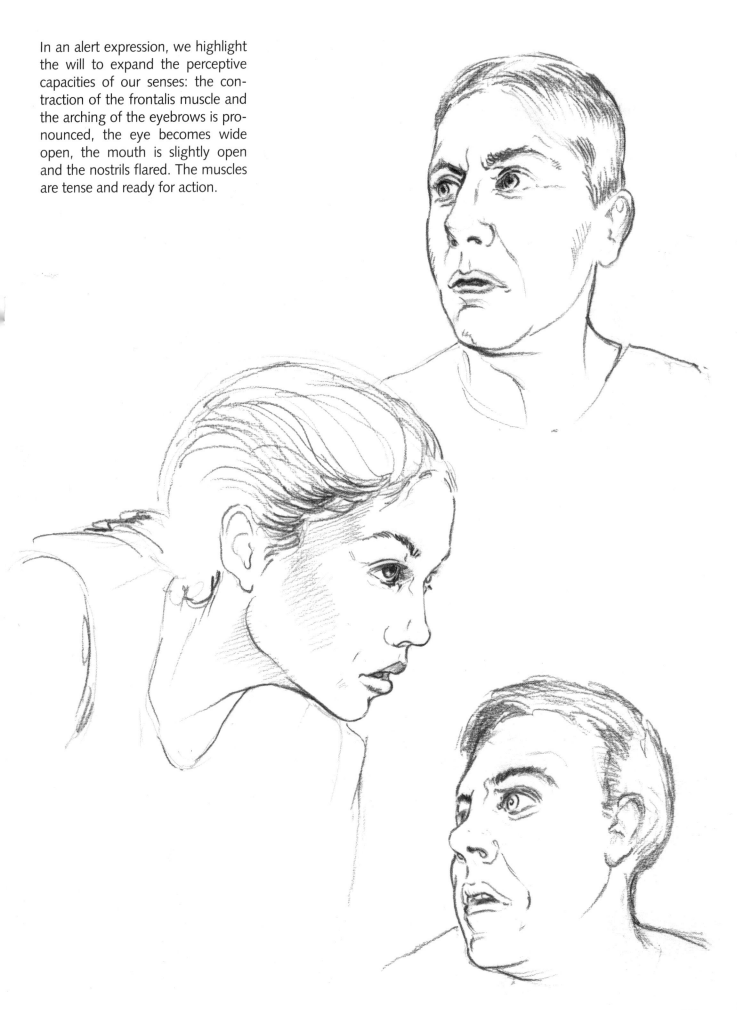

Sadness/Melancholy

Giorgione, Double Portrait *(detail), 1502*

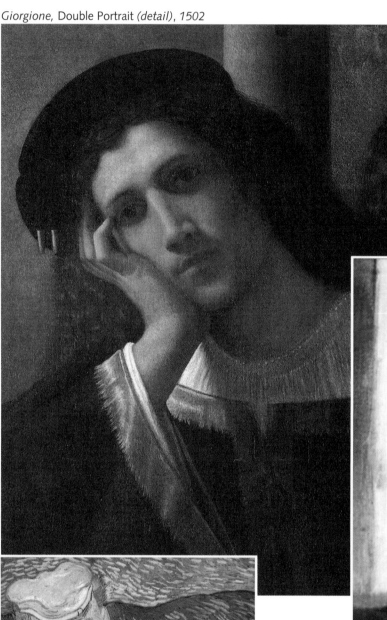

Melancholy is manifested by the wrinkling of the brow and the lowering of the upper eyelids and the corners of the mouth. The eyes, not very attentive at all to that which is happening around the subject, appear dull and expressionless. The overall expression is that of a face which droops downwards, as if the muscle masses were softly starting to give way.

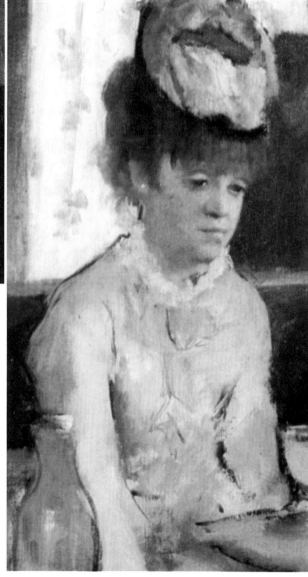

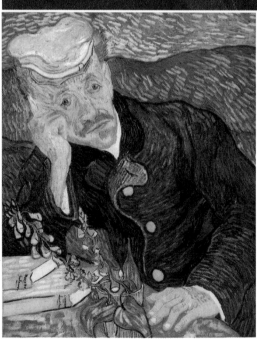

Vincent Van Gogh, Portrait of Doctor Gachet*, 1890*

Edgar Degas, L'Absinthe*, 1873*

Sadness/Crying

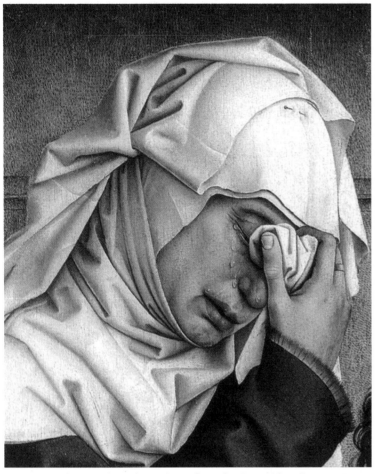

Rogier van der Weyden, The Descent from the Cross *(detail), 1433-35*

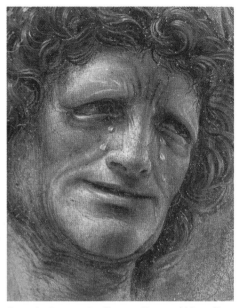

Donato Bramante, Democritus and Heraclitus *(detail), 1478-88*

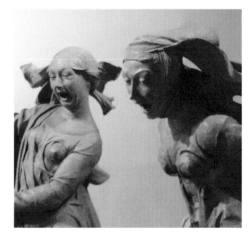

Niccolò dell'Arca, Lamentation over the Dead Christ, *1463-90*

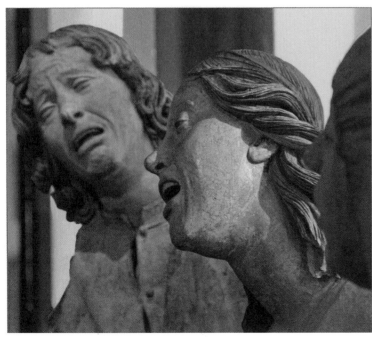

Guido Mazzoni, Lamentation over the Dead Christ, *1480-85*

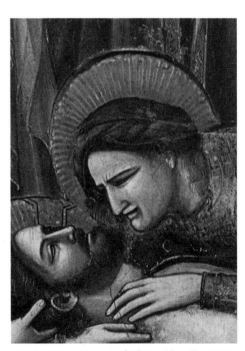

Giotto, Lamentation of Christ *(detail), 1303-05*

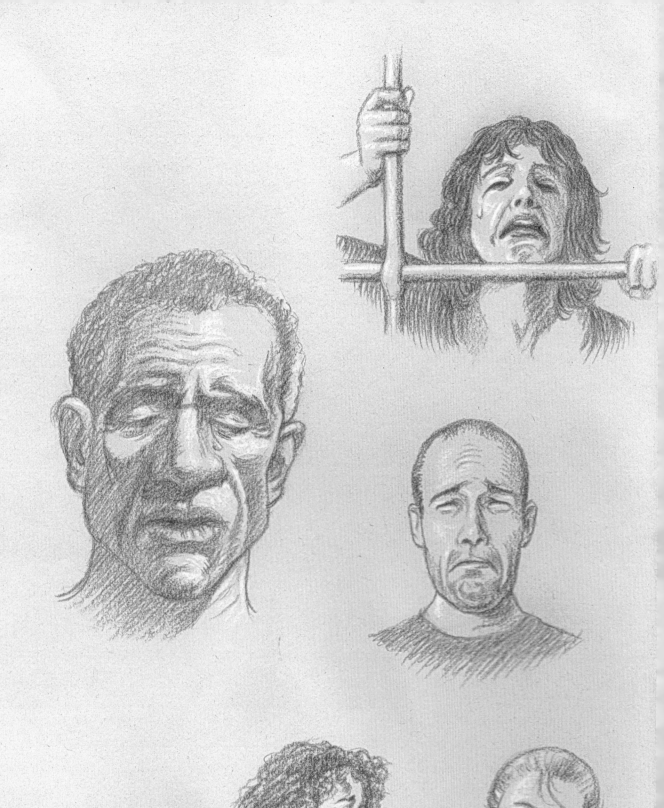

Crying is the strongest sign we can provide about our emotional state (as well as the first). All mammals, if frightened or in pain, have some sort of sharp crying yelp.

As a visual stimulation, the expressive character that the face has with just the corners of the mouth pointed downward is unique, just as is its opposite (the smile).

The mouth alone can thus communicate, apparently, sadness or happiness.

Anguish/Pain

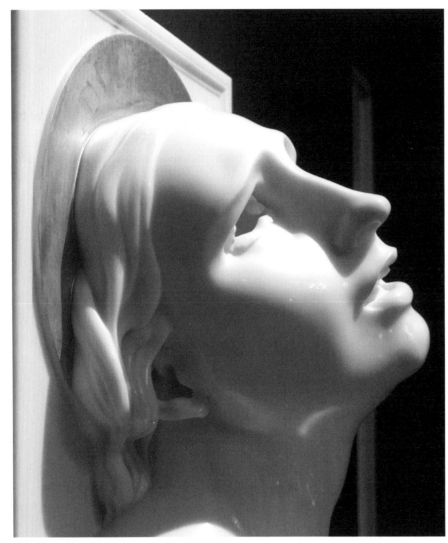

Adolfo Wildt, Saint Lucy, 1926

There are numerous expressions of sadness, from melancholy to crying, up to the expression of anguish and pain. The eyebrows contract and are lowered, the procerus muscle lowers the middle part of the skin on the forehead and the medial eyebrows create the short transversal wrinkles on the root of the nose.

There is a narrowing of the eyes, the corners of the mouth are

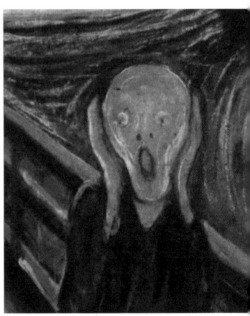

Edvard Munch, The Scream, c. 1910

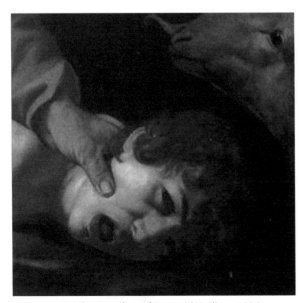

Caravaggio, The Sacrifice of Isaac (detail), c. 1598

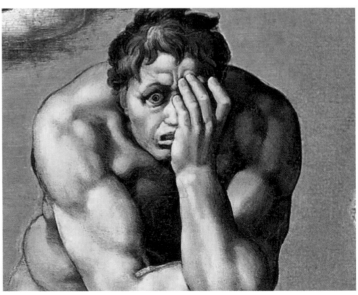

Michelangelo, The Last Judgement (detail),1535-41

lowered and, at the lower part of the nose, two characteristics grooves form at the mouth. The upper lip curves inward and drops down, the lower lip curves outward and rises, the chin rises.

The main muscles involved are the frontalis (contraction), the procerus, the corrugator supercilii, and the levator labii superioris group.

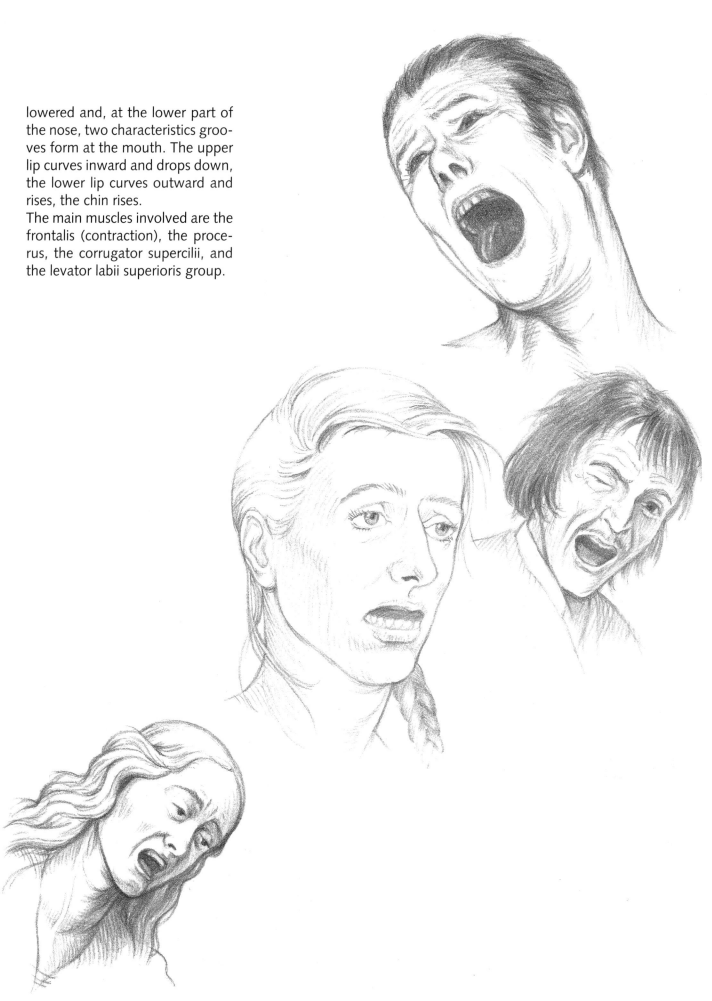

Hate

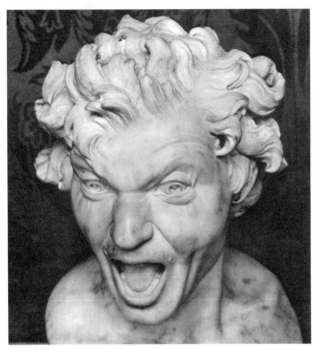

Gian Lorenzo Bernini, Damned Soul, *1619*

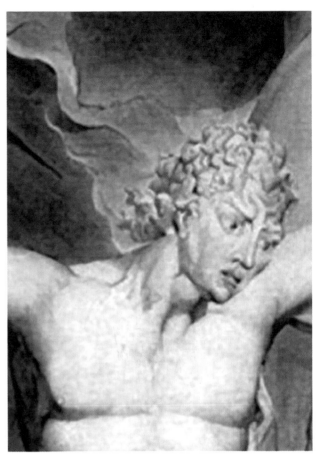

William Blake, Sin and Death, *detail of Satan, 1808*

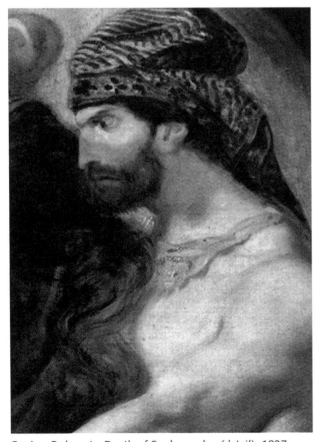

Eugène Delacroix, Death of Sardanapalus *(detail), 1827*

Hieronymus Bosch, Christ Carrying the Cross *(detail), 1515-16*

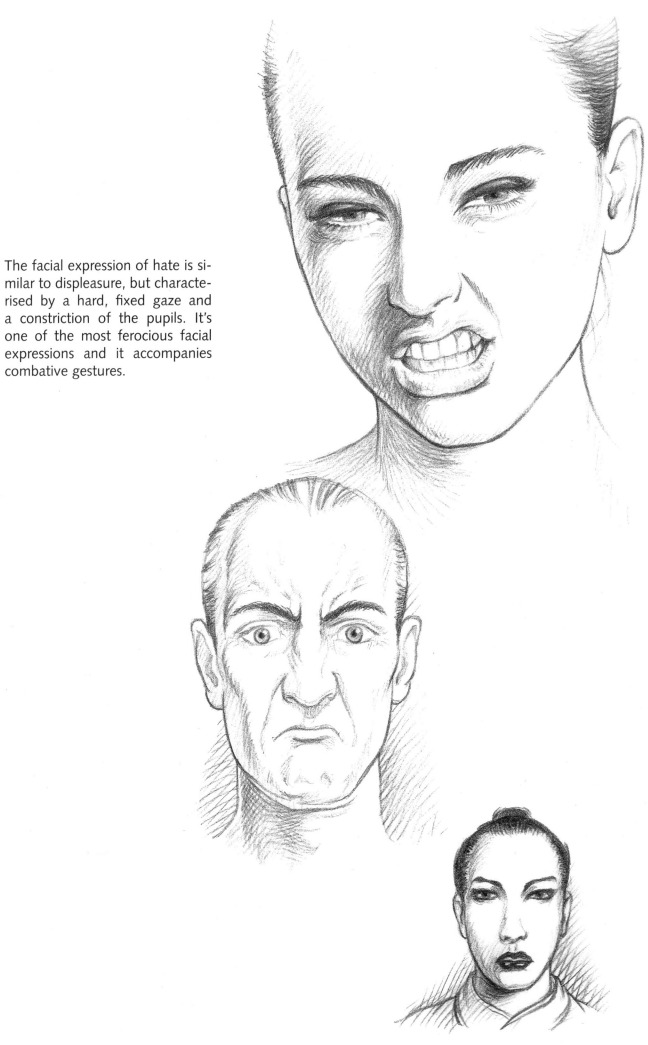

The facial expression of hate is similar to displeasure, but characterised by a hard, fixed gaze and a constriction of the pupils. It's one of the most ferocious facial expressions and it accompanies combative gestures.

Disgust

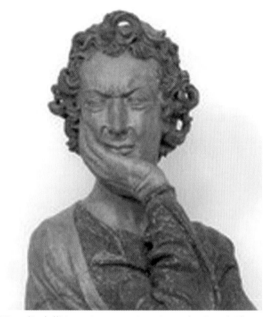

Niccolò dell'Arca, Lamentation Over the Dead Christ *(detail of Saint John), 1463-90*

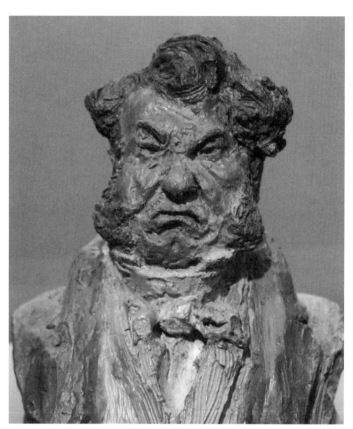

Honoré Daumier, Laurent Cunin, *c. 1832*

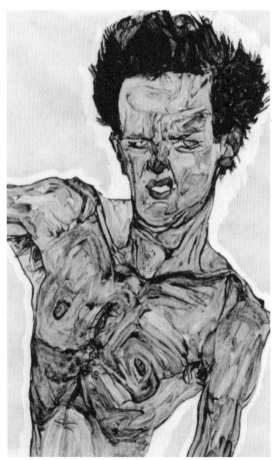

Egon Schiele, Self-Portrait, *1910*

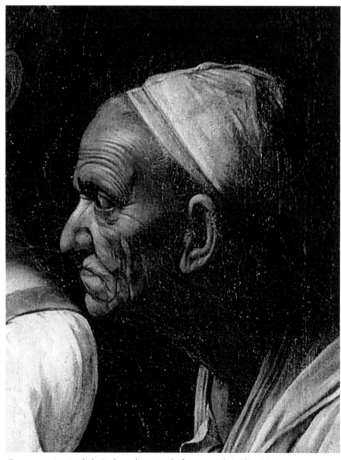

Caravaggio, Judith Beheading Holofernes *(detail), 1599*

Disgust is displayed in a similar way as revulsion. Also similar, but much less pronounced, are faces of contempt. Disgust is marked by a squinting of the eyes, the sides of the mouth angle downwards, the lower lip rises and sticks out, taking on the characteristic shape (it's that of vocalized revulsion "YUCK"). The nose produces transverse folds (wrinkling of the nose).

The main muscles involved are the orbicularis oris, the transverse muscles of the nose, and the levator labii superioris (alaeque nasi) (contraction).

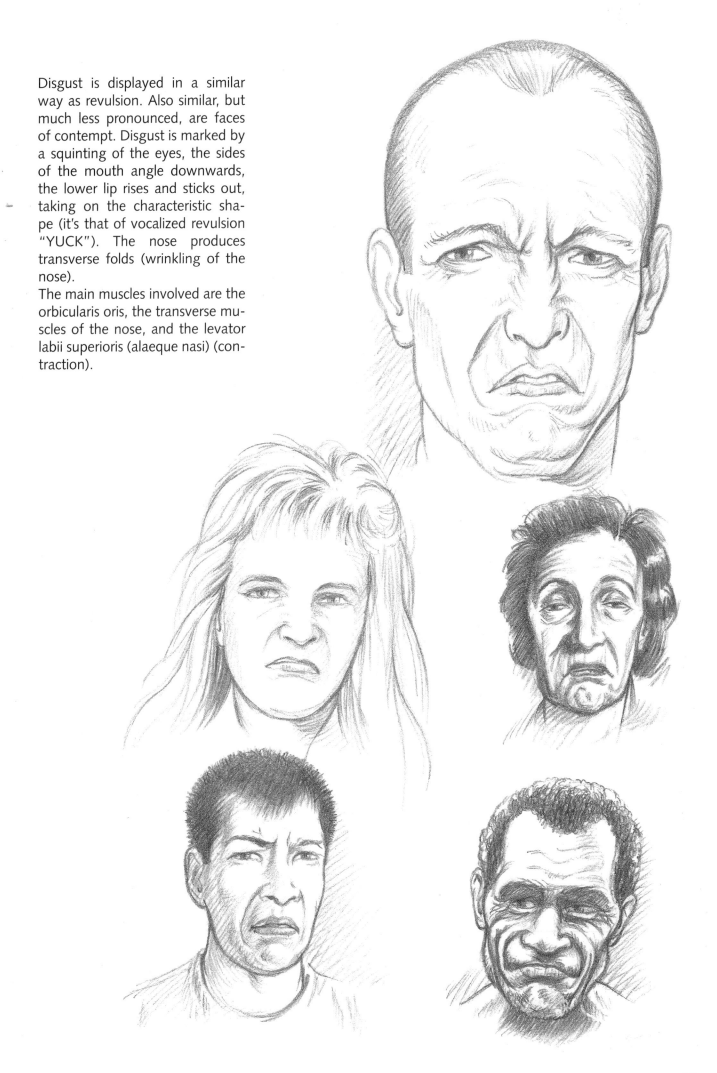

Boredom

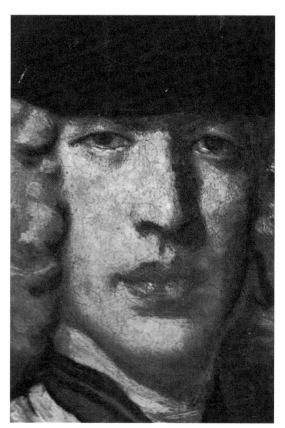

Fra Galgario (born Vittore Ghislandi), Portrait of a Knight of the Constantinian Order *(detail), 1745*

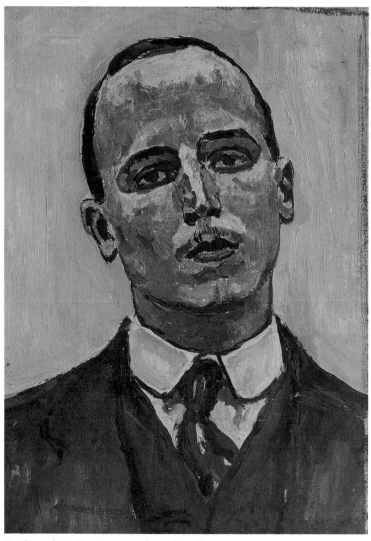

Ferdinand Hodler, Portrait of Josef Müller, *1916*

With boredom, the face "turns off". The loss of facial muscle tone results in a lowering of the eyelids, which then cover a good part of the iris; the gaze is fixed and lacks liveliness, the corners of the mouth tilt downwards and the lips open slightly due to the jaw relaxing. Extreme boredom is expressed through yawning, the physical manifestation of a state of numbness which has reached its peak.

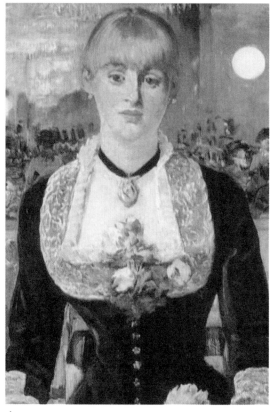

Édouard Manet, The Bar at the Folies-Bergère, *1881-82*

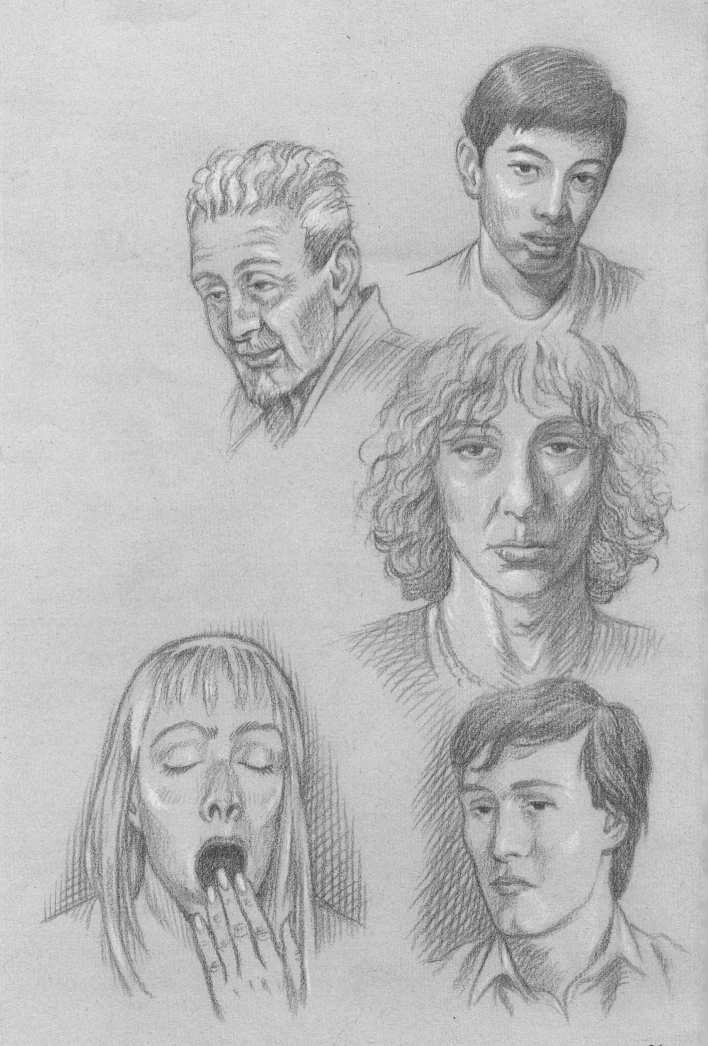

Distraction

Le Sueur, A Gathering of Friends, *c. 1640*

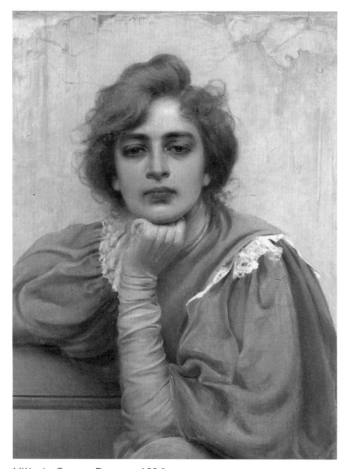

Vittorio Corcos, Dreams, *1896*

Frédéric Bazille, Portrait of a Woman, *1868*

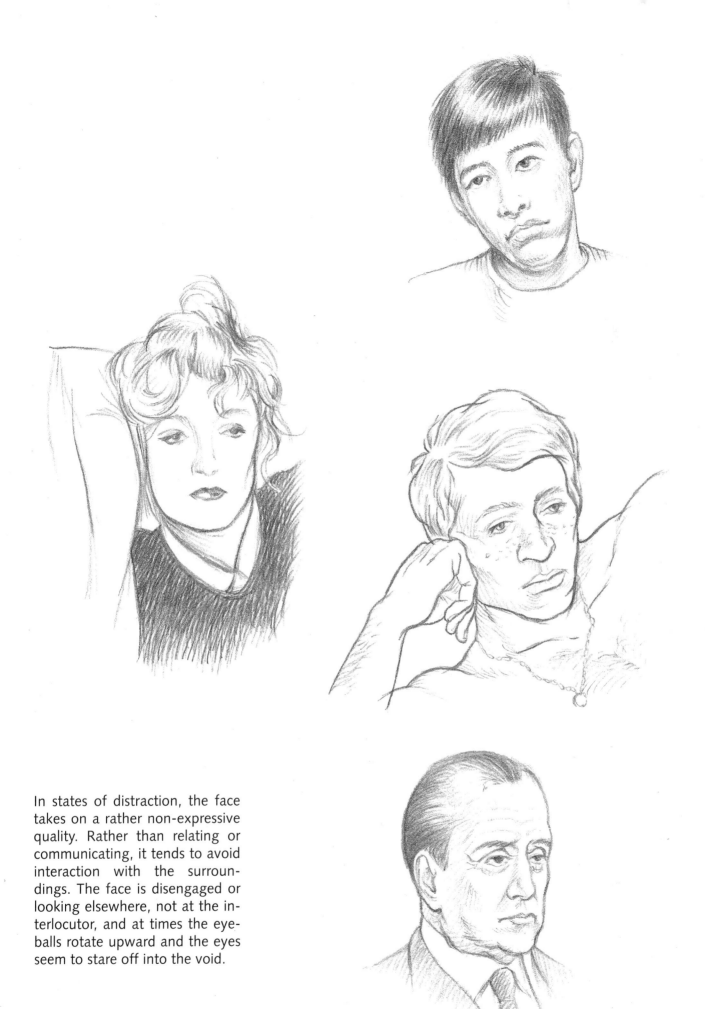

In states of distraction, the face takes on a rather non-expressive quality. Rather than relating or communicating, it tends to avoid interaction with the surroundings. The face is disengaged or looking elsewhere, not at the interlocutor, and at times the eyeballs rotate upward and the eyes seem to stare off into the void.

Surprise/ Amazement

Open mouth, wide eyes, raised eyebrows and an astonished gaze: this is the classic expression of amazement. The transition from amazement to surprise is easy: just accentuate the expression's characteristics. That is: gaping mouth, arching eyebrows and a furrowed brow, wide eyes. Facing an entirely unexpected and threatening, as with fright, involves the maximum contraction of the frontal muscle.

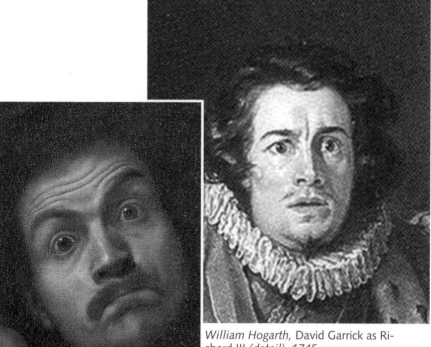

William Hogarth, David Garrick as Richard III *(detail), 1745*

Pietro Bellotti, Self-Portrait as Stupor, *1654-55*

Francisco Goya, The Third of May, 1808 in Madrid, *1808*

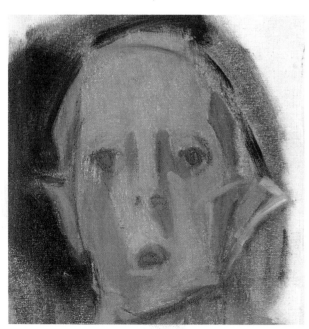

Helene Schjerfbeck, Omakuva, *1945*

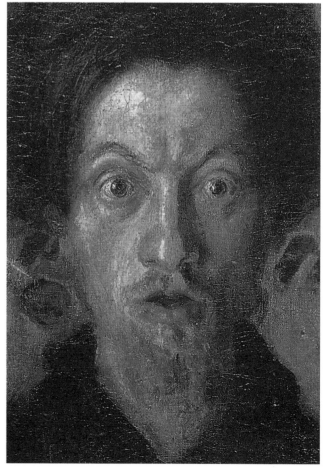

Luigi Russolo, Self-Portrait, *1909*

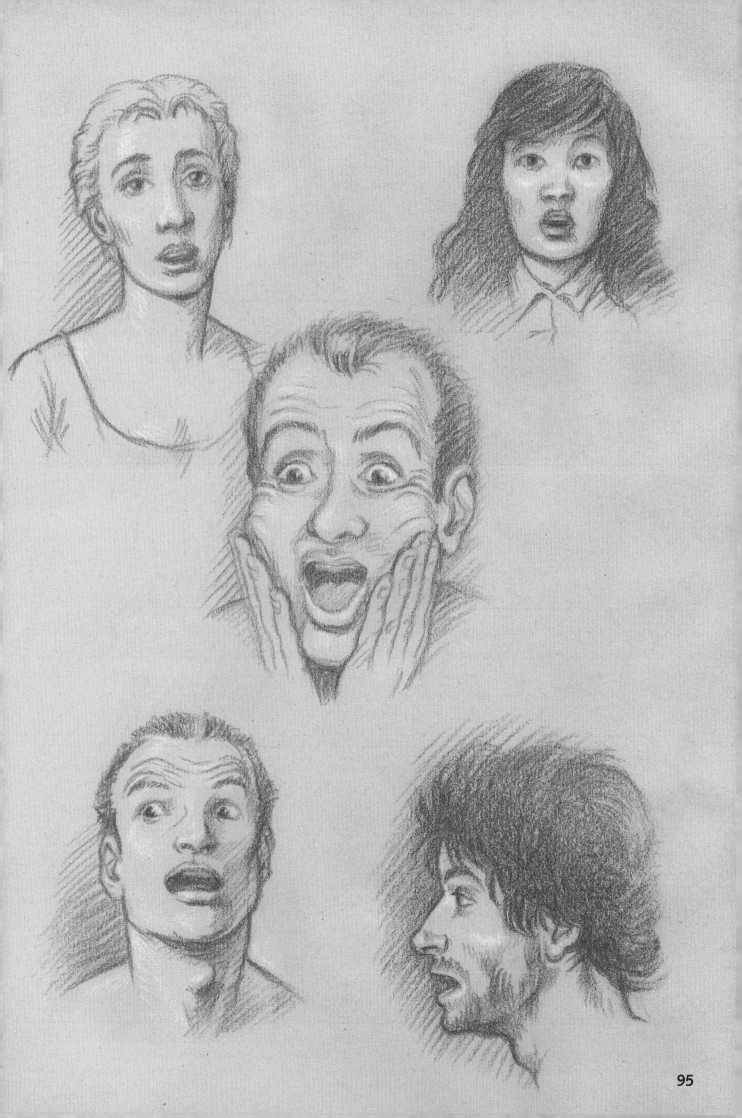

Worry/Anxiety

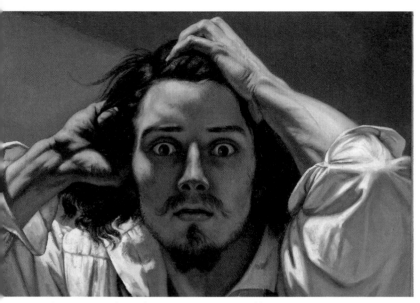

Gustave Courbet, The Desperate Man (Self-Portrait)*, 1844-45*

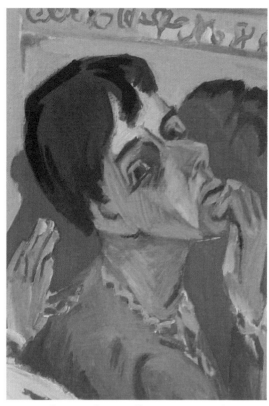

Ernst Ludwig Kirchner, Self-Portrait as a Sick Man *(detail), 1918*

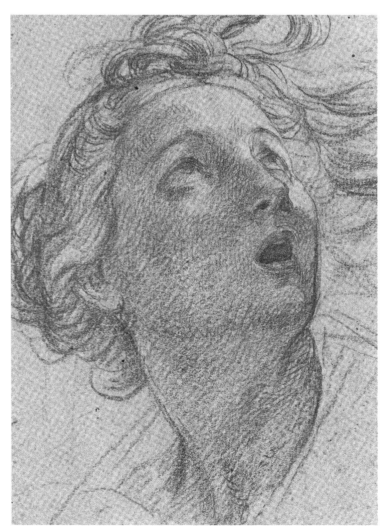

Pompeo Batoni, Study of a Head*, 1760*

Apprehension and anxiety are manifested in ways which are not dissimilar from awaiting. The contraction of the frontalis muscle, is accompanied by the arching or the furrowing of the brow, according to whether the emotion is more linked to a fear of something unexpected or a state of worry over something noticed. The eyes are often wide open, alert and moving. The corners of the mouth, which may be more or less open, are turned downwards.

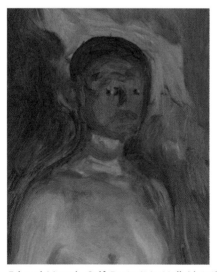

Edvard Munch, Self-Portrait in Hell *(detail), 1903*

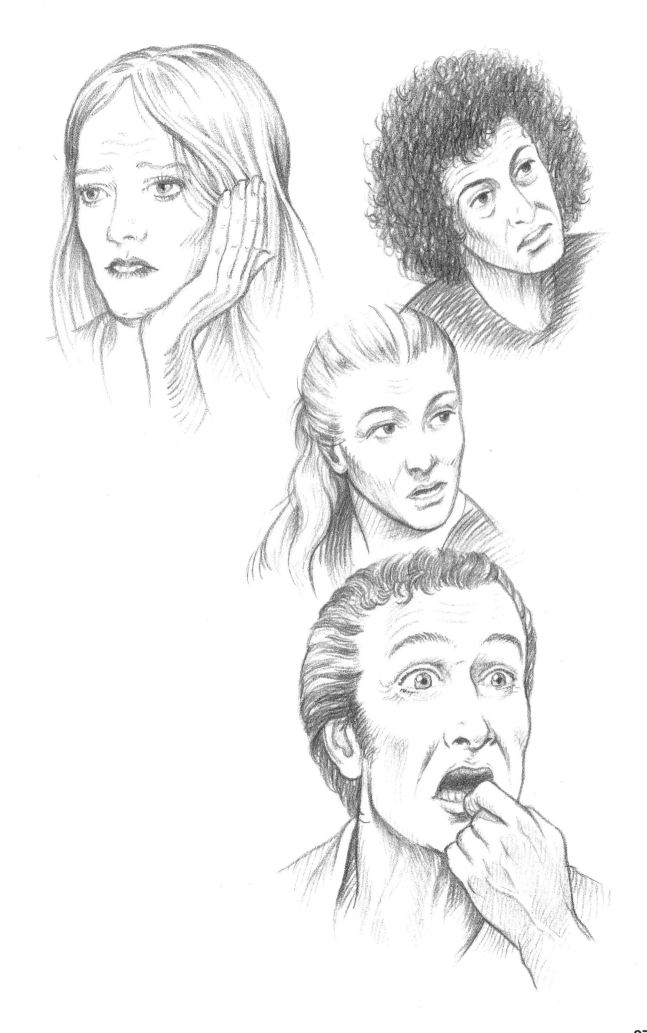

Fear/Terror

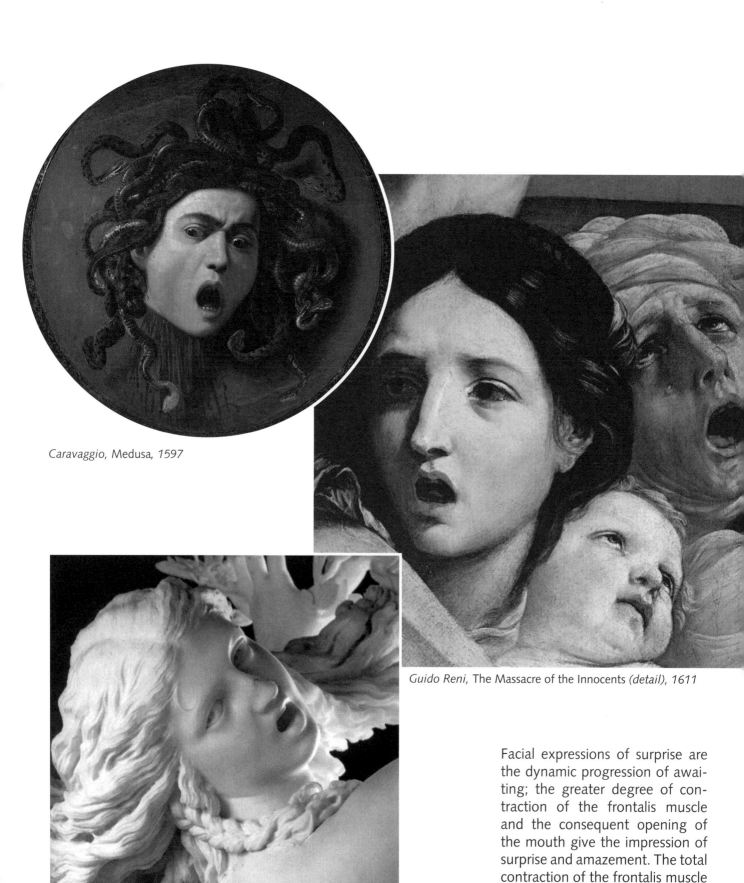

Caravaggio, Medusa, 1597

Guido Reni, The Massacre of the Innocents (detail), 1611

Gian Lorenzo Bernini, Apollo and Daphne (detail), 1622-25

Facial expressions of surprise are the dynamic progression of awaiting; the greater degree of contraction of the frontalis muscle and the consequent opening of the mouth give the impression of surprise and amazement. The total contraction of the frontalis muscle and the constriction of the nostrils then produce the impression of fear and terror. In moments of intense fright, the face becomes pale and the hair stands on end.

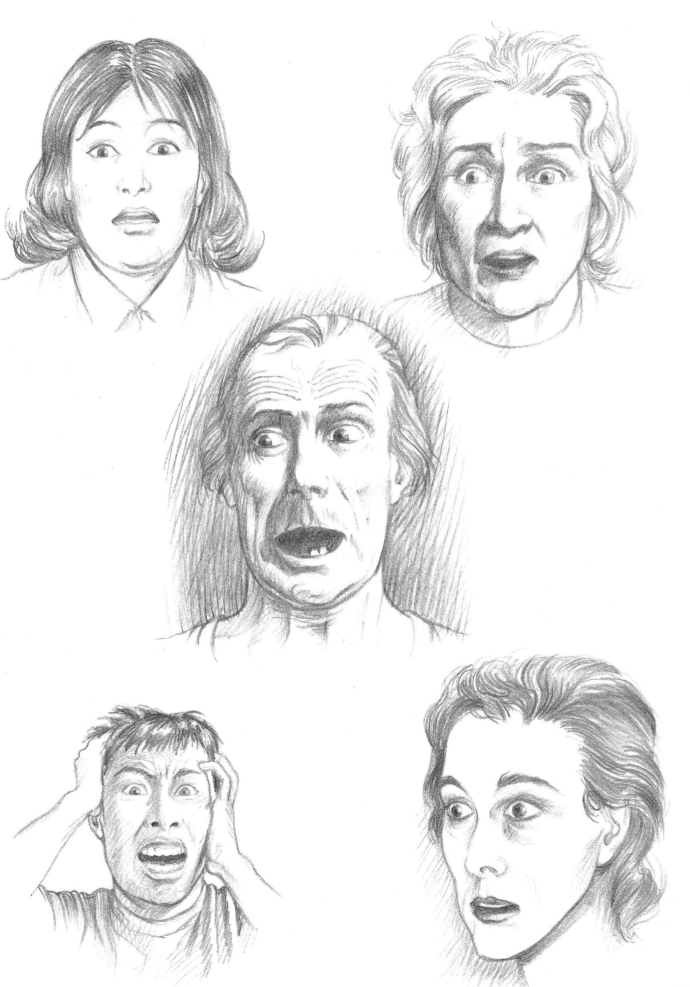

In addition to being the preferred system of indicating emotions and interpersonal attitudes, the face transmits information related to mental processes (concentration, uncertainty) and participates significantly in the production of conversational signals.

This practice is called "paralinguistic" and is used to maintain constant contact with the person being spoken to. We continuously engage in these gestures, whose meaning varies according to the conversational context or the culture one belongs to, which involve not just the face, but also other parts of the body.

This category also includes those expressions which are generically called grimaces. In addition to emotional expressions, Paul Ekman and Wallace Friesen divided paralinguistic gestures into four other categories: **Emblems**, which are always voluntary, make up or modify the sense of the discussion (for example, raising one's eyebrows may express doubt, the wink of an eye expresses understanding and complicity, puffing and looking upward means "I can't stand you").

Illustrators, which are often voluntary, used to underline part of the discussion or which serve to indicate a position in space (for exam-

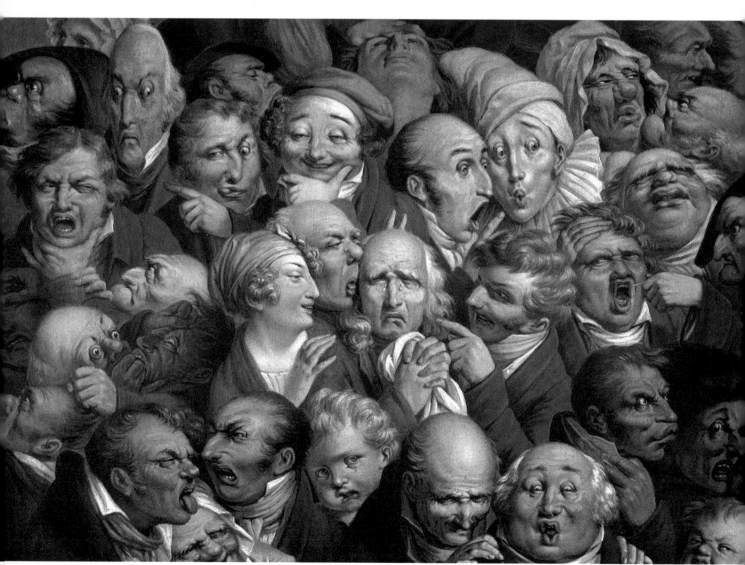

Louis-Léopold Boilly, Thirty-six Faces of Expression, *1822*

ple, eyebrows raised in the centre reinforce an unpleasant message, or a rotation of the gaze and a nod of the head indicate a person or location).

Regulators keep the communication lively in absence of verbal expression, alternating with words during pauses (for example, we nod with our head or raise the eyebrows to invite the other person who is talking to continue, or we open our mouth, as if we would like to talk to interrupt him/her).

Adaptors are the most ambiguous of the gestures. Within commu-nication, they occupy a marginal significance, often casual and irrel-evant to the context (biting one's lips or moistening them continu-ously with the tongue, closing the eyes tight or clenching one's jaw). The expressive importance of the face increases, hand in hand, with the species' phylogenetic develop-ment. It seems logical to say that facial expression is much more de-veloped among species which live in permanent communities and for whom that development has an adaptive function for social inter-action.

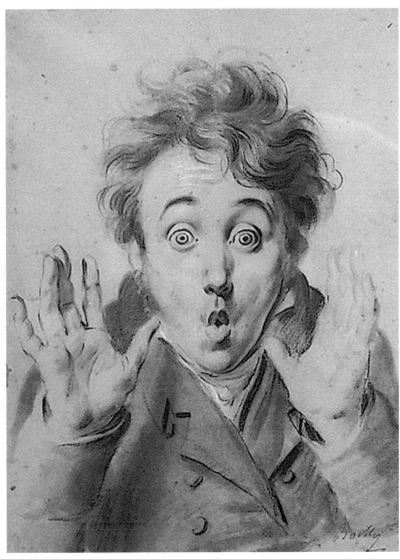
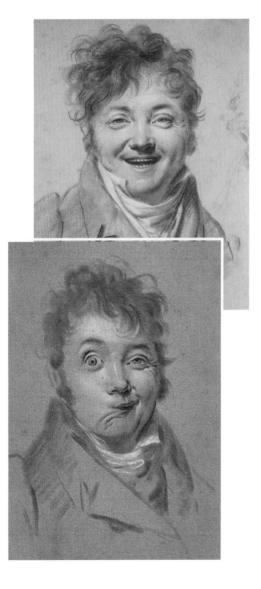

A few self-portraits by Louis-Léopold Boilly

Vexation

Wrath is the visual manifestation of puzzlement, concentration and mental effort. It's the typical manifestation of the activity of thinking intensely. The absolute star of this expression is the corrugator supercilii which is linked to the frontalis and the procerus. At times even the depressor anguli oris and the depressor labii inferioris participate in the expression, furrowing and lifting the chin.

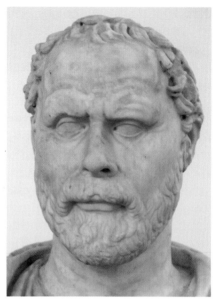

Polyeuktos, Demosthenes, *3rd century BC (Roman copy from the 2nd century AD)*

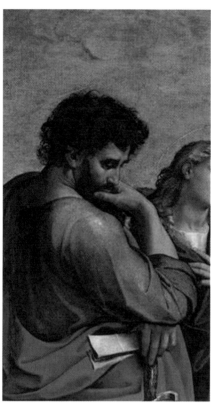

Raphael, Ecstasy of Saint Cecilia *(detail)*, *1514-16*

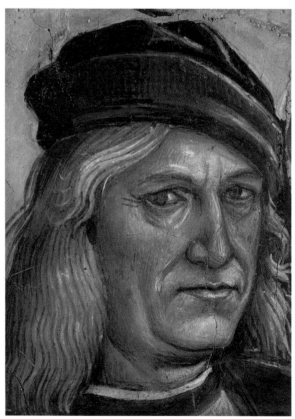

Luca Signorelli, Self-Portrait in the chapel of San Brizio in the Duomo of Orvieto, *1499-1502*

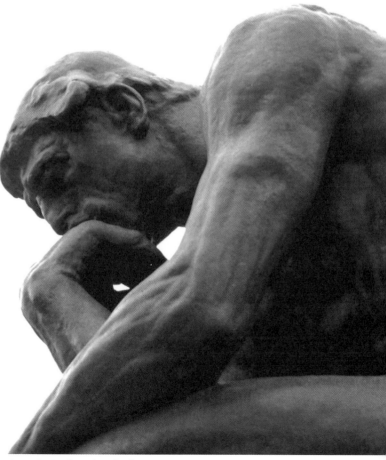

Auguste Rodin, The Thinker, *1880*

Pleasure/Wellbeing

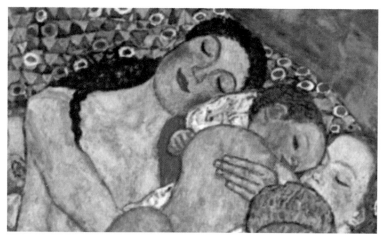

Gustav Klimt, Death and Life *(detail), 1908-15*

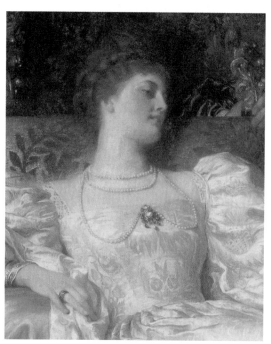

Sir Frank Dicksee, An Offering *(detail), 1898*

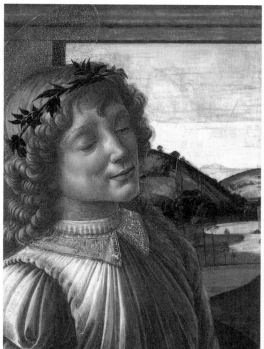

Sandro Botticelli, Madonna and
Child with an Angel, *c. 1470*

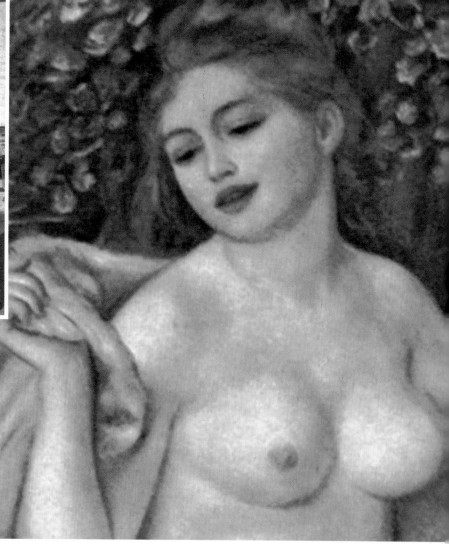

Pierre-Auguste Renoir, The Bathers *(detail),1887*

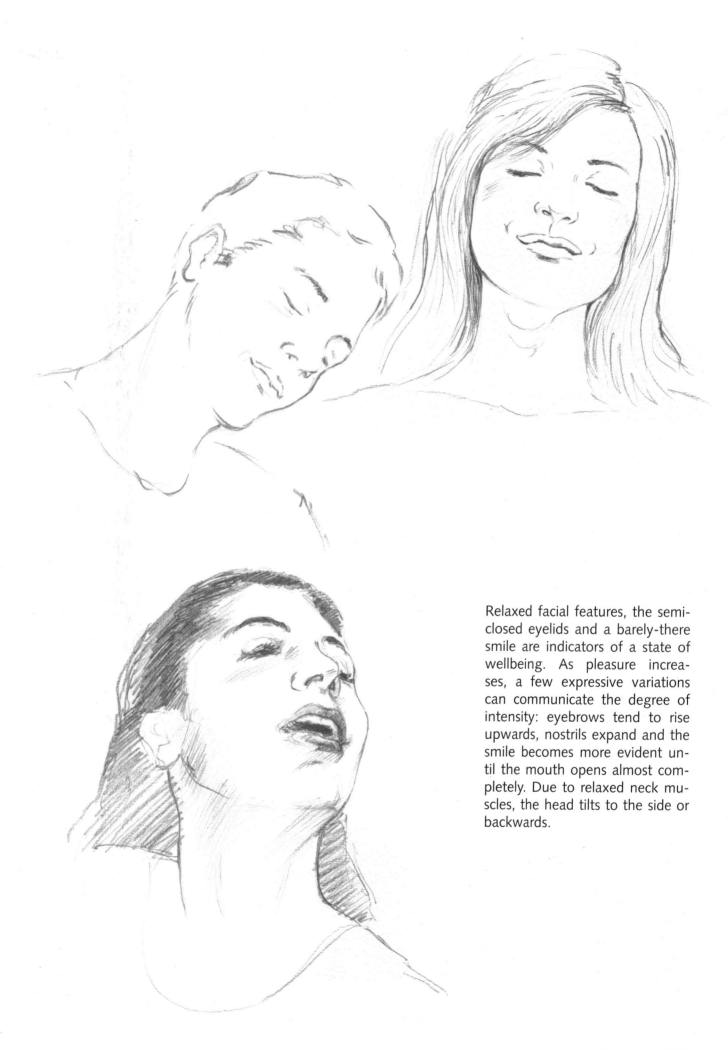

Relaxed facial features, the semi-closed eyelids and a barely-there smile are indicators of a state of wellbeing. As pleasure increases, a few expressive variations can communicate the degree of intensity: eyebrows tend to rise upwards, nostrils expand and the smile becomes more evident until the mouth opens almost completely. Due to relaxed neck muscles, the head tilts to the side or backwards.

Pride

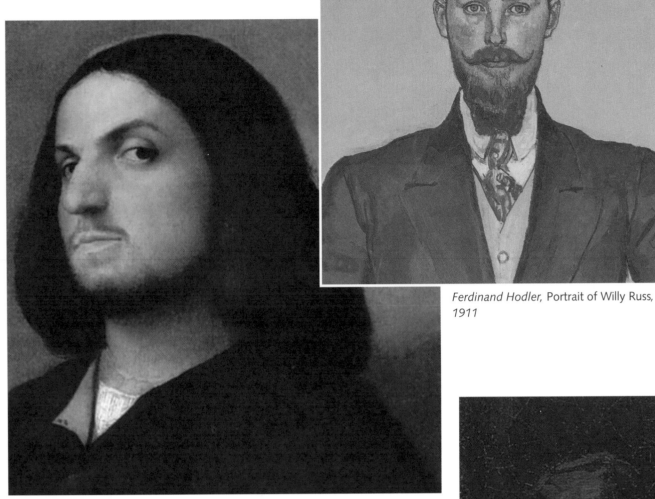

Ferdinand Hodler, Portrait of Willy Russ, *1911*

Giorgione, Portrait of a Venetian Gentleman, *c. 1510*

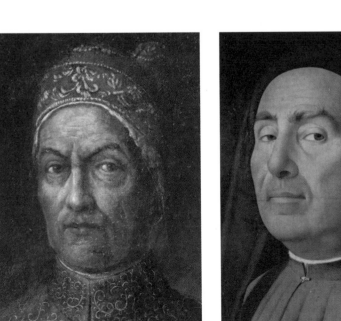

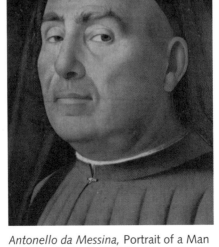

Fra' Galgario (born Vittore Ghislandi) attr., Portrait of a Doge, *1743*

Antonello da Messina, Portrait of a Man (Trivulzio Portrait), *1476*

Honoré Daumier, Two Lawyers *(detail)*, *1848*

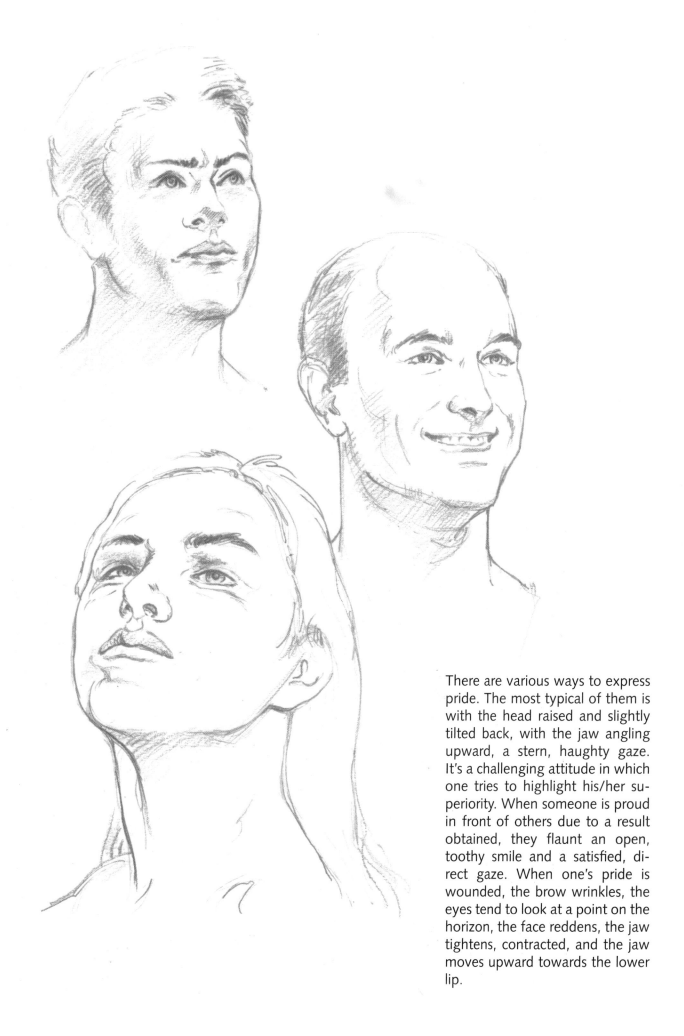

There are various ways to express pride. The most typical of them is with the head raised and slightly tilted back, with the jaw angling upward, a stern, haughty gaze. It's a challenging attitude in which one tries to highlight his/her superiority. When someone is proud in front of others due to a result obtained, they flaunt an open, toothy smile and a satisfied, direct gaze. When one's pride is wounded, the brow wrinkles, the eyes tend to look at a point on the horizon, the face reddens, the jaw tightens, contracted, and the jaw moves upward towards the lower lip.

Uncertainty

That which most characterises un-
certainty and doubt is the asym-
metry of the expression. The face
mirrors inner hesitation, so the
mouth wrinkles and moves to the
side with the corners at different
heights, the mouth's closure line
becomes even more undulating,
the eyes open differently, with
one eyebrow raised and the other
lowered, and the gaze is often tur-
ned upwards or to the side.

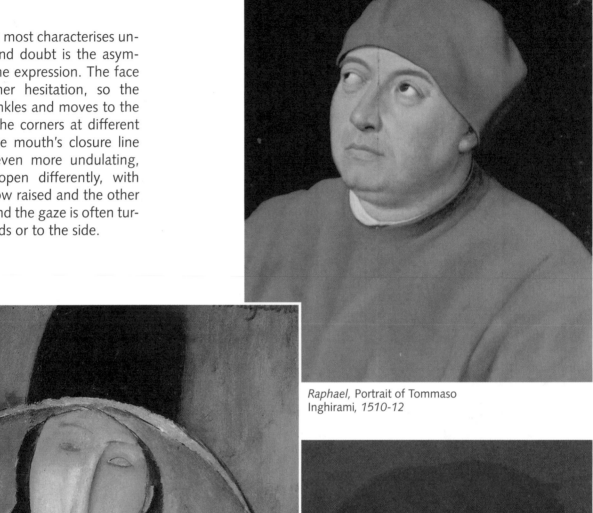

Raphael, Portrait of Tommaso
Inghirami, *1510-12*

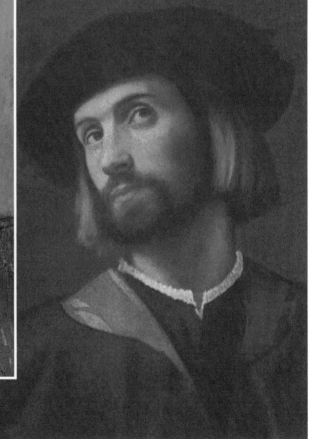

Amedeo Modigliani, Portrait of Jeanne
Hébuterne in a Large Hat, *1917*

Lorenzo Lotto, Portrait of a Man, c. *1520*

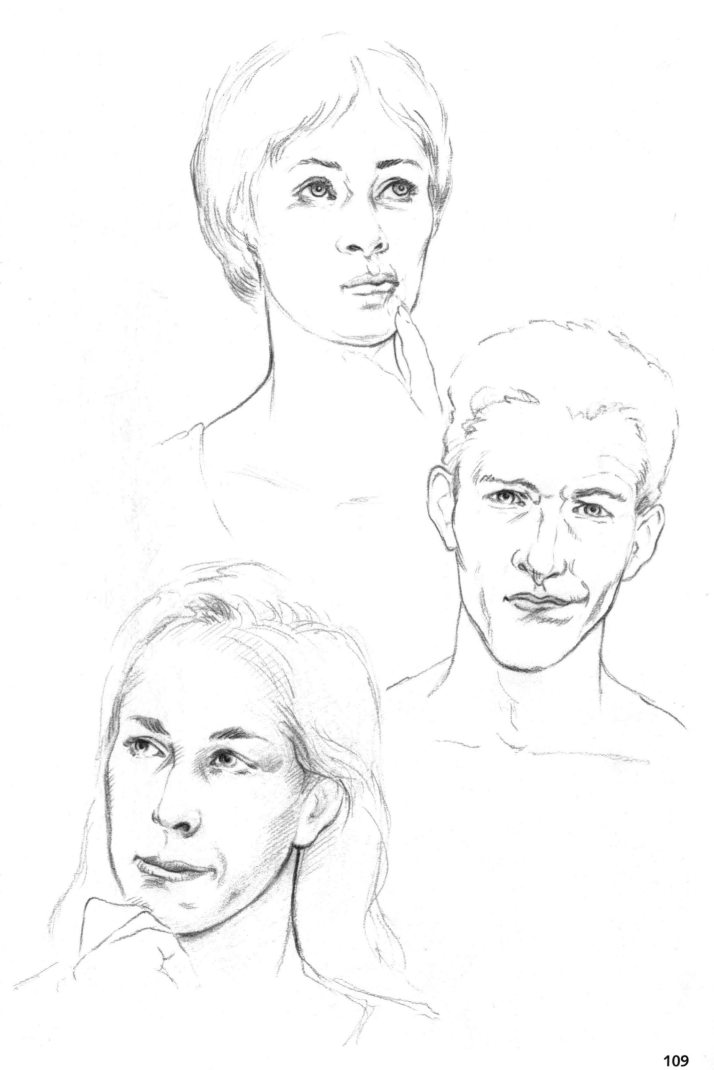

Embarrassment

Embarrassment is generally expressed by blushing of the cheeks, which can be rather intense, and through the contraction of the muscles of the mouth. These muscles create an asymmetrical, forced grin which is an attempt to garner the observer's favour. The gaze becomes bewildered and naive and it becomes difficult to look at the other person directly. When the sense of shame intensifies, people often raise a hand to cover the face (partially or entirely), as if trying to conceal the emotions which s/he is feeling.

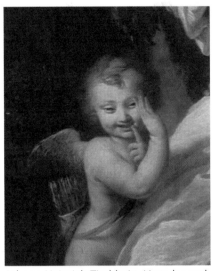

Johann Heinrich Tischbein, Hercules and Omphale *(detail), 1754*

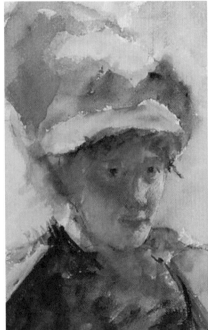

Mary Stevenson Cassatt, Self-Portrait *(detail), c. 1880*

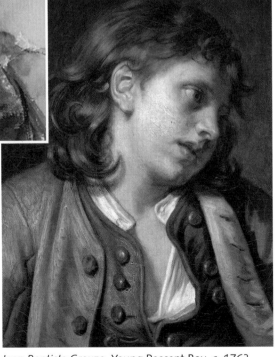

Jean Baptiste Greuze, Young Peasant Boy, *c. 1763*

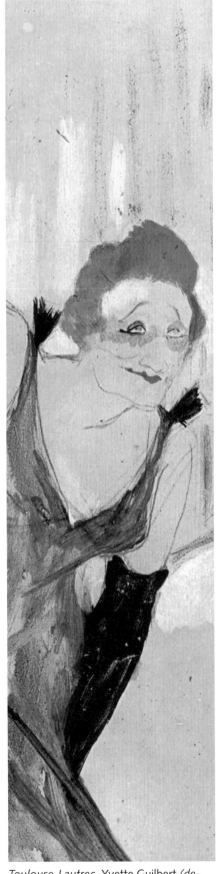

Toulouse-Lautrec, Yvette Guilbert *(detail), 1894*

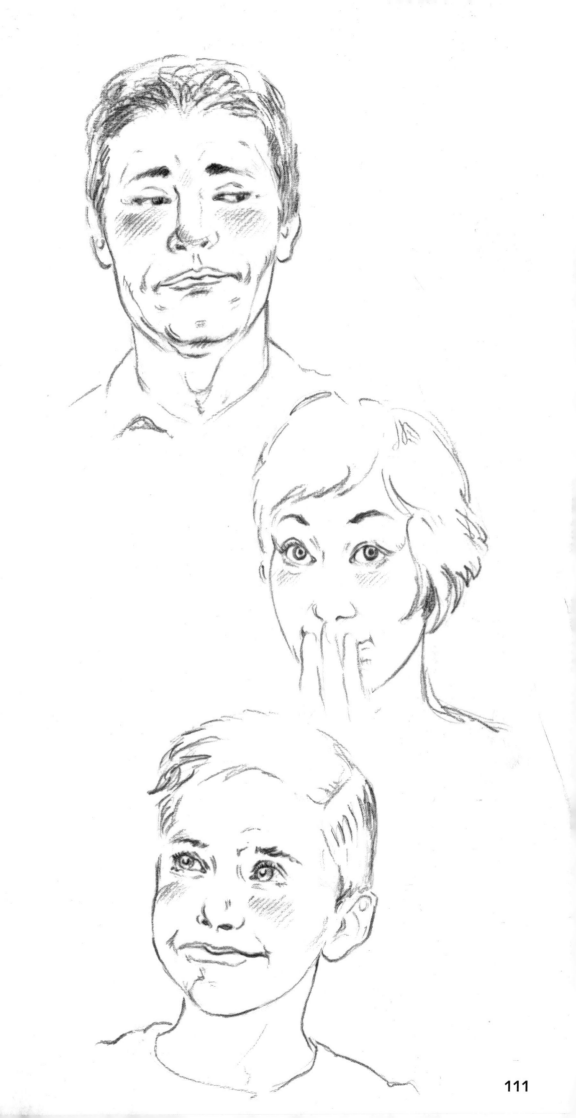

Jealousy/Envy

Jean-Auguste-Dominique Ingres, Paolo and Francesca, *1819*

Thèodore Géricault, Insane Woman (Woman Alienated by Envy), *1822-23*

Henri de Toulouse-Lautrec, In the Restaurant La Mie, *1891*

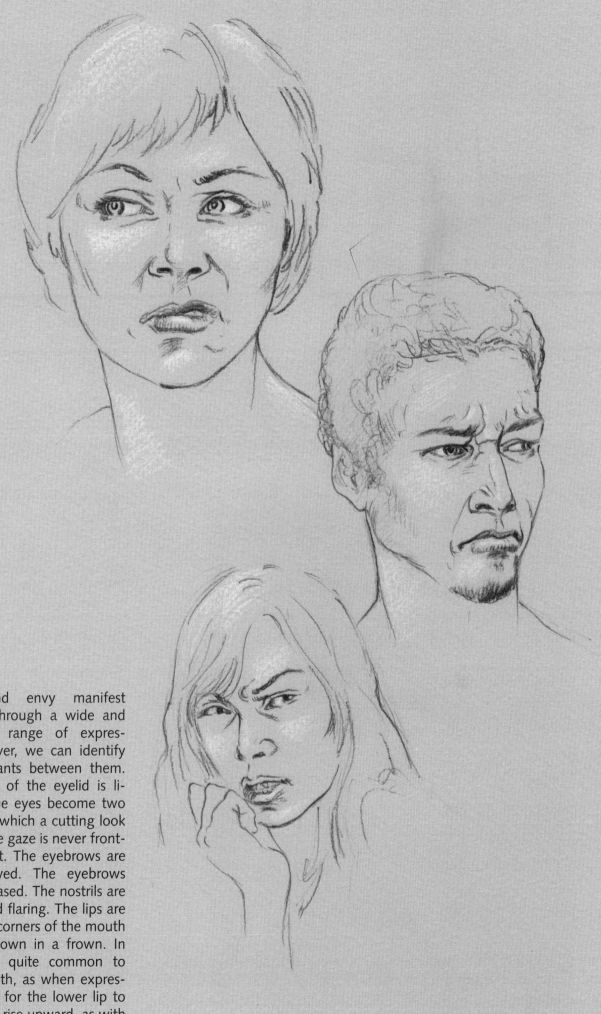

Jealousy and envy manifest themselves through a wide and controversial range of expressions. However, we can identify a few constants between them. The opening of the eyelid is limited and the eyes become two slits through which a cutting look darts out. The gaze is never front-on and direct. The eyebrows are often furrowed. The eyebrows are often creased. The nostrils are quivering and flaring. The lips are stiff and the corners of the mouth are turned down in a frown. In addition, it's quite common to grind the teeth, as when expressing hate, or for the lower lip to protrude and rise upward, as with disgust.

113

Guilt

Caravaggio, Penitent Magdalene *(detail),*
1594-95

Sandro Botticelli, Pallas and the Centaur *(detail), c. 1482-85*

Artemisia Gentileschi, Penitent Magdalene, *1630*

Sadness, vexation and embarrassment all seem to factor in to a sense of guilt. We thus have a variety of expressions which include the following characteristics consistently: a furrowed brow with eyebrows raised eyebrows in their centres, wet, often closed eyes, lowered corners of the mouth, the head slightly tilted forward.

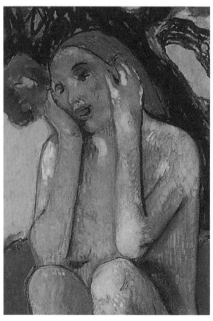

Paul Gauguin, Breton Eve, *1889*

Disapproval/Contempt

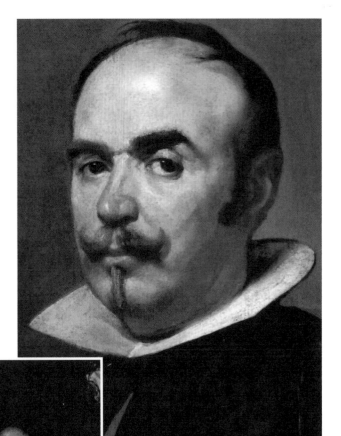

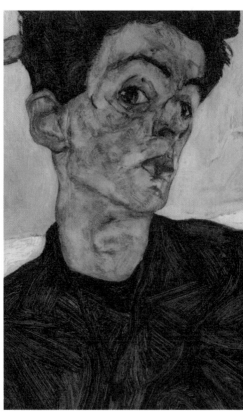

Egon Schiele, Self-Portrait with Physalis *(detail), 1912*

Diego Velázquez, Don Pedro de Barberana y Aparregui, *c. 1631*

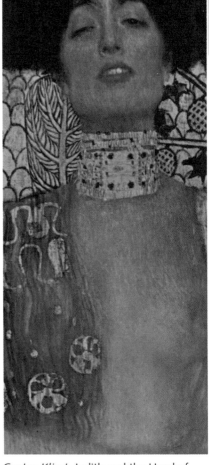

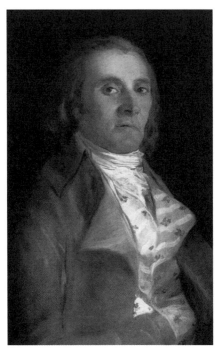

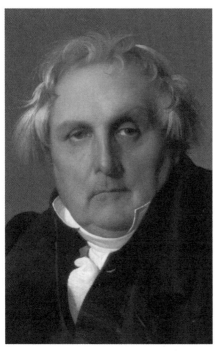

Gustav Klimt, Judith and the Head of Holofernes *(detail), 1901*

Francisco Goya, Portrait of Don Andres Del Peral, *1798*

Jean-Auguste-Dominique Ingres, Portrait of Monsieur Bertin, *1832*

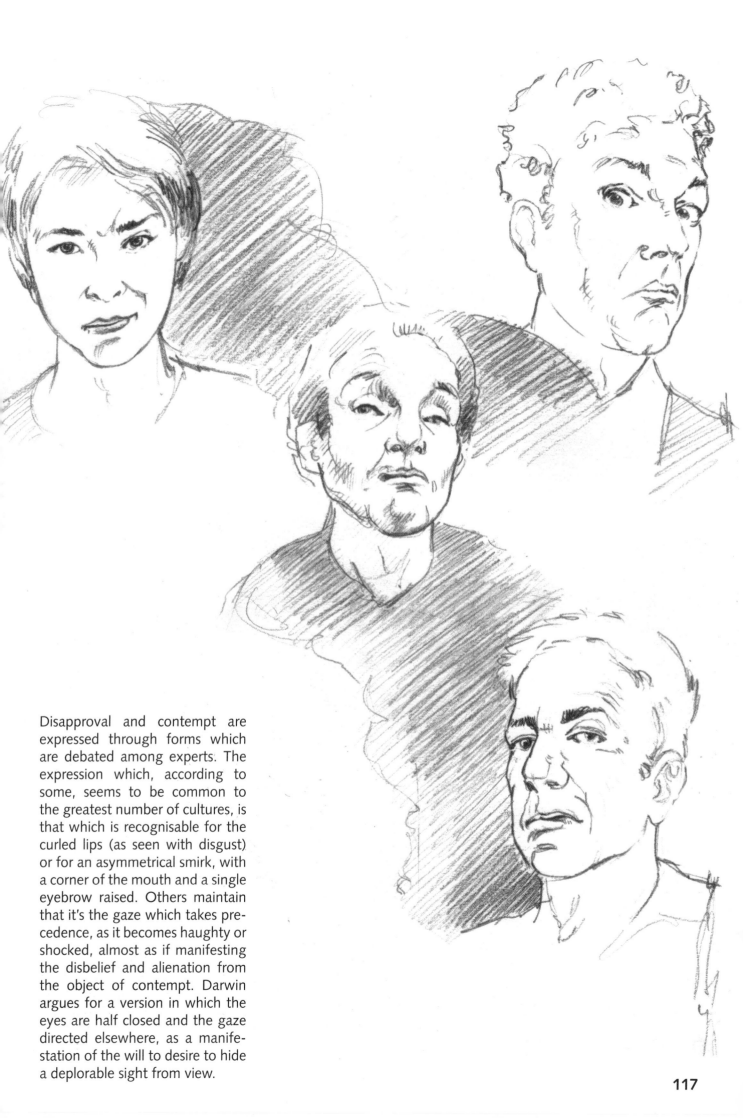

Disapproval and contempt are expressed through forms which are debated among experts. The expression which, according to some, seems to be common to the greatest number of cultures, is that which is recognisable for the curled lips (as seen with disgust) or for an asymmetrical smirk, with a corner of the mouth and a single eyebrow raised. Others maintain that it's the gaze which takes precedence, as it becomes haughty or shocked, almost as if manifesting the disbelief and alienation from the object of contempt. Darwin argues for a version in which the eyes are half closed and the gaze directed elsewhere, as a manifestation of the will to desire to hide a deplorable sight from view.

Disbelief/Scepticism

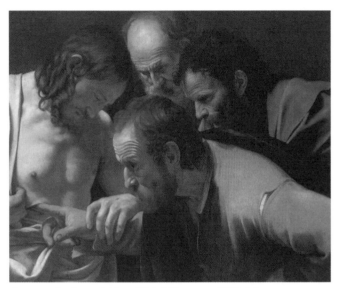

Caravaggio, Incredulity of Saint Thomas, *1600-01*

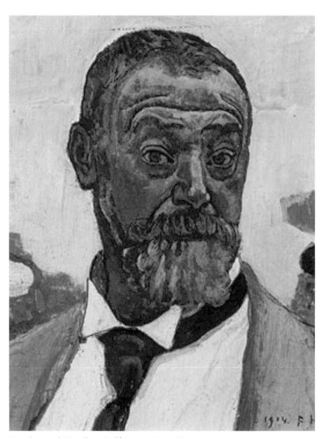

Ferdinand Hodler, Self-Portrait, *1914*

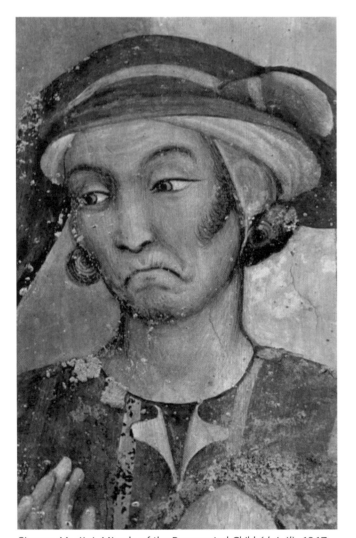

Simone Martini, Miracle of the Resurrected Child *(detail), 1317*

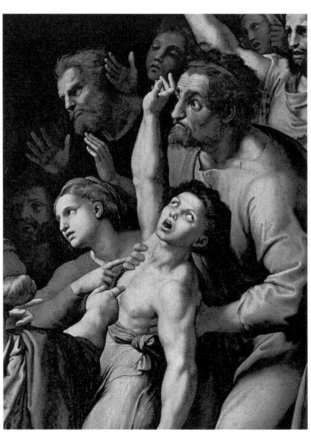

Raphael, The Transfiguration *(detail), 1518-20*

The face of disbelief and scepticism substitutes sentences such as "I have no clue what you are talking about", "I don't believe you", and "I can't believe my eyes". It's an intentional expression which belongs to the sphere of emblematic gestures. It is shown mainly through the raising of the eyebrows and the chin with a simultaneous frown, as with disgust.

Disbelief and scepticism are different in the positioning of the eyes: wide open, to express shock, dull and empty, to indicate diffidence and disdain.

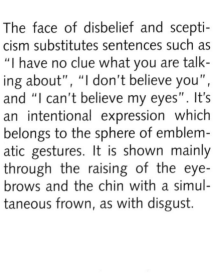

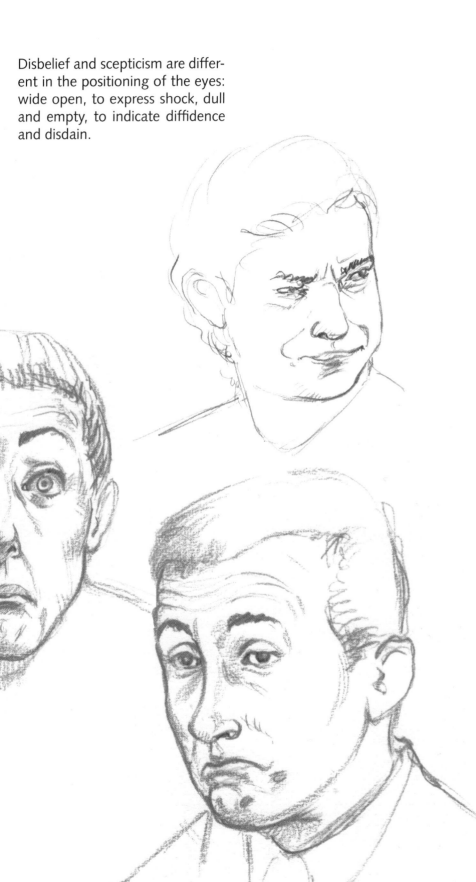

Expressive Grimaces

There is an almost unlimited variety of expressive grimaces. Many of them are closely tied to the culture in which they appear, or they have ambiguous meanings. On this and the following page, we offer a few of them, purely by way of example.

On subsequent pages, we'll cover more in detail those which, often responding to physiological functions, do not express emotions or states of mind but rather actions (coughing, blowing, kissing, etc.).

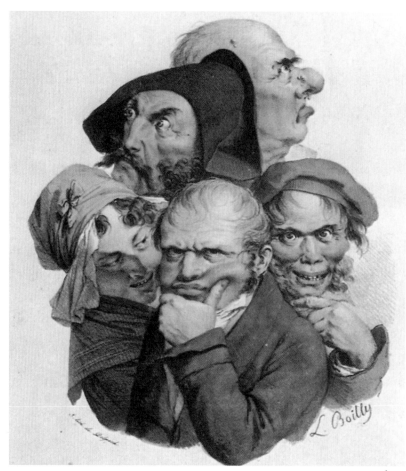

Louis-Léopold Boilly, The Grimaces, *1824-1825*

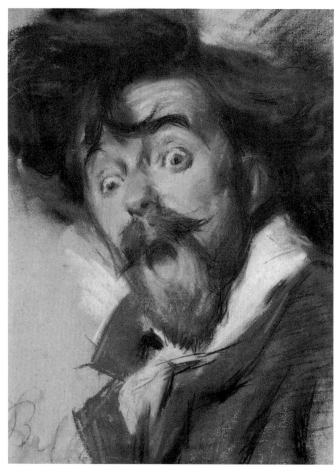

Giacomo Balla, Autosmorfia (Self-Portrait), *1900*

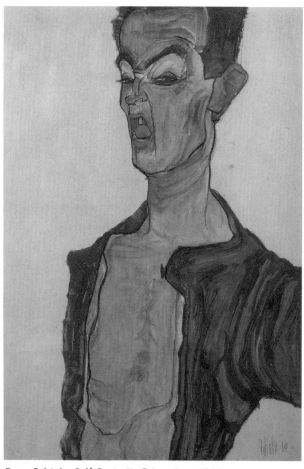

Egon Schiele, Self-Portrait, Grimacing, *1910*

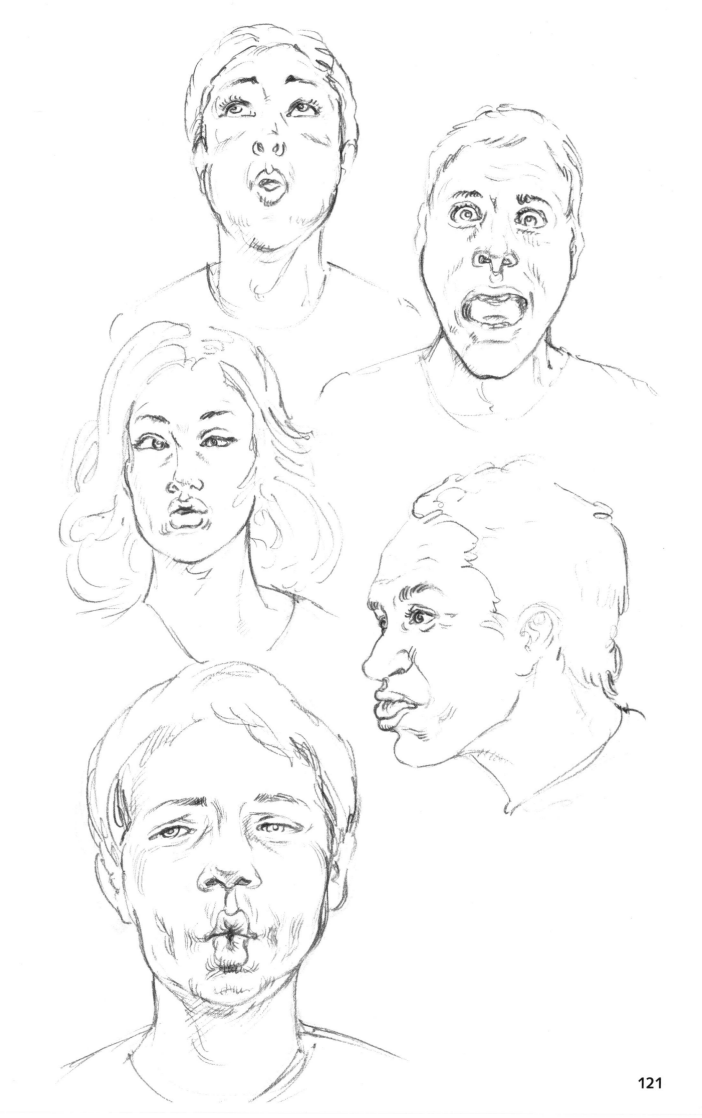

Expressive Grimaces

Along with expressions which *emphasize* an argument or which reinforce an emotional state, there are others still which are entirely involuntary and which often are inconsistent with the context. A few attitudes (sticking out one's tongues, making funny eyes, etc.) have a purely playful purpose.

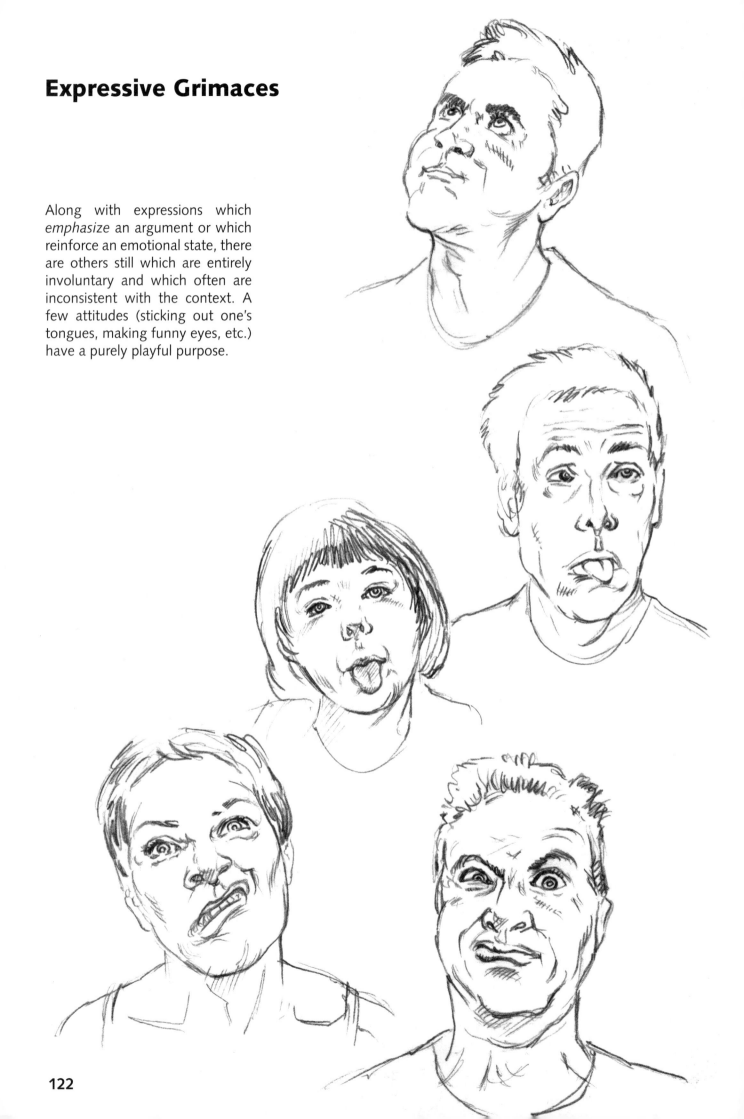

Coughing/ Sneezing

Coughing and sneezing are actions, response to purely physiological stimulations, in which facial muscles undergo considerable transformations.

Both situations are characterised, in their culminating phase, by the violent contraction and closure of the eyelids, of the wrinkling of the eyebrows and the nose, and by the greater or lesser opening of the mouth. When coughing, the lower lip becomes more prominent, partially caused by the pressure of the tongue and the under part of the throat becomes hidden in part of the jaw. Sneezing is characterized by a preparatory phase in which the eyebrows rise and the forehead generates wrinkles which curve upward. As a consequence of coughing or sneezing, the eyes tear up.

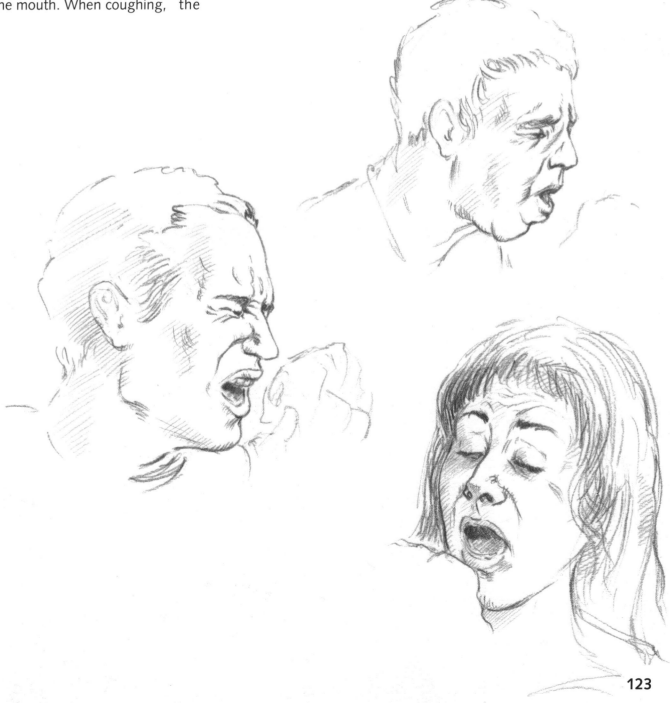

Blowing

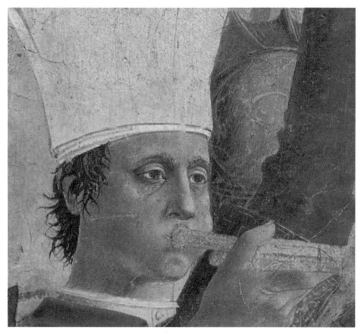

Piero della Francesca, The Battle of Heraclius and Chosroes *(detail)*, *1452-66*

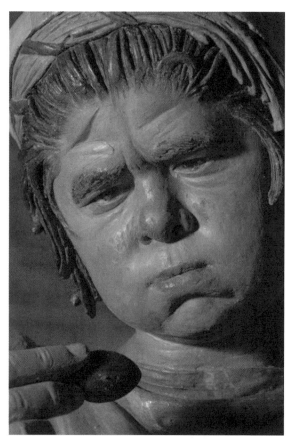

Guido Mazzoni, Nativity (Madonna della Pappa), *1480*

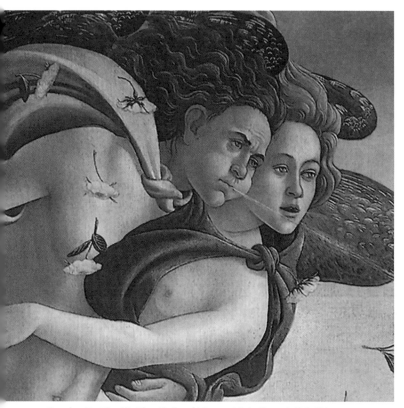

Sandro Botticelli, The Birth of Venus *(detail)*, *c. 1482-85*

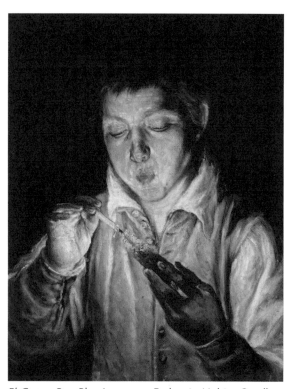

El Greco, Boy Blowing on an Ember to Light a Candle, *1575*

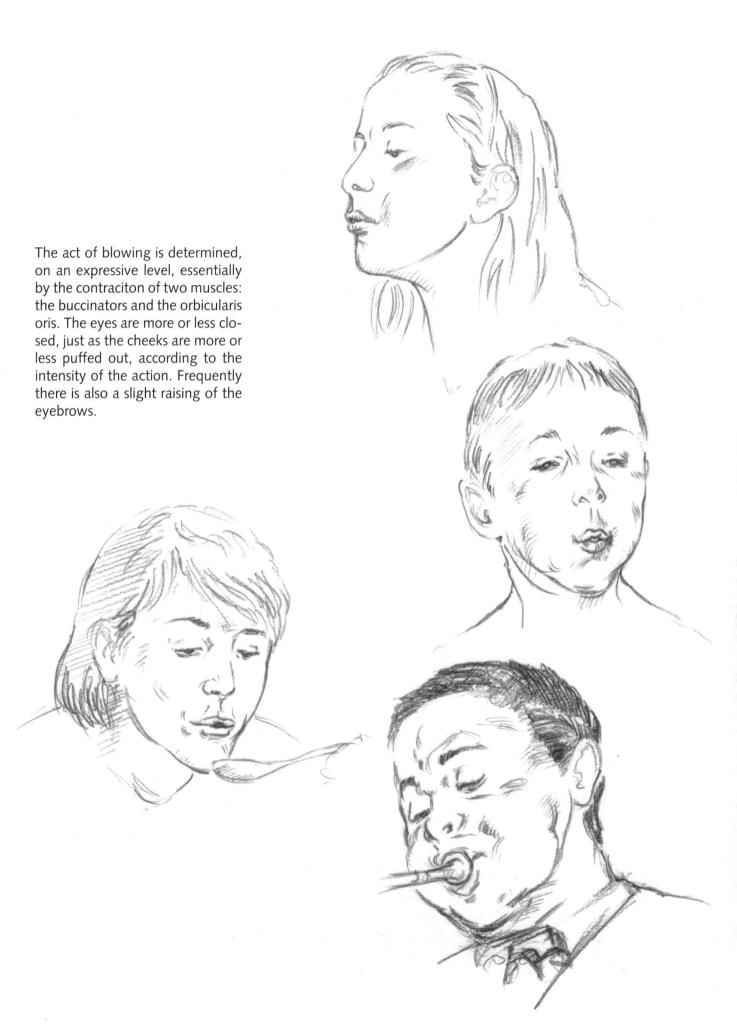

The act of blowing is determined, on an expressive level, essentially by the contraciton of two muscles: the buccinators and the orbicularis oris. The eyes are more or less closed, just as the cheeks are more or less puffed out, according to the intensity of the action. Frequently there is also a slight raising of the eyebrows.

125

Kissing

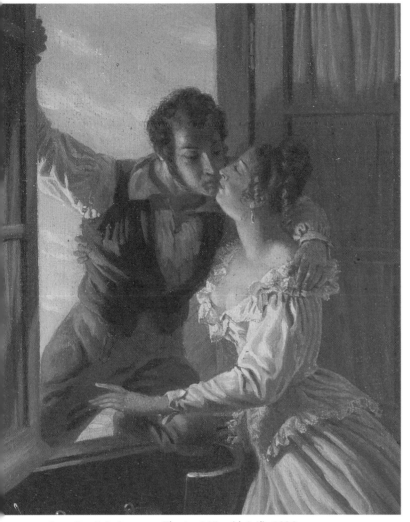

Jean Baptiste Lecoeur, The Last Kiss *(detail), 1820*

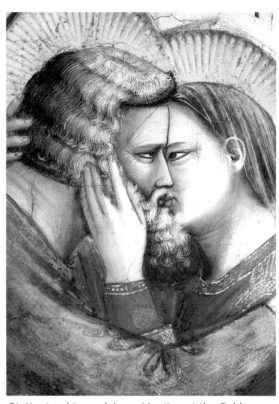

Giotto, Joachim and Anne Meeting at the Golden Gate *(detail), 1303-06*

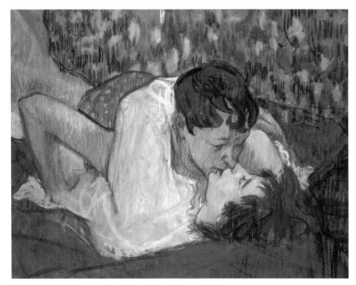

Henri de Toulouse-Lautrec, The Kiss, *1892*

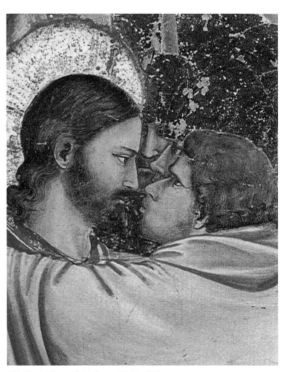

Giotto, Kiss of Judas, *1303-06*

The kiss is manifested by the contraction of the peripheral portion of the orbicularis oris. The slight raising of the eyebrows is an indication of serenity and sincerety, while the furrowing of the brow conveys duplicity or repulsion. The eyes are generally half-closed.

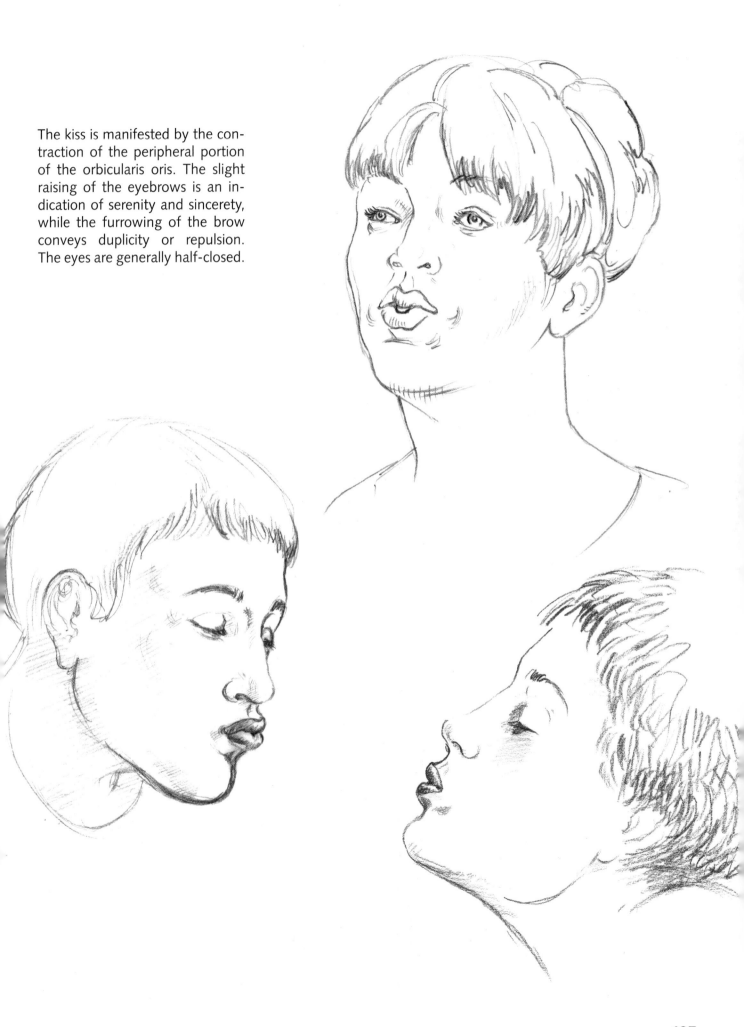

Physical Pain

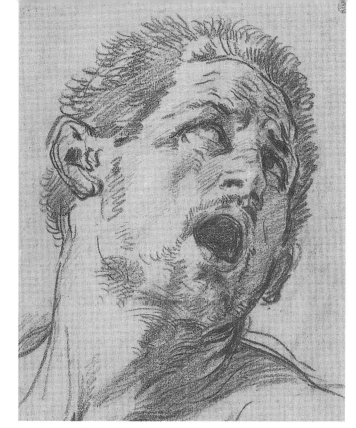

Guido Reni, The Head of Marsyas, *1618*

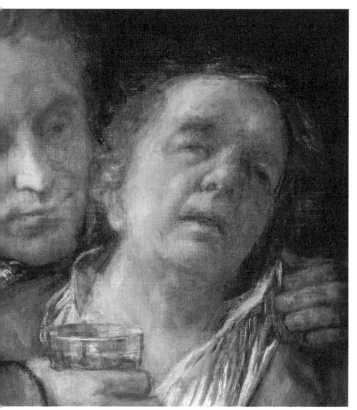

Francisco Goya, Self-Portrait with Dr Arrieta, 1820

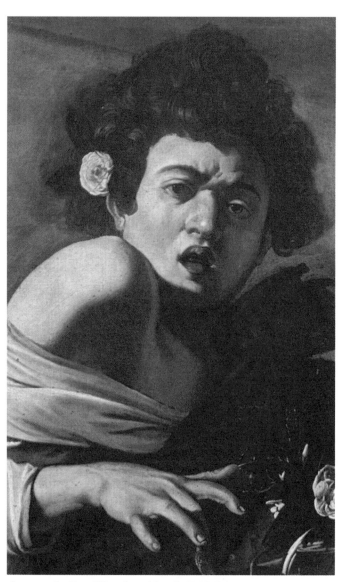

José de Ribera, Prometheus, c. 1630

Caravaggio, Boy Bitten by a Lizard, 1595-96

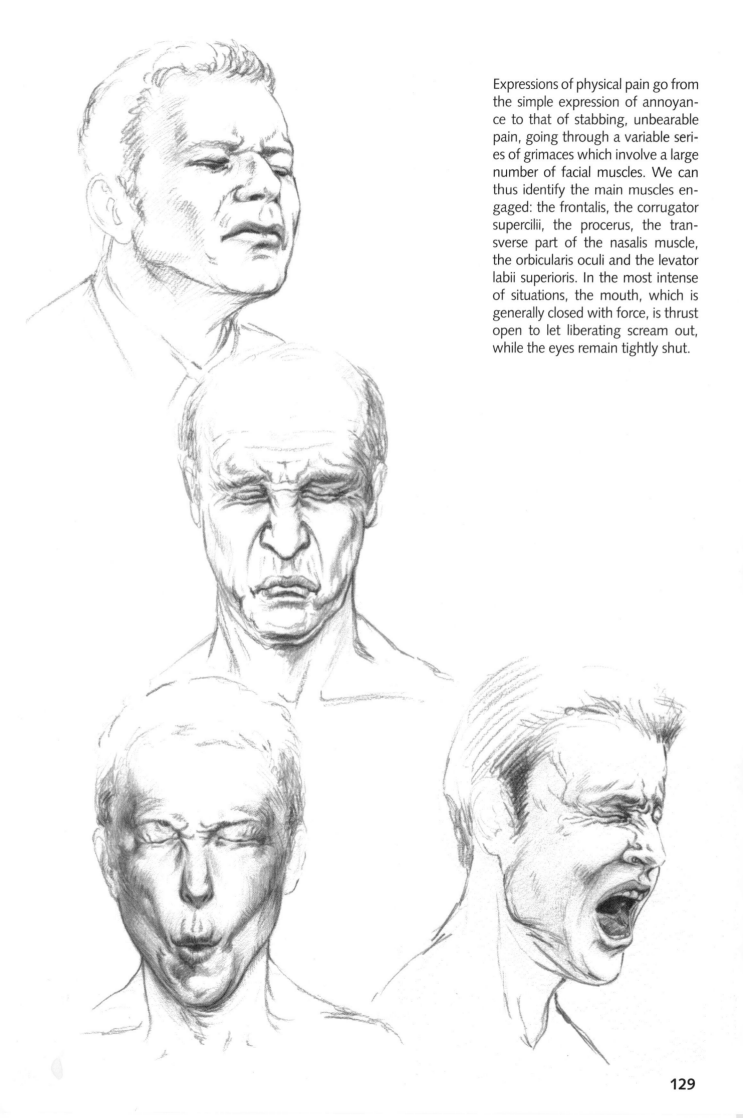

Expressions of physical pain go from the simple expression of annoyance to that of stabbing, unbearable pain, going through a variable series of grimaces which involve a large number of facial muscles. We can thus identify the main muscles engaged: the frontalis, the corrugator supercilii, the procerus, the transverse part of the nasalis muscle, the orbicularis oculi and the levator labii superioris. In the most intense of situations, the mouth, which is generally closed with force, is thrust open to let liberating scream out, while the eyes remain tightly shut.

Sleep/Death

In quiet sleep, the face's features are relaxed. The eyelids are, of course, closed, mostly by the drooping of the upper eyelid, following the relaxing of its levator muscle.

Unlike in sleep, in death muscles lose any sense of vital tone and are progressively released. The eyelids, shut or half-shut, moved closer together in a way that the lower lid rises upwards, lay idle and inert on the eyeballs sunken

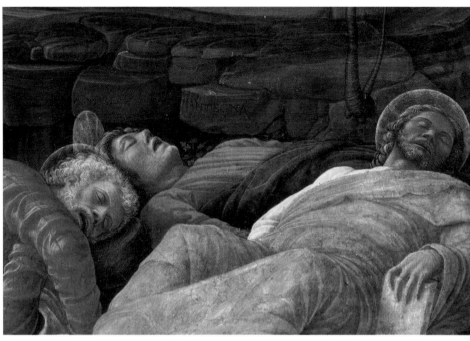

Andrea Mantegna, Agony in the Garden, *c. 1455*

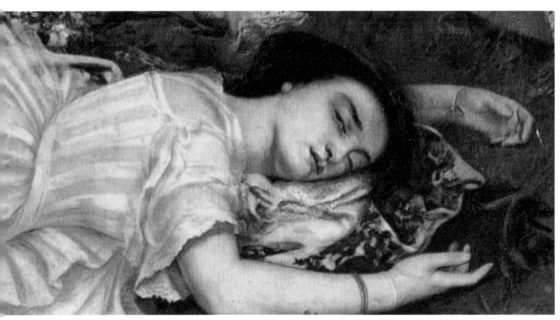

Gustave Courbet, Young Ladies on the Bank of the Seine, *1856/57*

in their sockets. Similarly, the relaxed muscles of the mouth cause the opening of the oral cavity.

For the same reason, this time in reference to the neck musculature, the head tilts backwards.

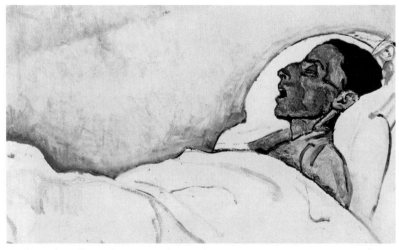

Ferdinand Hodler, Valentine Godè-Darel, *1915*

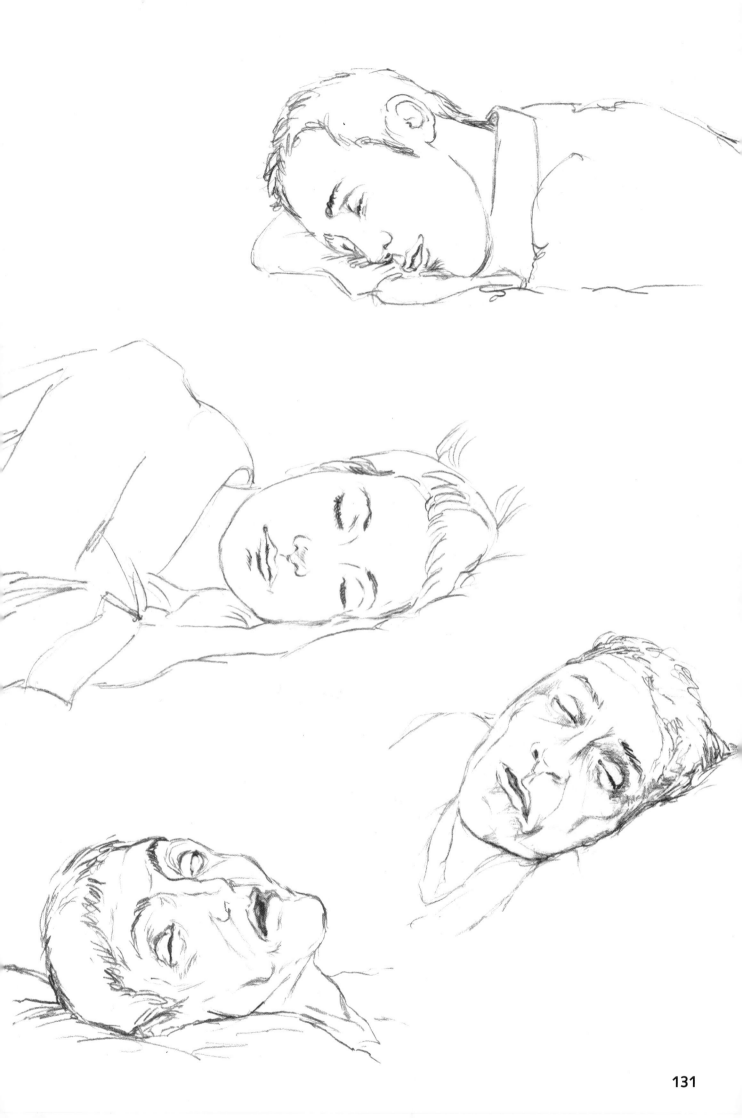

Expression of the Five Senses

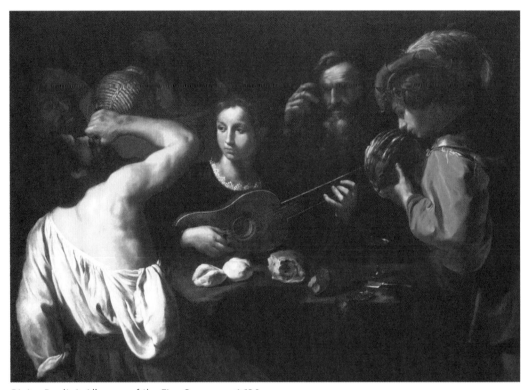

Pietro Paolini, Allegory of the Five Senses, *c. 1630*

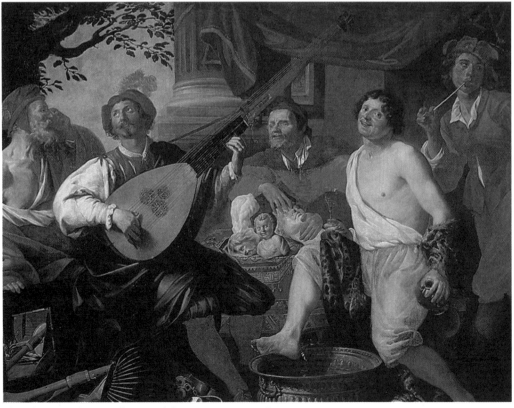

Theodoor Rombouts, Allegory of the Five Senses, *17th cen.*

The five senses are what allow us to connect with the world. According to the classification created by Aristotle, who defined them as different ways to perceive external reality, they're ranked as followed, according to degree of importance and refinement: sight, hearing, smell, taste and touch.

The actions put into place to communicate with the external world through our senses (eating, looking, caressing), just like the pure and simple reception of messages through our perceptive organs, give rise to a varied series of facial expressions. In the following pages, we'll present a few of the most emblematic ones.

Allegory of Hearing and Allegory of Sight: *two paintings by Jan Brueghel the Elder, 1617*

Looking

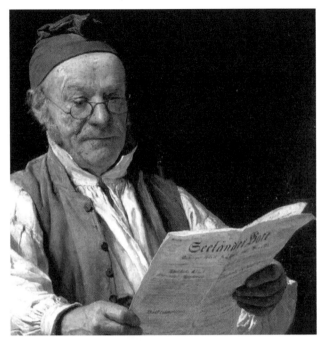

Albert Anker, Man Reading a Newspaper, *1878*

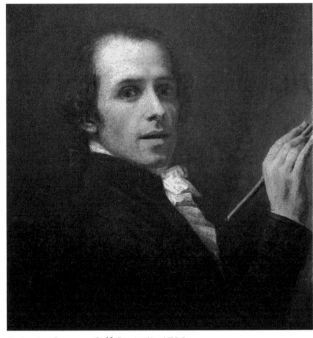

Antonio Canova, Self-Portrait, *1790*

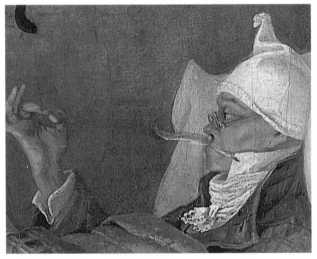

Carl Spitzweg, The Poor Poet, *1839*

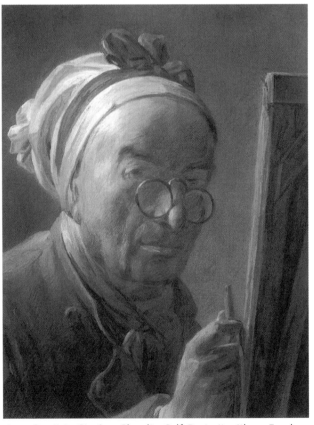

Jean-Baptiste-Siméon Chardin, Self-Portrait with an Easel, *1779*

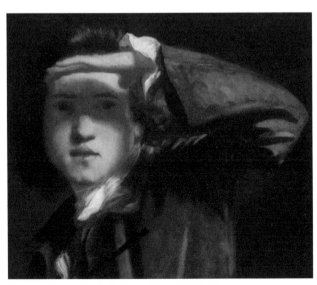

Joshua Reynolds, Self-Portrait, *c. 1747-49*

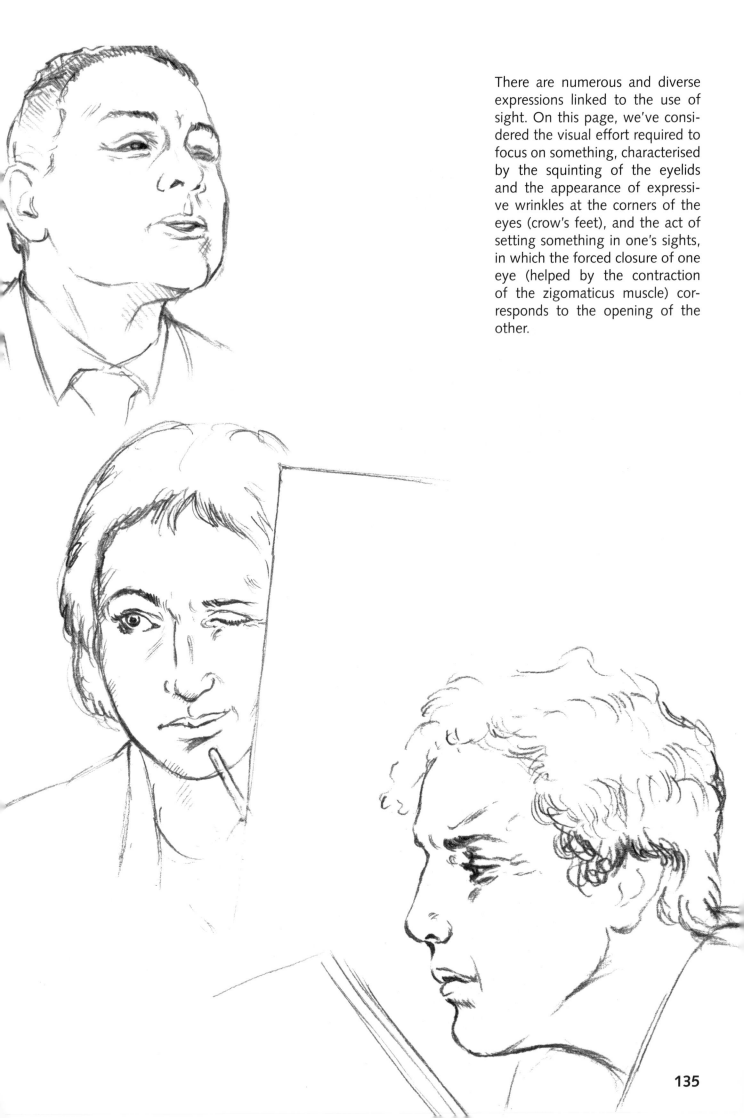

There are numerous and diverse expressions linked to the use of sight. On this page, we've considered the visual effort required to focus on something, characterised by the squinting of the eyelids and the appearance of expressive wrinkles at the corners of the eyes (crow's feet), and the act of setting something in one's sights, in which the forced closure of one eye (helped by the contraction of the zigomaticus muscle) corresponds to the opening of the other.

135

Listening

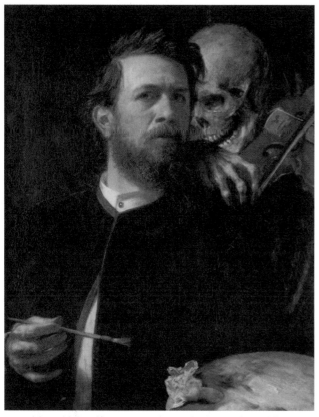

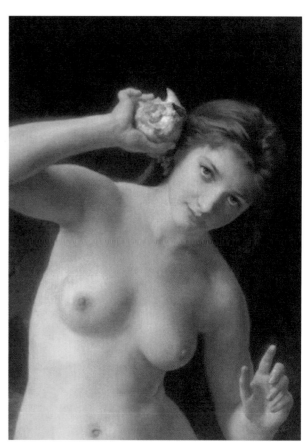

Adolphe William Bouguereau, Woman with Shell *(detail)*, *1885*

Arnold Böcklin, Self-Portrait with Death Playing the Fiddle, *1872*

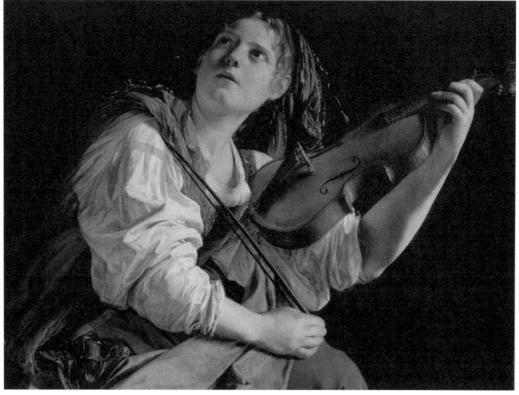

Orazio Gentileschi, Young Woman Playing a Violin (Saint Cecilia), *c. 1612*

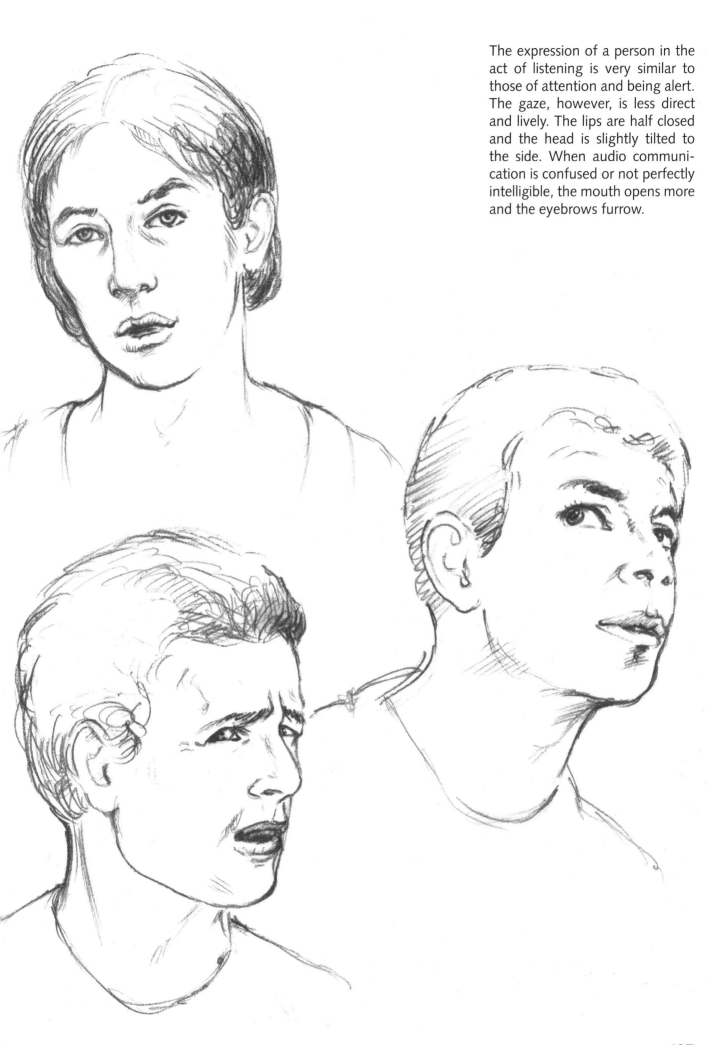

The expression of a person in the act of listening is very similar to those of attention and being alert. The gaze, however, is less direct and lively. The lips are half closed and the head is slightly tilted to the side. When audio communication is confused or not perfectly intelligible, the mouth opens more and the eyebrows furrow.

Smelling

The act of smelling is manifested, of course, through the dilation of the nostrils. The head juts outward towards the object of *olfactory exploration*. The eyes close and the forehead lifts. Any unpleasant sensations lead to a wrinkling of the nose through the contraction of the transverse part of the nasalis muscle.

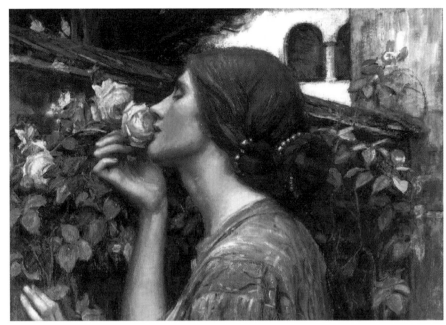

John William Waterhouse, The Soul of the Rose, *1908*

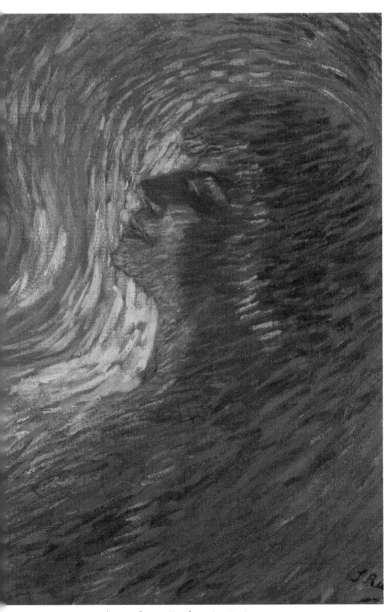

Luigi Russolo, Profumo (Perfume), *1910*

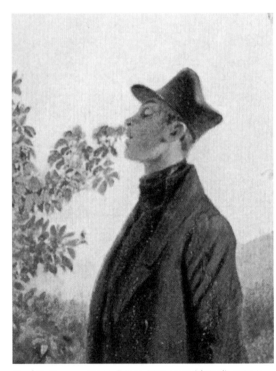

Carl Spitzweg, Rose Scent Memory *(detail), 1850*

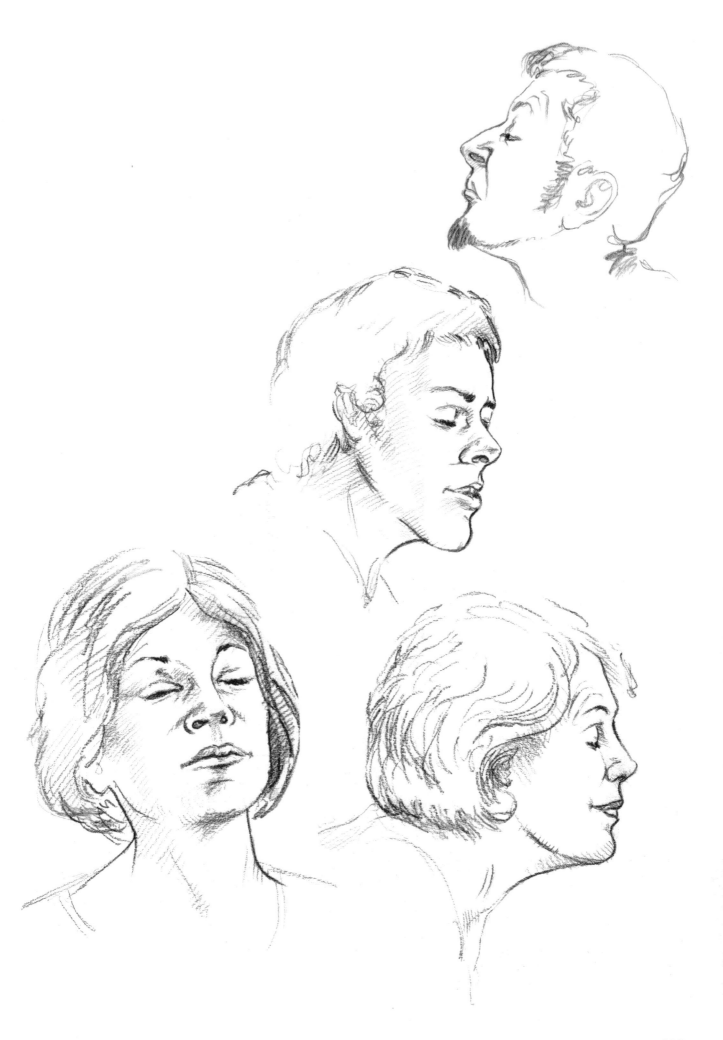

Tasting

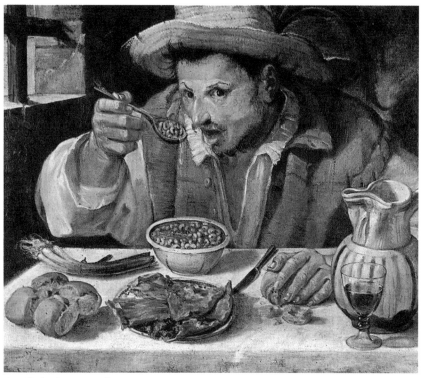

Peter Paul Rubens, Two Satyrs, *1618-19*

Annibale Carracci, The Bean Eater, *1583*

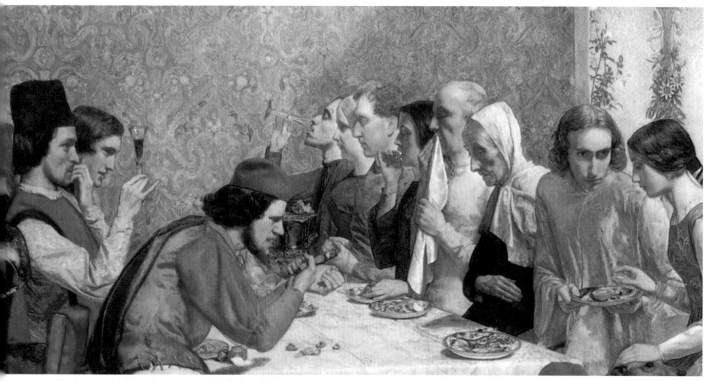

John Everett Millais, Lorenzo and Isabella, *1849*

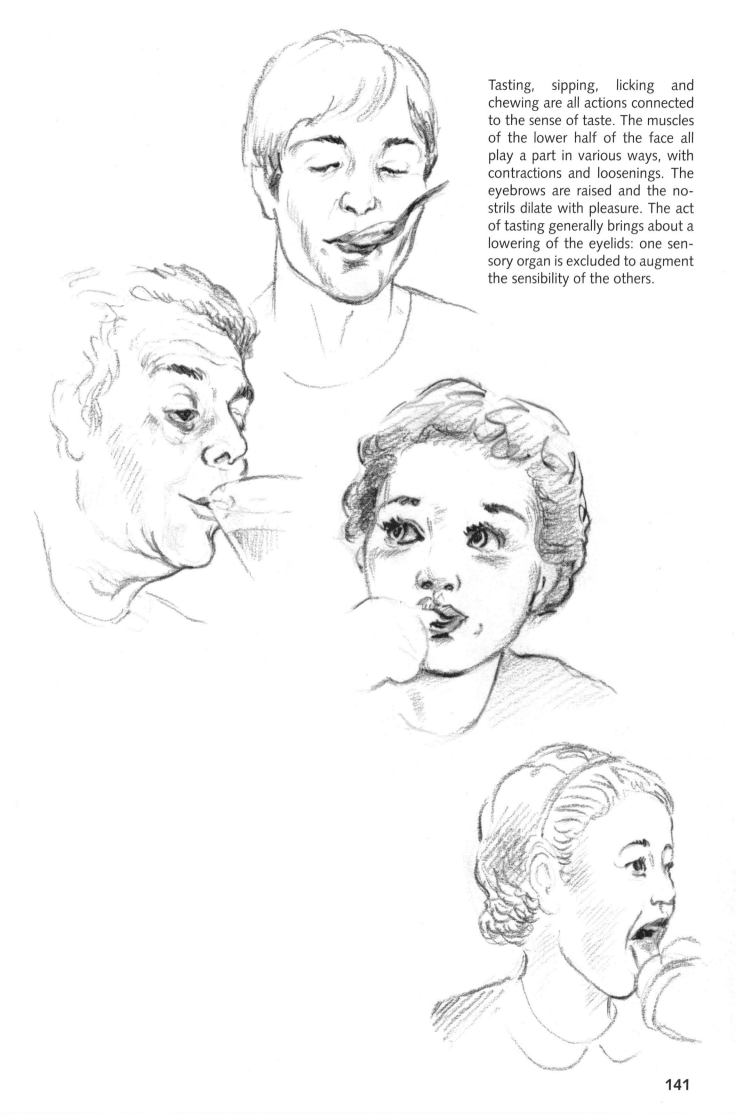

Tasting, sipping, licking and chewing are all actions connected to the sense of taste. The muscles of the lower half of the face all play a part in various ways, with contractions and loosenings. The eyebrows are raised and the nostrils dilate with pleasure. The act of tasting generally brings about a lowering of the eyelids: one sensory organ is excluded to augment the sensibility of the others.

Touching

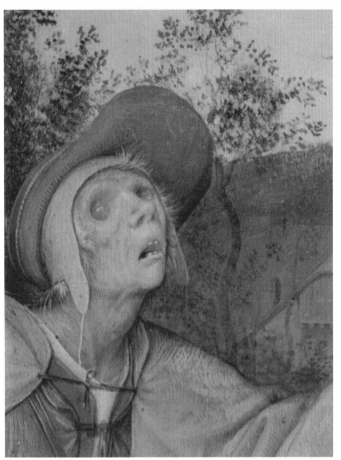

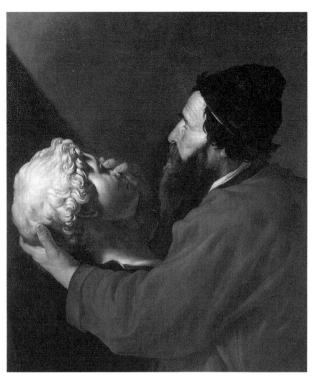

José de Ribera, The Sense of Touch, *1613-16*

Brueghel the Elder, The Parable of the Blind (*detail*), *1568*

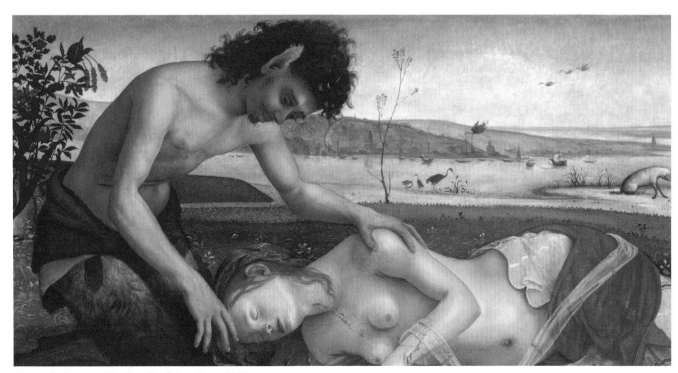

Pietro di Cosimo, The Death of Procris, *c. 1500*

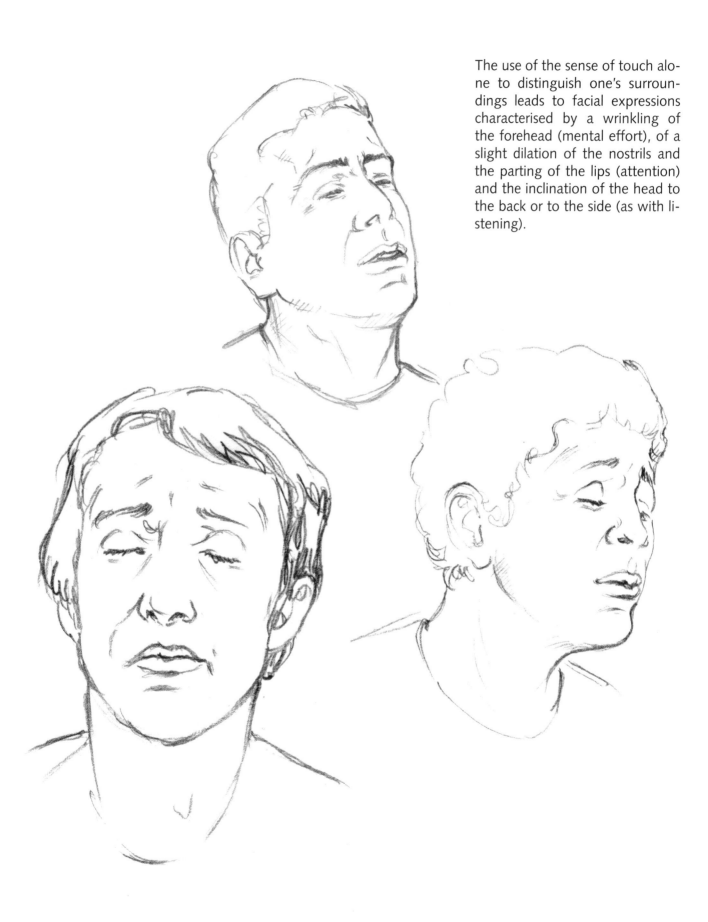

The use of the sense of touch alone to distinguish one's surroundings leads to facial expressions characterised by a wrinkling of the forehead (mental effort), of a slight dilation of the nostrils and the parting of the lips (attention) and the inclination of the head to the back or to the side (as with listening).

In the previous chapter we analysed expressions according to emotions and various attitudes, separating them by genre or the physiognomy of the person. Now we'll look at other decisive factors which change the look of the face – aging first and foremost.

The specific qualities of facial expression owing to age vary greatly for two reasons: changes in the skull and the skin. Hair and body hair are also significant aspects of the face, but we can't consider them as 'structural' as the previous elements.

From birth to old age, the skull undergoes changes in its shape and proportions large enough that they can't be ignored by the artist. In newborns, the cranium's dimensions dominate those of the face. As we grow, the proportions become more balanced as the nose and jawbone develop. In the elderly, on the other hand, the oral cavity sinks as we lose our teeth, making the chin appear less prominent; the jaw may atrophy until it reaches a third of its height, and the cranial vault tends to flatten.

These changes – the thinning of bones and, in particular, the loss of teeth – change the structure upon with facial expressions are shaped.

The skin is a continuous, thick, elastic and resistant membrane whose main role is essentially that of protection. Its thickness varies according to the individual, but the

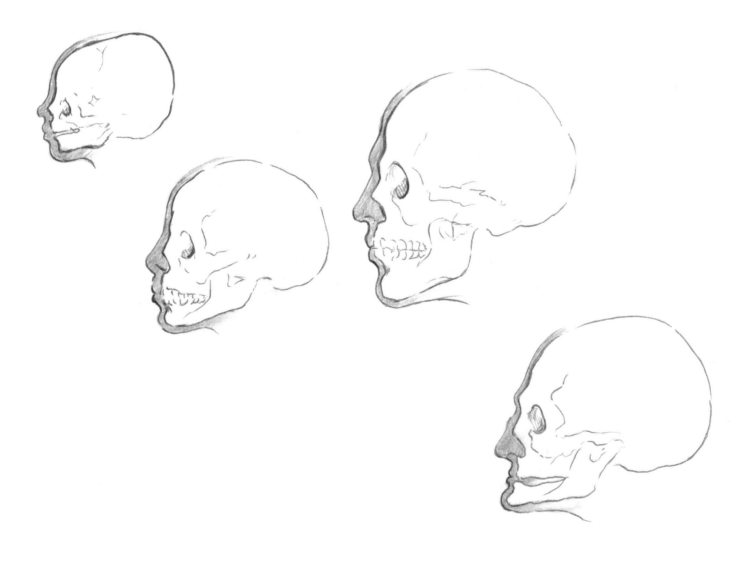

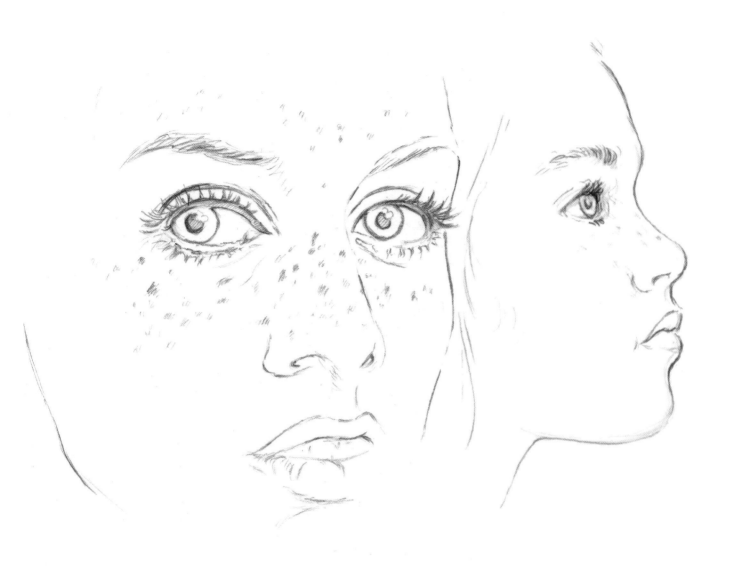

average measurement is 1-2 milli-metres while the minimum drops below half a millimetre. Incredibly thin on the eyelids and on the ex-ternal part of the ear, the skin can reach a maximum thickness of 4 millimetres. Women have thinner skin than men, and as they age it tends to wear thin.

The skin's colouring depends on one particular pigmentation, mela-nin, which is found in the deepest layers of the epidermis. It can vary greatly due to age, gender and, in particular, ethnic backgrounds, which are often classified accord-ing to skin colour.

A few people, specifically those with fair skin and blond hair or even more so, those with red hair, often have small yellowish marks spread over the skin, especially the face, commonly called freckles.

The pinkish colouring of new-borns' skin is due to its subtle-ty, which allows the capillaries to "breathe". That gradually disap-pears with age and the increased thickness of the skin. In the elderly, however, undergoing the effects of general 'regression', skin becomes thin again, wrinkled, and has a darker, more yellowish tone.

Wrinkles. The skin is no longer a smooth surface, replaced by a large quantity of grooves or folds, the products of the movement of underlying muscles and joints.

In facial expressions, these mus-cular folds accentuate a person's mood or attitude. Such folds are at first temporary, but later on, with

the force of repetition, they are slowly imprinted on the skin. They become increasingly accentuated, eventually becoming permanent in our more mature years, that is, from around 40 years old.

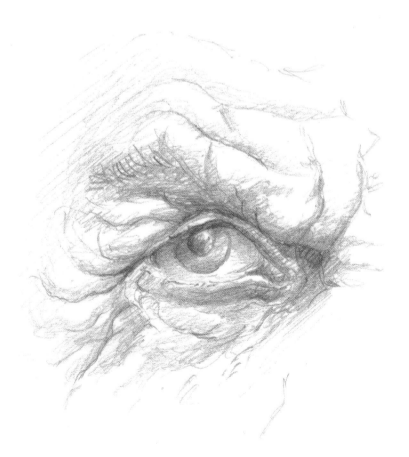

Seniors' wrinkles also come from the progressive disappearance of the elastic fibres of the skin and of the subcutaneous adipose tissue. The skin of an elderly person, no longer taut, is too abundant relative to the surface it is supposed to cover, thus creating wrinkles. It's typical to see creases on the forehead, the eyelids, the corner of the eyes, the cheeks and the sides of the mouth.

Changes to one's expressions due to age also come from less obvious, though equally influential, factors such as: the carriage of the head, interpersonal attitudes and the gaze – all elements which imperceptibly characterise growth, maturity and decline.

A child's innocent gaze, with a large iris and dilated pupil, then gives way to the vivacious, luminous face of an adolescent, and evolves into the small iris of the detached gaze of a mature adult, finally becoming the cloudy, almost fluid look of old age.

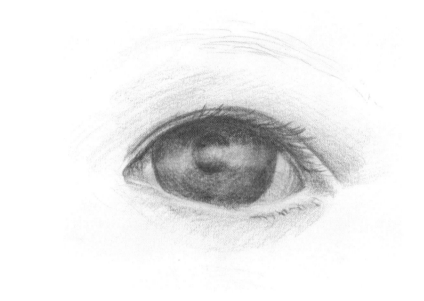

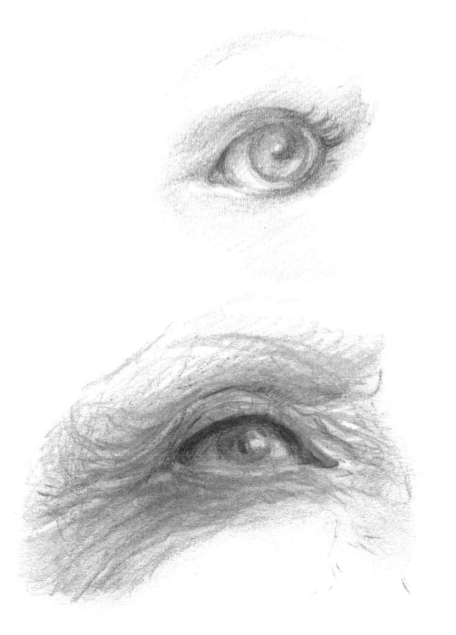

The various ages

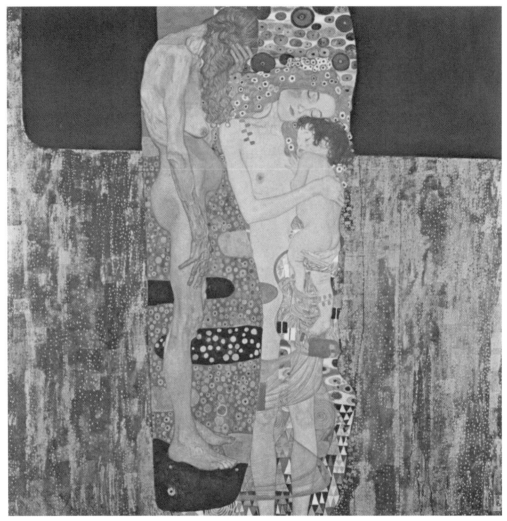

Gustav Klimt, The Three Ages of Woman, *1905*

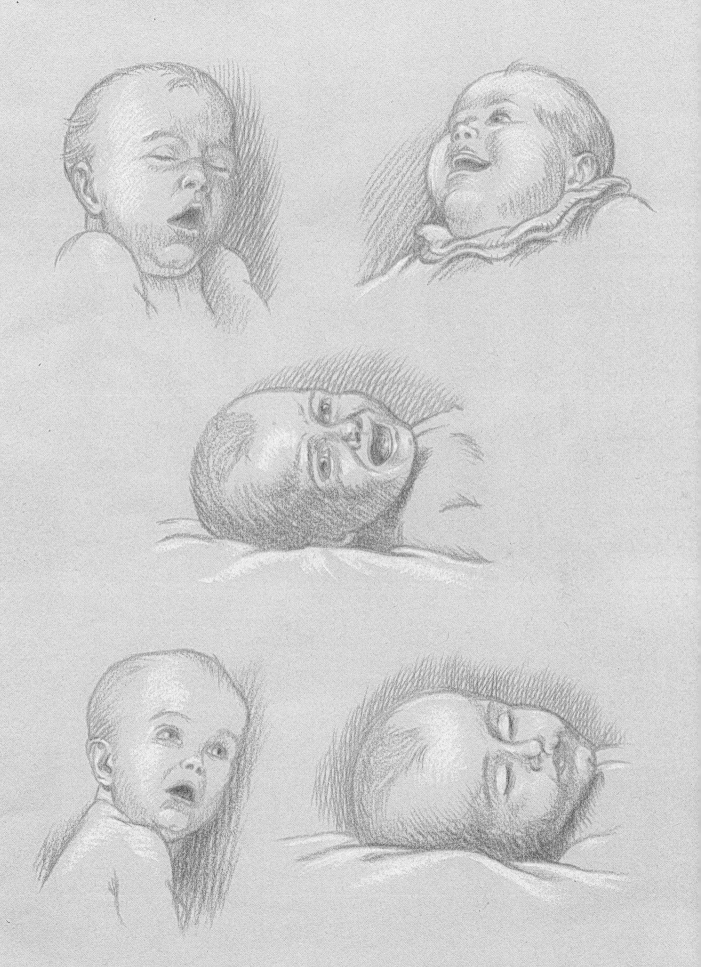

newborn

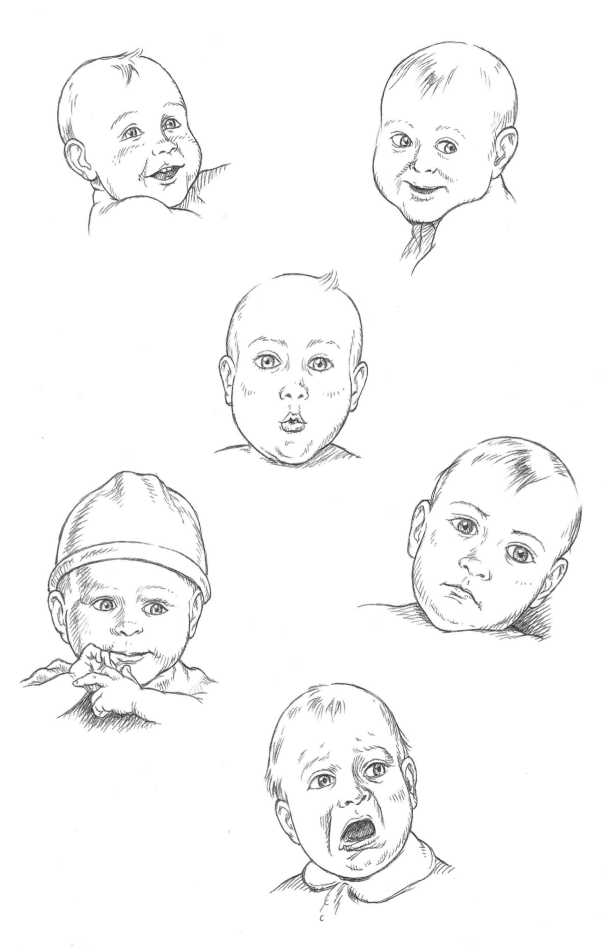

from six months to a year

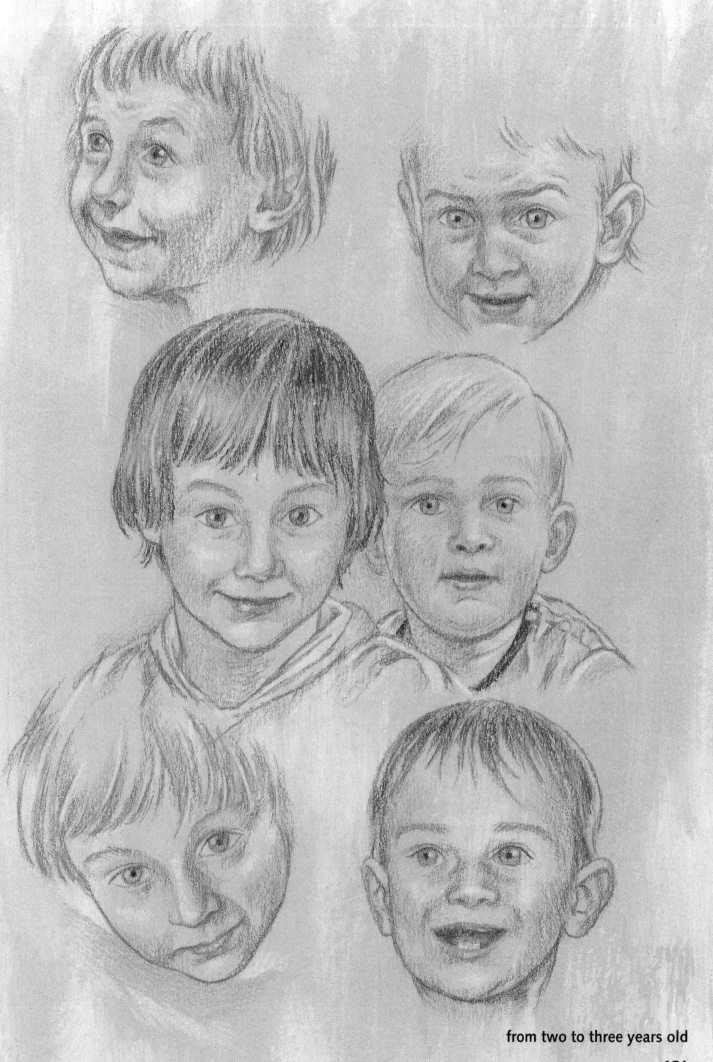

from two to three years old

151

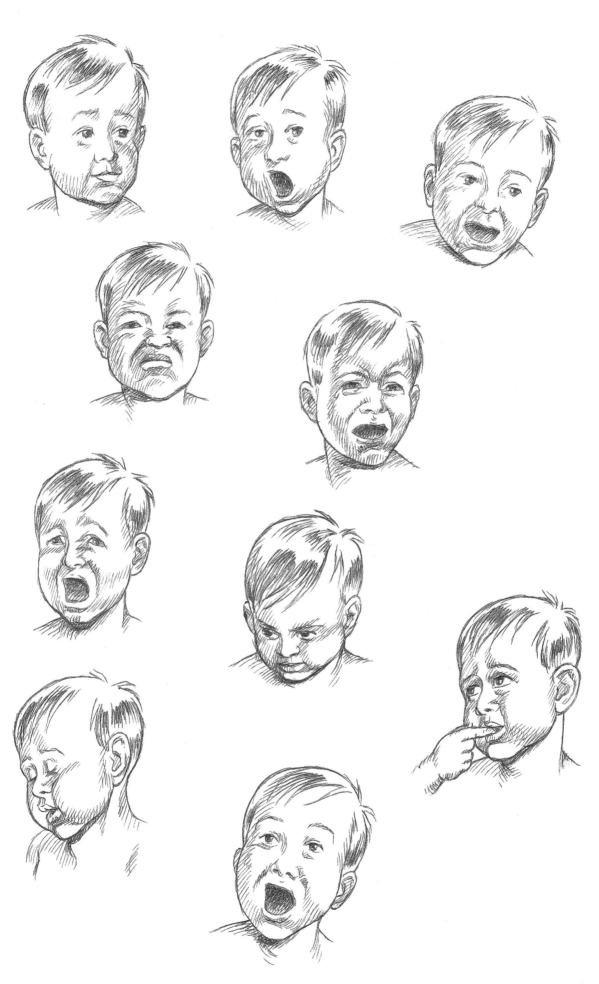

from three to four years old

152

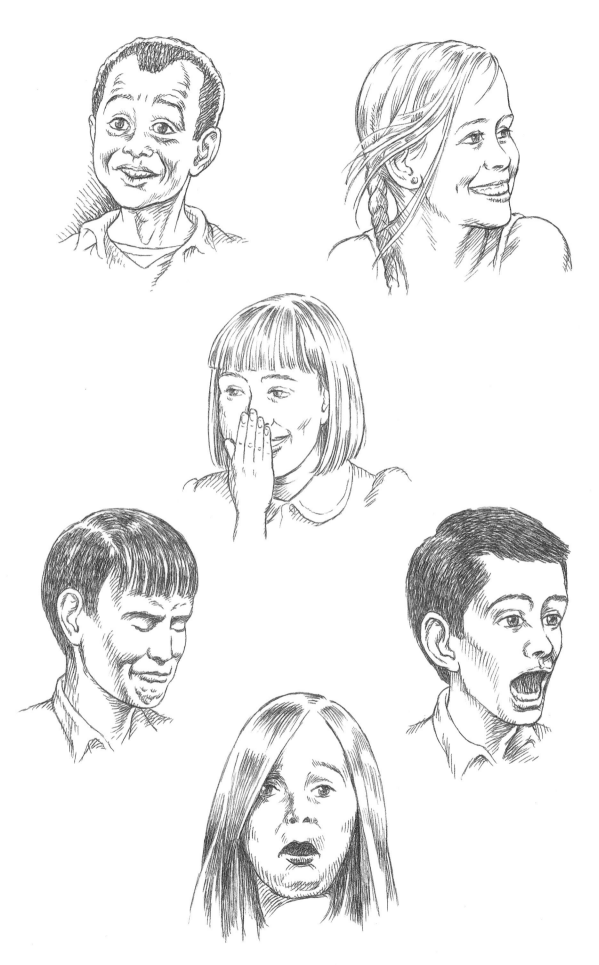

from five to seven years old

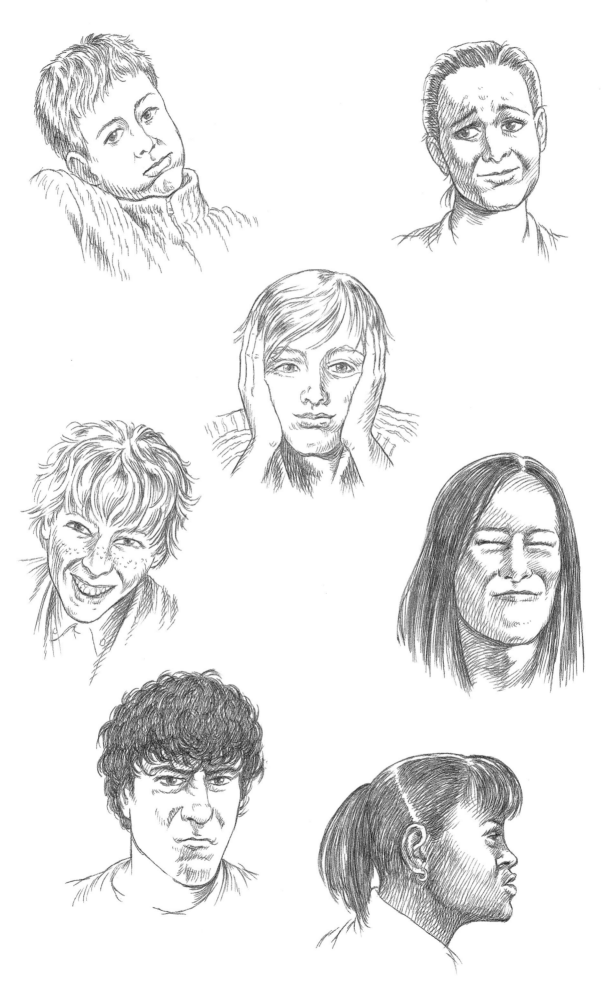

from ten to fourteen years old

154

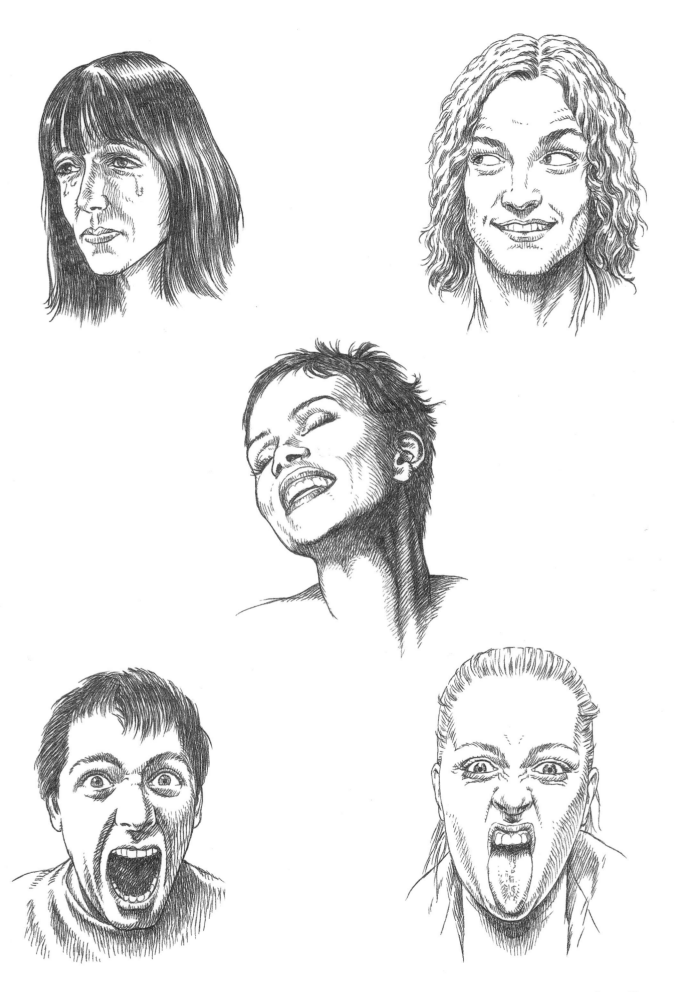

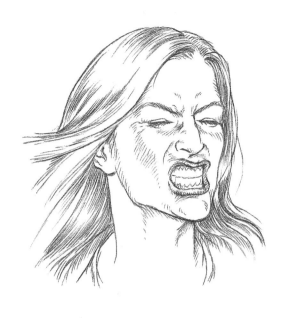
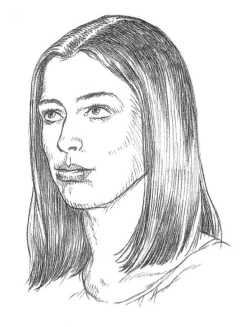
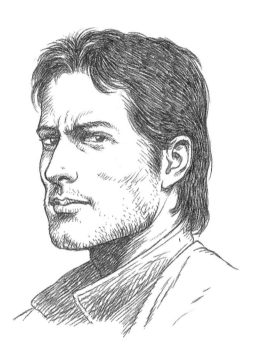
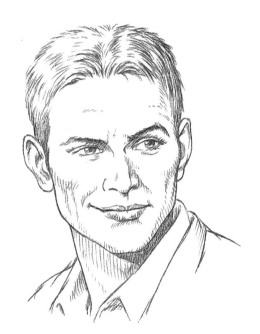
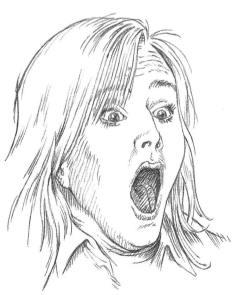

thirties

156

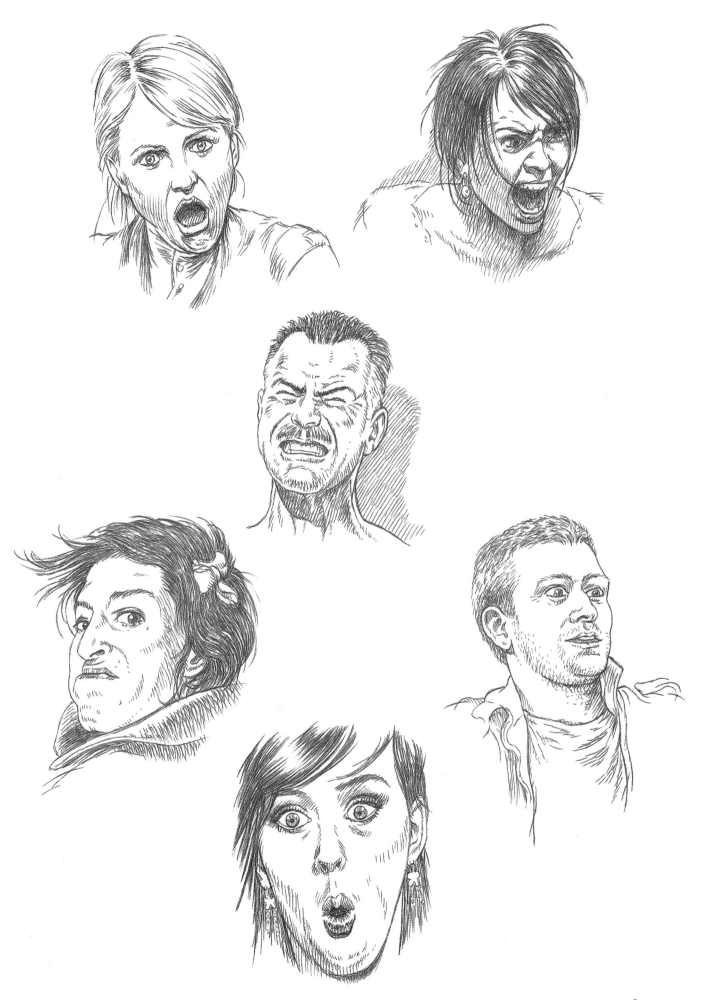

forties

157

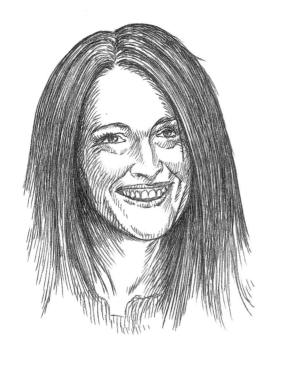

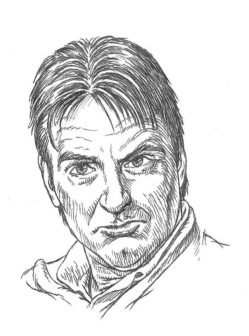

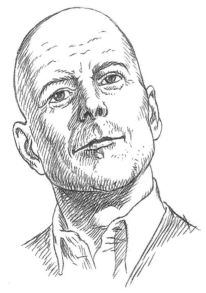

fifties

158

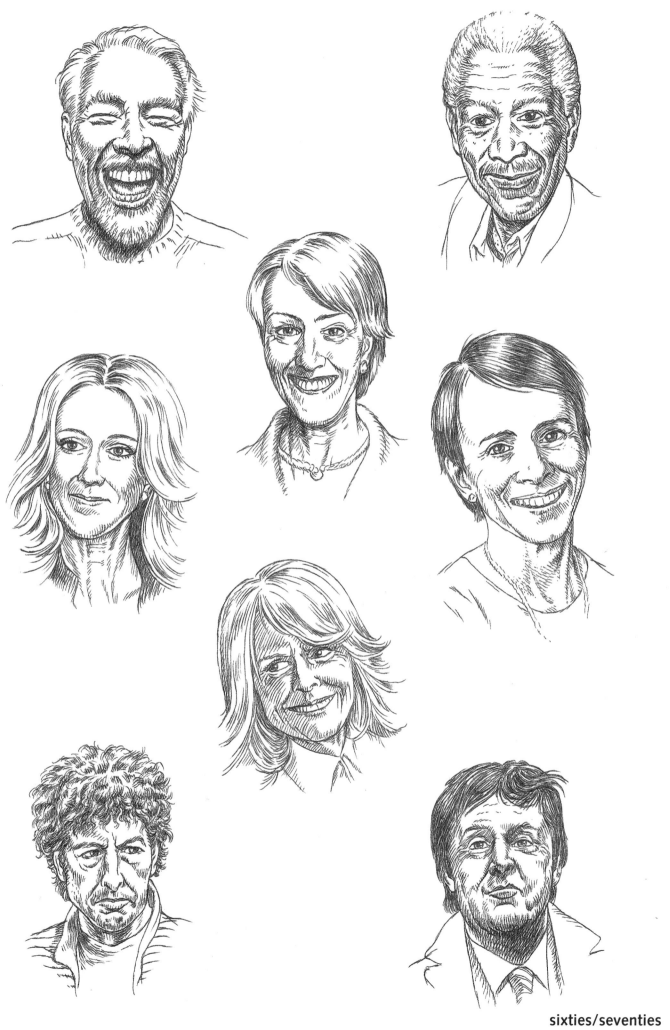

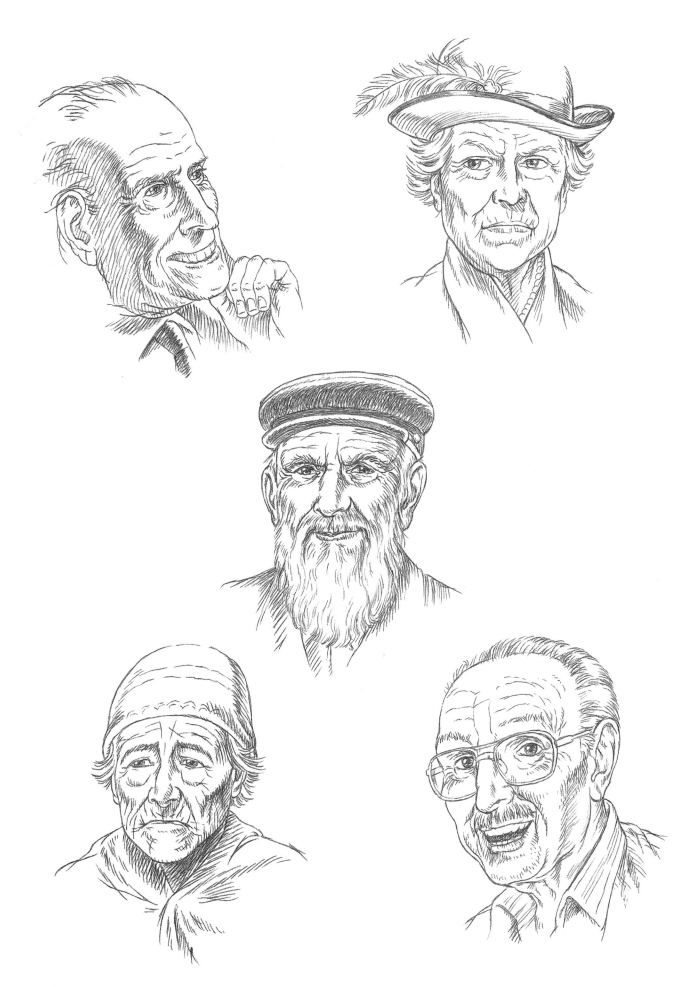

eighties

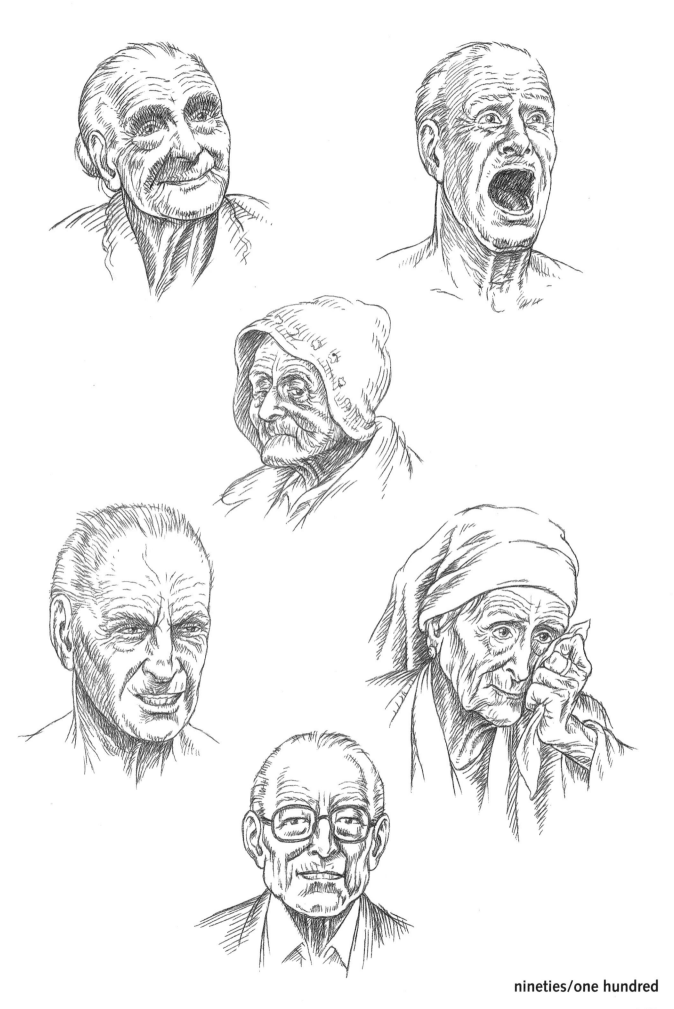

nineties/one hundred

The 20th century saw the emergence of new media for the production and spread of images such as photography, film and comics. These means of communication brought about a remarkable proliferation of visual messages, capable of reaching ever-increasing masses of people and generating innovative ways to use the images. Along the way, these expressive forms were gradually freed from the high arts and developed their own autonomous and codified linguistic structures.

Far from wanting to present an exhaustive treatment of the subject, we'll offer a few insights for further study on the representation of facial expressions through such language.

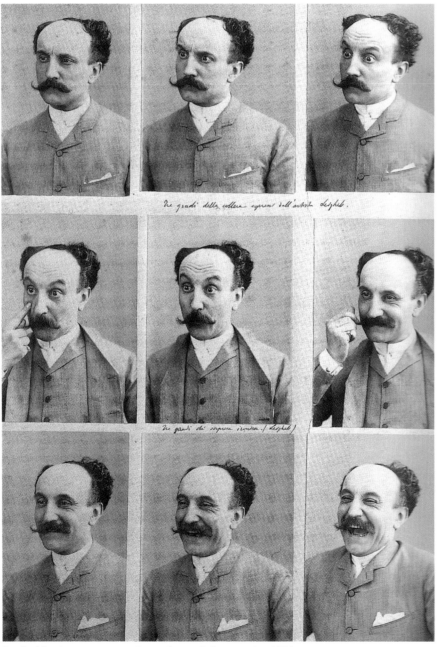

Paolo Mantegazza, expressions of moods by an actor,1873

Photography and film

Film does not present man's thoughts but his behaviour: film does not think, it feels. In this sense it is more similar to visual arts than to a novel. Film gives us a way to enter into the world of humanity: gestures, looks and facial displays of emotion. Human expression, already strong in photography, becomes even more intense in film. Photographing is drawing with light. Starting from this statement, it's easy to understand why, in the fields of photography and film, lighting plays a fundamental role. We can assert that psychological reactions and interpretive responses before an image are largely dictated by the atmosphere created by lighting effects.

Through the adoption of specific lighting techniques, the photographer and the director effectively communicate feelings and emotions, even in cases where the subject doesn't "perform" that specific expression (see: *Suggested Considerations and Procedures – Expressive Variations in an Image - Lighting*).

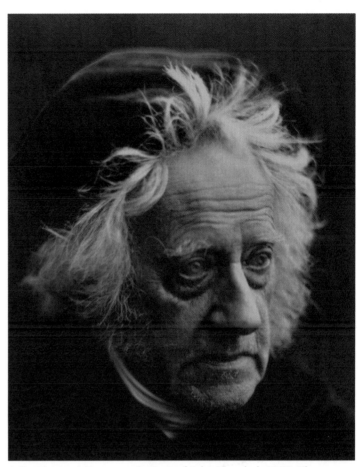

Julia Margaret Cameron, Portrait of John Herschel, 1867. The pronounced shadows reinforce the subject's intense expression.

Victor Sjöström, from Wild Strawberries *by Ingmar Bergman (1957)*

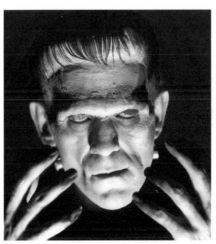
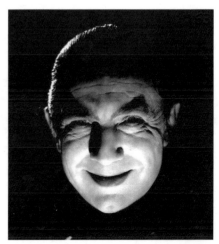

Boris Karloff in Frankenstein *(1931) and Bela Lugosi in* Mark of the Vampire *(1935): the lighting arrives from below and accentuates the mysterious and terrifying qualities of the faces.*

As part of the treatment of facial expressions, we should point out how the attention to lighting and the framing often regard the part of the face considered most eloquent: they eyes. Many photographers consider the eyes much more communicative than the entire face, tending to emphasise the intensity of the gaze of those on film.

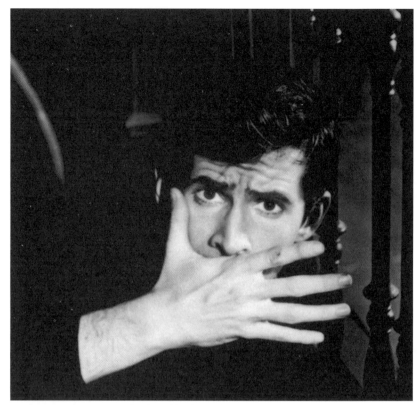

Anthony Perkins in Psycho *by Alfred Hitchcock, 1960*

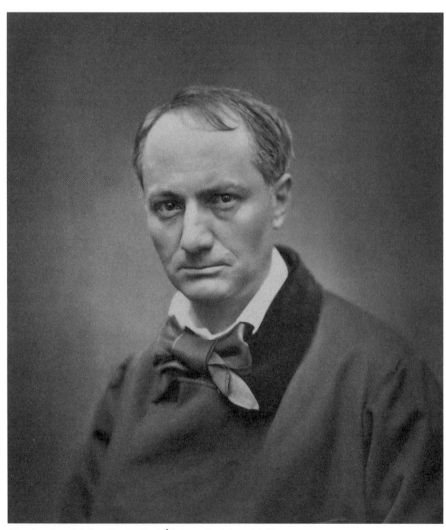

Charles Baudelaire, Portrait of Étienne Carjat, c. 1862

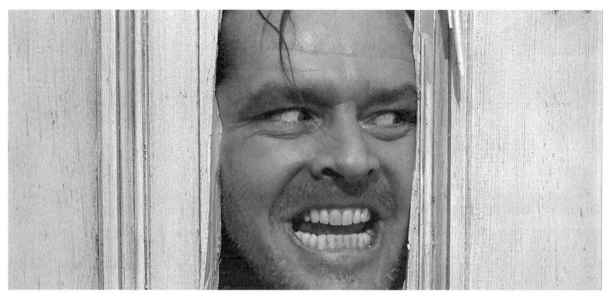

Jack Nicholson in The Shining *by Stanley Kubrick, 1980*

Are the eyes really the window to the soul? It certainly seems that the eyes can't lie and that their communicative potential is strong enough so as to resist the emotionally concealing tricks performed by the facial muscles of other areas (no matter how talented, those who fake emotions are often "unmasked" by their gaze).

For this reason, it's often enough to observe only the expression in someone's eyes to receive any emotional messages they are sending (see: *Exercises - Drawing Gazes*).

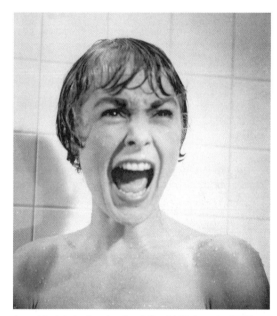

Janet Leigh in Psycho *by Alfred Hitchcock, 1960*

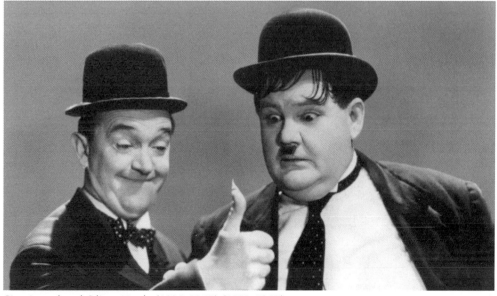

Stan Laurel and Oliver Hardy (1890-1965) (1892-1957)

Comics

A story presented by a comic strip, in its most typical form, is made up of vignettes which can be compared to the frames of a film: they're not intended for contemplation, rather they are to be integrated into a narration made up of sequences of a pre-established length.

Therefore, by means of a few lines, the cartoonist gives life to immediately comprehensible images. To do so, s/he carries out an operation of synthesis: s/he discards the inessential descriptive indicators, those which aren't absolutely necessary for a quick reading of message to be communicated, referring to simplified patterns of facial expressions (see: *Exercises – Drawing Expressions*) As a result, characters' physical aspects and facial expressions are

Winsor McCay, Little Nemo, 1905

Two drawings by Guido Crepax which represent the physiognomy and the emotions of Valentina in just a few descriptive strokes (1971)

The expressive eyes of Diabolik, a character created by Angela and Luciana Giussani in 1962

accentuated: in most cases, their faces end up taking on caricature or mask-like connotations.

These sketching patterns become a code in which two categories stand out: that of "functional expressions" and that of "indicatory expressions". The first category includes attitudes presented identically by all characters when they find themselves in a similar situation, such as the expression of anger, fear, etc. On the other hand, "indicatory expressions" include facial displays which characterise an entirely stereotypical type of character.

Cartoonists and graphic illustrators of unrealistic illustrations have spontaneously adopted a

The cynical, cruel face of Zanardi, a character by Andrea Pazienza in a drawing from the 1980s

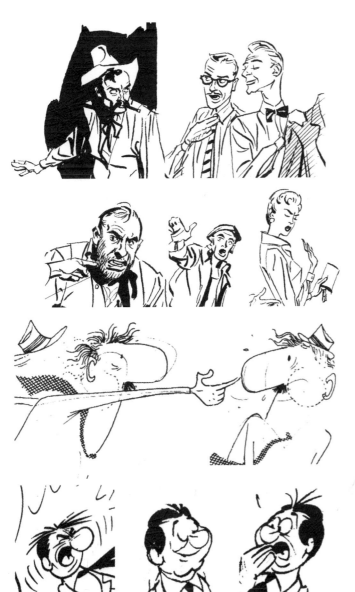

Drawings taken from La Tecnica del Fumetto, *Ikon Editrice, 1991*

code of schematic symbols which are a simplification of human facial expressions (for example: hair on end = fear, rage; furrowed brow = bad mood; closed eyes = sleep, trust; mouth open wide = surprise; etc.). In addition, in the physiognomy of the characters, a particular application of "metonymy", a rhetorical figure which expresses the moral aspect through the physical (for example: the charming hero, the evil "bad guy" with a repulsive face, the blond damsel with snow white skin, etc).

Robert Crumb, facial details from La Genesi, *2009*

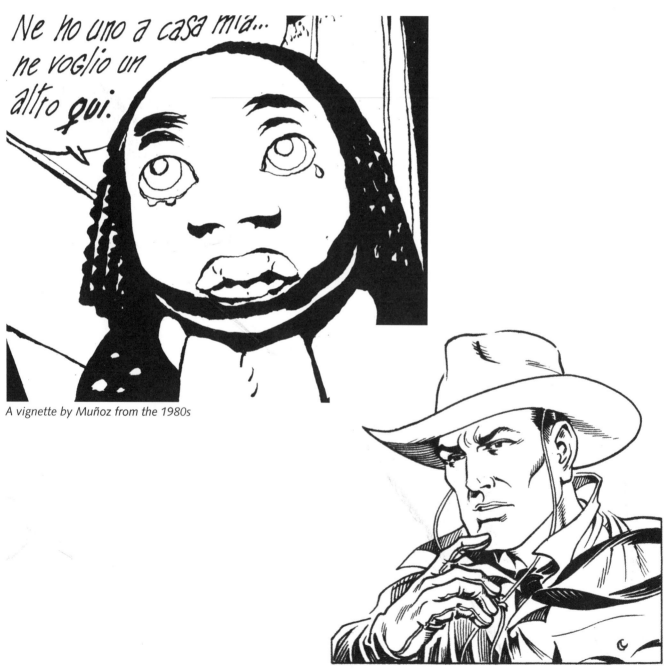

A vignette by Muñoz from the 1980s

Tex drawn by Magnus in 1996, Sergio Bonelli Editore

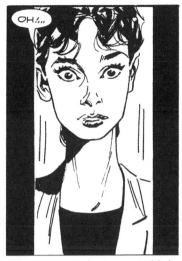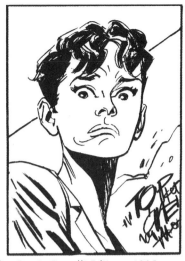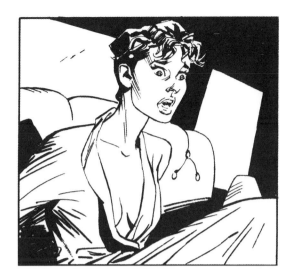

A few vignettes by Marco Soldi for Julia, Sergio Bonelli Editore, 1998

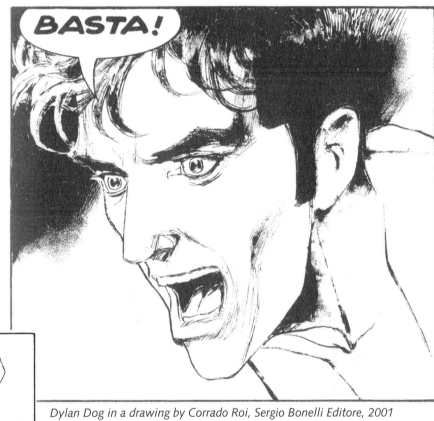

Dylan Dog in a drawing by Corrado Roi, Sergio Bonelli Editore, 2001

Giuseppe Bergman by Milo Manara, 1978

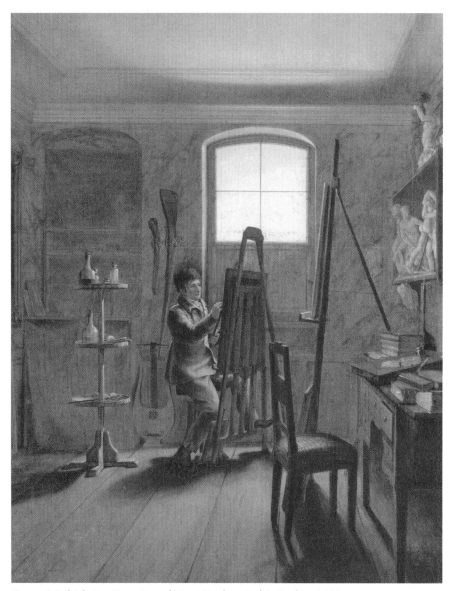

Georg Friedrich Kersting, Gerard Von Kügelgen in his Studio, *1811*

Expressive variations in an image

Emotions represented on a face aren't enough to make an image expressive. Expression also is found in the formal qualities of the image itself and the means which by which they are reproduced or represented are not secondary at all.

Artists were aware of the expressive possibilities of shapes and colours well before Expressionist theory defined this aspect in painting and in film. By the 1700s, what Jonathan Richardson wrote was already common knowledge: "If the subject be grave, melancholy or terrible, the general tint of the colouring must incline towards brown, black, or red, and gloomy; but be gay, and pleasant in subjects of joy and triumph [...]

Generally if the character of the picture is greatness, terrible, or savage...or even the portraits of men of such characters there ought to be employed a rough, bold pencil; and contrarily, if the character is grace, beauty, love, innocence, etc., a softer pencil and more finishing is proper." (*An Essay on the Theory of Painting*, p. 155 and 166, London 1725).

Thus given a face, with fixed expressive characteristics and fixed physical features (local variations of physiognomy, which maintain the overall formal qualities, give rise to caricatures), we can experiment with expressive variations, such as technique, colour and lighting.

Technique

Technique is a means and not an end. Creativity makes use of technique to express its forms, and the same concept or emotion may be expressed in different ways. Artistic ability, which first and foremost is the ability to 'see', to intuit or to imagine, then must be matched with the most suitable technique, the one which best expresses it.

Technique, colour and lighting are the main factors which add greater expressivity to the face. Here we have used them on faces with little to no expression so as to avoid confusing the evidence of the demonstration.

Giovanni Colombo, Tribute to Hermann Hesse, *mixed media, 2007*

Ink on cartridge paper - dramatic

Watercolour on Japanese paper - delicate

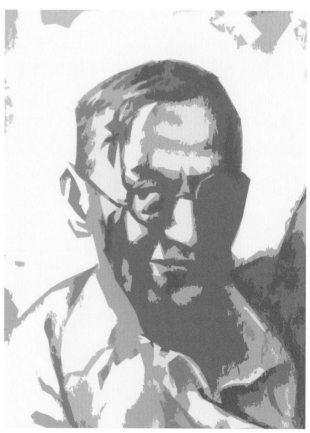

Tonal separation done on the computer - graphic

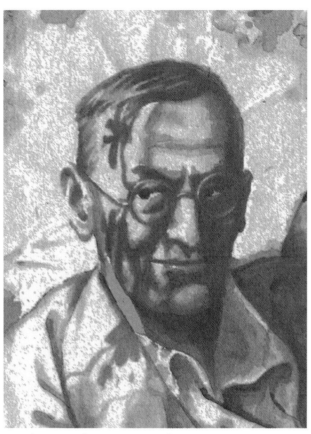

Pastel on cartridge paper - nostalgic

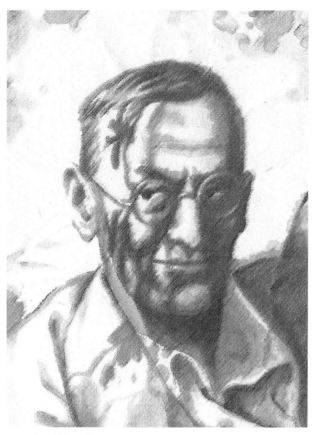

Pastel with hatching - extemporaneous

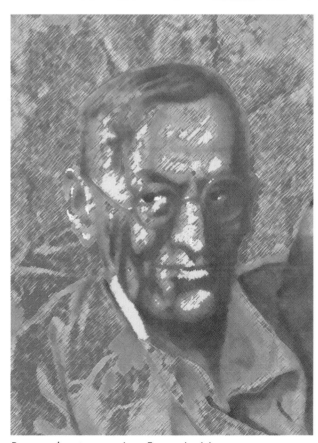

Processed on a computer - Expressionist

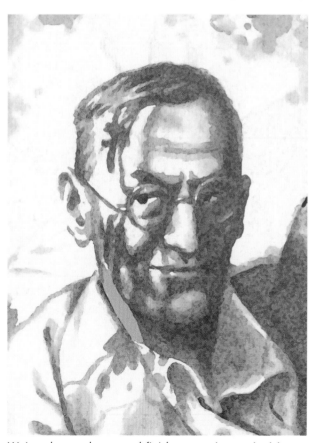

Watercolour on hammered-finish paper - Impressionist

Colour

Colour, like shape, line and any other formal element, has strong expressive potential. Formal factors are the bearers of the mind's contents. They reproduce interior feelings and attitudes: outer expression is connected to inner emotions, passions, pathos, enthusiasm and involvement.

Even J. W. Goethe had identified the ability to embody one's inner resonance (Goethe, Theory of Colours), moving the observer mentally and morally. An image which is not very expressive can be nudged towards a specific formal quality according to the colour of light used, producing not just warm or cold expressions, but soft and hard, shrill or deaf. (Many such examples can be found in fine art, photography and theatre).

Giovanni Colombo, Portrait of the Artist as Young Man, *digitally processed.*

Mostly yellow - *happy, carefree*

Mostly orange - *joyous, relaxed*

Mostly pink - *sensitive, sweet, young*

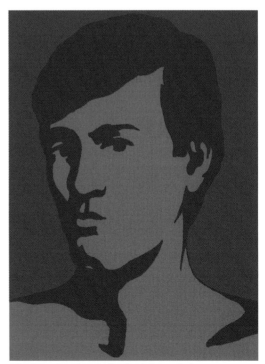

Mostly red - *strong, lively, extroverted*

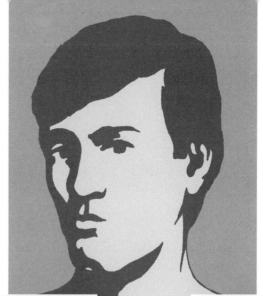

Mostly grey - *indifferent, in one's head, old*

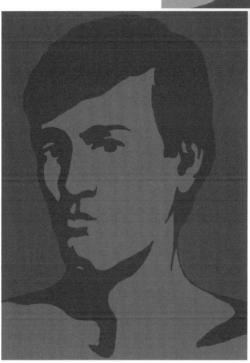

Mostly warm brown - *assured, sociable*

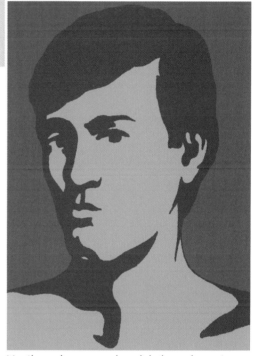

Mostly cool green - *relaxed, balanced, passive*

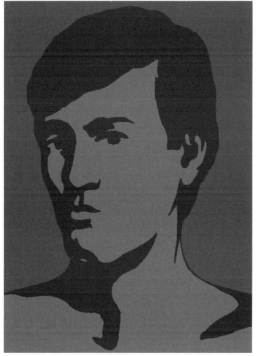

Mostly bright blue - *introverted, collected, calm*

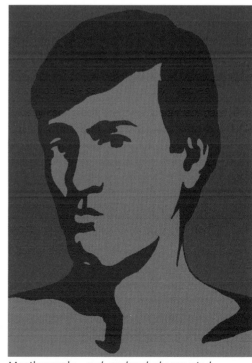

Mostly purple - *sad, melancholy, worried*

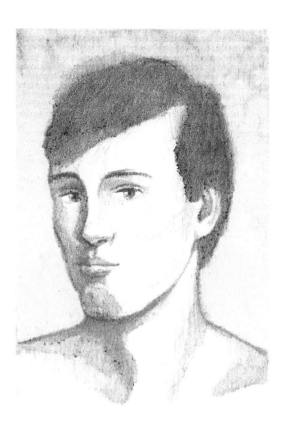

Front lighting
- *harsh shadows (attention)*

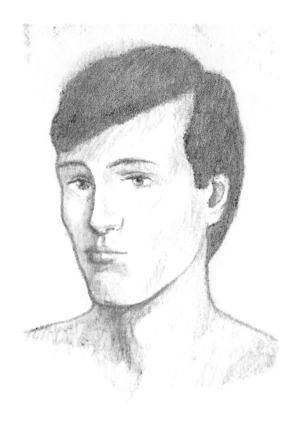

Diffused lighting
- *soft shadows
(serenity-satisfaction)*

Lighting

Another expressive variant of an image of a face is that of the light. As painters, photographers and directors know quite well, the lighting is always the result of a specific communicative plan. It's a perceptual lighting effect and can be classified according to its various sources. As such, we have front, side, diffused, acute and back lighting. You can create "warm" atmospheres with the use of soft, intense lights, or "cold" atmospheres (icy white or bluish lights), daytime (high, solar lights) or night-time atmospheres (low-muted lights). You can also create unique effects, for example, by isolating details (a part of the face) or by angling light from different sources.

Front: reflecting almost all the light, shapes become flat and surfaces bright. Diffused: this uniform type of lighting produced by multiple sources reduces chiaroscuro con-

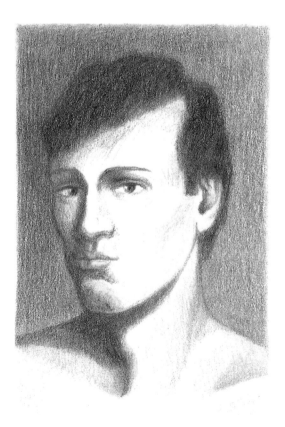

Acute lighting
- *net contrast of light/shadow (emotion)*

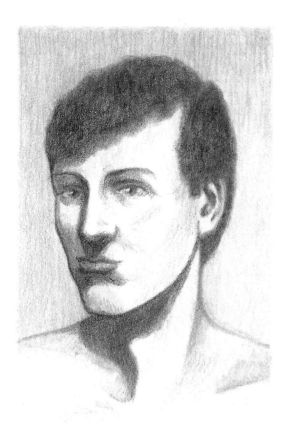

Side light from above
- *natural shadows (strength-displeasure)*

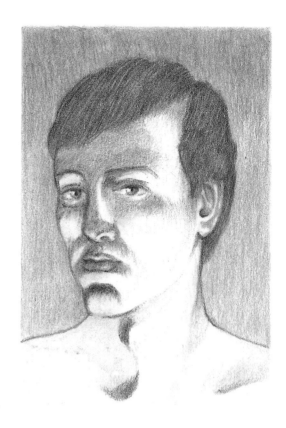

Side light from below
- *unnatural shadows
(drama-mystery)*

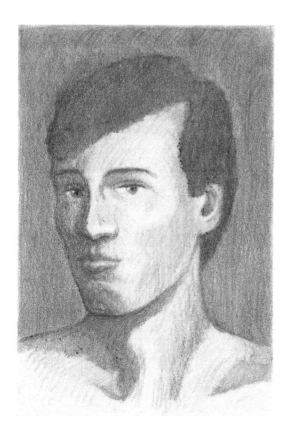

Bassa luminosità
- *penombra con lumeggiature
(calma-incertezza)*

trast and softens the plastic transitions between facial features. Acute: highlights the smallest variations along surfaces, carving deep shadows and articulates the convexity of the head.

Side: produces contrast between light and shadow which brings out the plasticity and volumes of the subject.

Backlit: makes the subject a dark, opaque figure; volume dematerialises into a flat shadow; from the side, the profile becomes a distant silhouette and a bit melancholy. Lighting can also change according to its brightness. This contributes the degree of clarity, the intensity of the light. In the examples provided here, figure 3 shows low lighting, while the other figures are all brightly lit. The quantity and quality of the light (a combination of specific factors) thus determine the expressive atmosphere of a portrait.

Giovanni Colombo, Portrait of the Artist as a Young Man, *mixed media*

177

Expressive sequences

The recognition of a determined expression always comes in its culminating phase; the intermediate phases escape our immediate deciphering because they are extremely short-lived and do not connote clear, unambiguous signals. From the first appearance of motion in the facial muscles up to the arrival at the expressive apex, a few seconds might pass, at times just a few fractions of a second. In this short time span, the face changes rapidly and takes on fleeting poses.

To study the phases of development of a given expression, experts have used photography (starting in the 1800s) and, more recently, film or video.

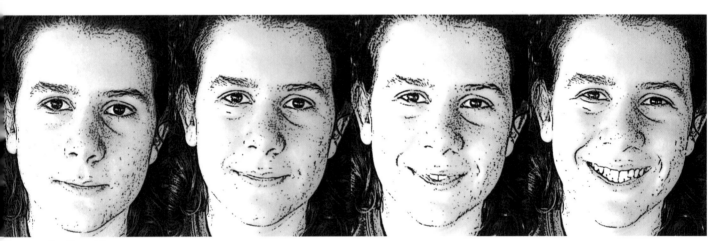

Joy/Laughter

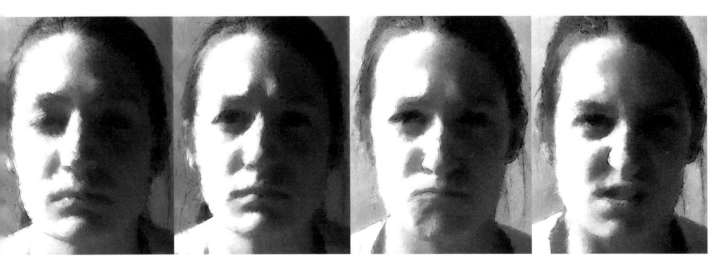

Anger/Rage

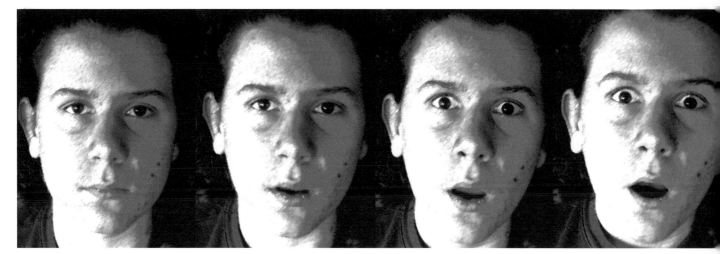

Surprise/Amazement

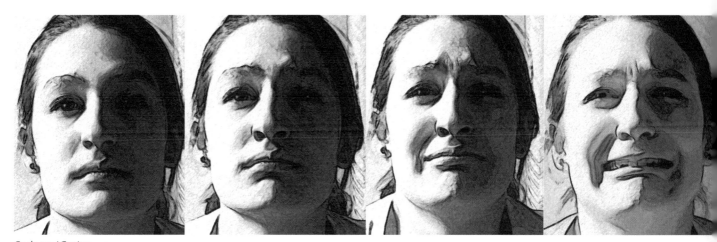

Sadness/Crying

Even those who are interested in the study of facial expressions for artistic purposes should grapple with such techniques for recording reality, so as to gather those facial signals which suggest a certain type of emotion even before it reaches its maximum intensity, or to identify the intermediary stages which unite different expressions. In amazement, for example, one passes from an expression of attention to that of surprise in a few short seconds. While crying, the face first becomes melancholy, followed by an expression of increased suffering. The examples provided here have been made by selecting a few meaningful stills from short films. The sequences obtained have then been altered with the same digital processing software.

Expressions in the busts of Franz Xaver Messerschmidt

Franz Xaver Messerschmidt (1736-1783), an Austrian sculptor, piqued the interest of scholars for his creation of "character heads", sixty or so sculptures in lead, stone or wood and subject to various interpretations.

For our purposes, we're not interested in the artistic and psychological interpretations which various researchers have given them, only the results obtained by the sculptor.

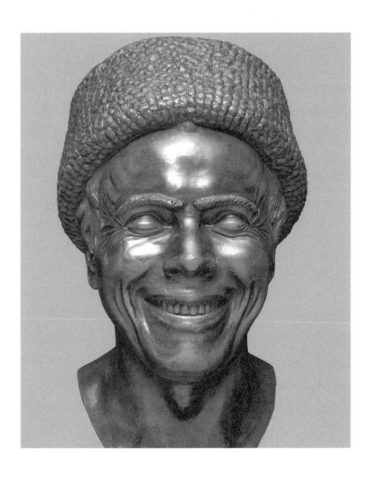

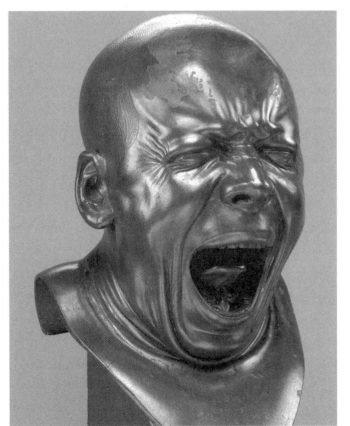

He began working on his "character busts" starting in the 1977s. These sculptures were never commissioned, being rather works that sprung from his own creativity and inspiration.

We have detailed information from the period in which he was working on these character busts, thanks to an account of the visits paid him by Friedrich Nicolai, in whom the artist often confided. Messerschmidt's busts seem to be self-portraits, carried out in search of authentic expression.

At that time, his personal and professional life had taken a turn for the worse: his psychosis was increasingly present, isolating him from society and from academic committees. His artistic production and virtuosity didn't cease, however, and his search for his own face's expression continued right into his schizophrenia.

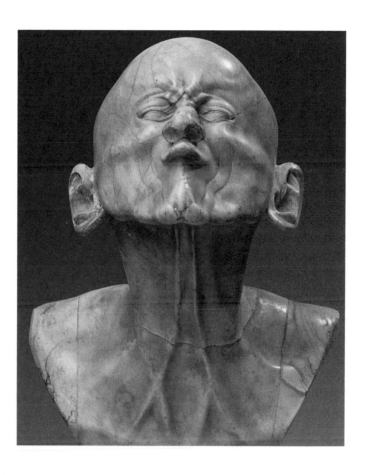

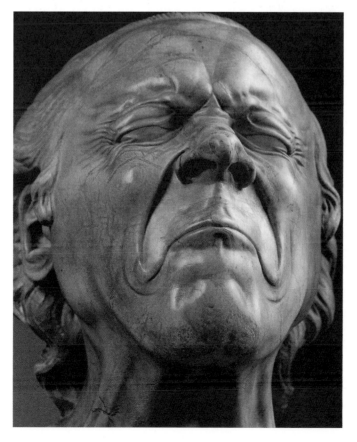

The mouth and lips are a central element in his work. In a few, tightly-shut lips indicate the fear of draining away into infinite space, while in others they indicate an attempt to block the influence of demons. From the period immediately following his death to the mid-19th century, there were numerous exhibitions showing the series of busts which would eventually bring fame to their creator. The names which were attributed to the individual figures are linked to an interpretation according to which he considered them studies of "character" or representations of "human passions".

Contrary to the line drawn by Charles Le Brun, it wasn't sown much the representation of affection which interested Messerschmidt as much as an effort to render the changes in the face in response to various experiences. That which the sculptor intended to represent was the change in the relationships between facial muscles as they performed different functions, such as yawning, laughing, sleeping, etc.

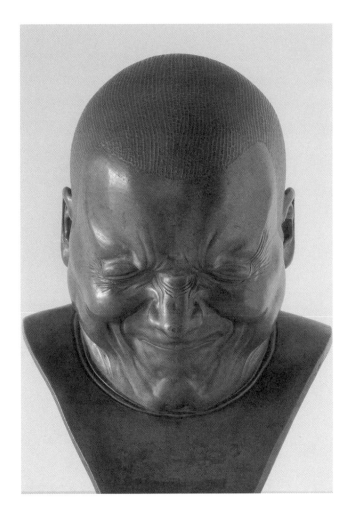

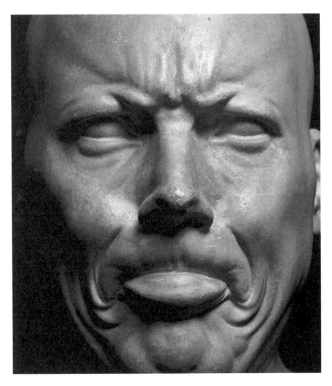

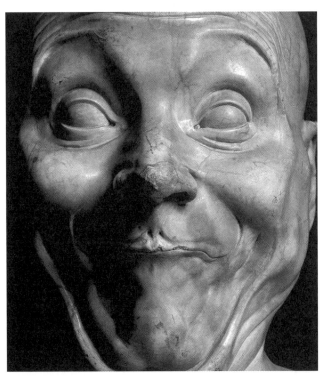

Deconstruction of a sculpture by F. X. Messerschmidt

Putting aside the precision and re-levance of the titles given by con-temporaries to the busts for this chapter, in such denominations we find expressions which are ra-ther unusual and in certain cases, such as the "The Incompetent Bassoonist", even contradictory.

For this reason, one of the authors of the book has taken this expres-sion and examined it in depth, making it the subject of study and graphic representation for the 3rd year exams in anatomy at the Ac-cademia di Belle Arti of Brera.

This expression is a unique fusion of two facial-muscular attitudes. Before trying to define it, we'll take a look at which cranial mu-scles interact to create it.

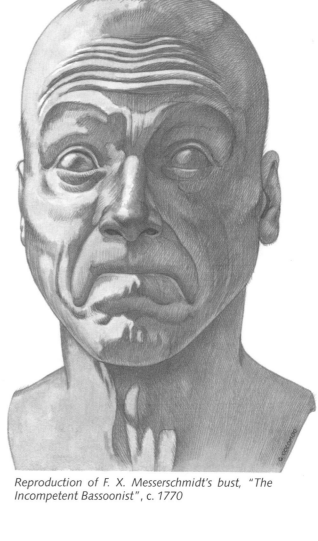

Reproduction of F. X. Messerschmidt's bust, "The Incompetent Bassoonist", c. 1770

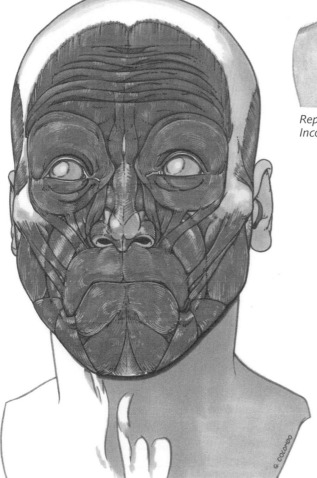

Superficial facial muscles

The expression on the upper part of the face (amazement or startled fear) is due in large part to the maximum extension of the frontalis muscle accompanied by the extension of the procerus. These two are joined by the orbicularis oculi (orbital portion), whose upper half is extended upwards. The zigomaticus (both major and minor) and the levator labii superioris (including the alaeque nasi) are extended and follow the movement of the muscles of the lips. The buccinator muscle compresses the mouth, dilated with air, pushing it towards the orbicularis oris of the lip, puffing it up. The depressor anguli oris, bringing the buccal rim down with his maximum amount of concentration, seems to express disgust or displeasure. This same action is followed with the risorius muscle and the depressor labii inferioris.

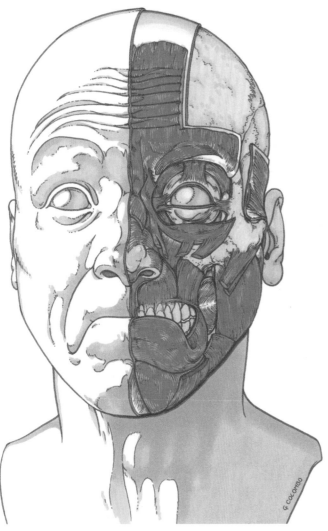

Sectioned superficial and deep facial muscles

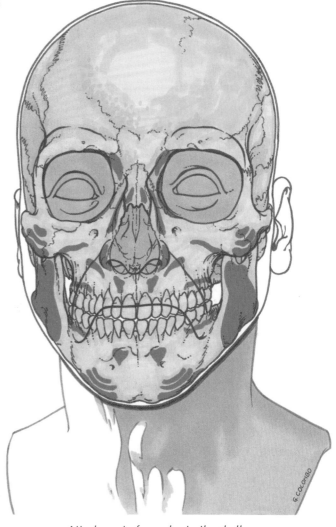

Attachment of muscles to the skull

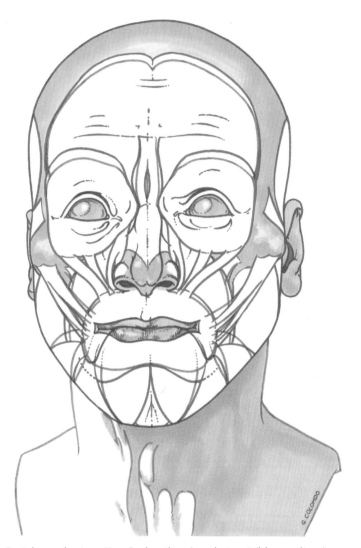

Facial muscles in action (red outlines) and at rest (blue outlines)

Below this, the mentalis, contracting, lifts the skin of the chin and produces wrinkles. Lastly, the central part of the orbicularis oris closes the oral cavity: folding the lips inward and forcing them up against the teeth, their outer edges disappear. Meanwhile, its outer part extends downward following the buccal rim.

Obviously, in a face's expression, all the muscles combine and interact with each other, but the previous analysis has revealed a contradiction. If the upper part of the face expresses amazement, the lower part is not consistent. In fact, more than an expression, it produces a grimace. This is due to an attempt to expel air from the oral cavity (to blow out) which is immediately repressed, forcefully and stubbornly, by the maximum closure and curvature of the buccal rim.

It is here that we can demonstrate the sculptor's interest in the study of the effects of signalling on the face, rather than representing human passions; this is without considering, among other things, the psychotic aspects already present in this piece, realistically titled "The Incompetent Bassoonist".

Book organisation

Despite being a single project, each chapter's images and/or text are by different authors, as listed below.

Introduction: Giovanni Colombo, Giuseppe Vigliotti

Emotional expression in art: Giovanni Colombo, Giuseppe Vigliotti.
Charles le Brun: Giovanni Colombo

Expressions and psychology: Giovanni Colombo

The anatomy and physiognomy of the head: Giovanni Colombo

Exercises:
Drawing facial details: Giuseppe Vigliotti
Expressive sketches: Giovanni Colombo
Drawing the head: Giovanni Colombo
Drawing expressions Giovanni Colombo
Drawing gazes: Giovanni Colombo

Classifying emotions:
Ecstasy, joy/laughter, laughter/smiling, admiration/adoration, affection, rage/anger, attention/awaiting, attention/alert: Giuseppe Vigliotti
Sadness/melancholy, sadness/crying, anguish/pain, hate, disgust, boredom, distraction, surprise/amazement, worry/anxiety, fear/terror: Giovanni Colombo

Expressions which reflect attitudes: Giuseppe Vigliotti

Modifying expressions: the various ages: Giovanni Colombo
Drawings for the introduction: Giuseppe Vigliotti
Drawings for the various ages: Giovanni Colombo

Photography, film, comics: Giovanni Colombo, Giuseppe Vigliotti

Suggested considerations and procedures:
Expressive variations in an image: Giovanni Colombo
Expressive sequences: Giuseppe Vigliotti
Expressions in the busts of Franz Xaver Messerschmidt: Giovanni Colombo

BIBLIOGRAPHY

Arnheim, Rudolf - *Toward a Psychology of Art*, Berkeley University of California Press, Berkeley, California, 1966.

Caroli, Flavio - (curated by) *L'anima e il Volto - Ritratto e Fisiognomica da Leonardo a Bacon*, Electa, Milan, 1998.

Caroli, Flavio - *Storia della Fisiognomica* - Arte e Psicologia da Leonardo a Freud, Electa, Milan, 2002.

Clair, Jean - (curated by) *Venice Biennale: Identity and Alterity - Figures of the Body 1895/1995*, La Biennale di Venezia, Venice, 1985.

Darwin, Charles - *The Expression of the Emotions in Man and Animals* (commentaries by Paul Ekman), Oxford University Press, 1998.

Facca, Gian Carlo - *Fisionomia*, Hoepli, Milan, 1933.

Faigin, Gary - *The Artist's Complete Guide to Facial Expression*, Watson-Guptill Publications, U.S.A., 1990.

Gombrich, Ernst H. - *Art and Illusion, a Study in the Psychology of Pictorial Representation*, Phaidon, London, 1960.

Gombrich, Ernst H. - Hochberg, Julian - Black, Max - *Art, Perception, and Reality*, Johns Hopkins University Press, Baltimore, 1972.

Kris, Ernst - *Psychoanalytic Explorations in Art*, International Universities Press, New York, 1952.

Le Brun, Charles - *Conferérence sur L'expression Générale et Particuliére des Passions di Charles Le Brun*, Paris, 1698.

Magli, Patrizia - "Il Sopracciglio è lo Specchio dell'anima", in *Kos*, n. 29, Franco Maria Ricci, Milan, 1987.

Mantegazza, Paolo - *Physiognomy and Expression*. W. Scott Publishing Company, 1890.

McNeill, Daniel - *The Face*, Visible Ink, Oakland, California, 1998.

Morelli, Angelo and Giovanni - *Anatomia per gli Artisti*, F.lli Lega Editori, Faenza, 1975.

Morris, Desmond - *The Naked Ape: A Zoologist's Study of the Human Animal*, Jonathan Cape, London, 1967.

Rosa, Leone Augusto - *L'espressione dei Sentimenti nelle Opere d'arte e nel Vivo...* Ed. Minerva Tecnica, Turin, 1959.

Timelli, Roberto and Verucchi, Daniele - *Espressione & gestualità - Semiologia del disegno anatomico*, Editiemme, Milano, 1988.

TABLE OF CONTENTS